KNOWLEDGE AND INFORMATION

The Potential and Peril of Human Intelligence

KNOWLEDGE AND INFORMATION

The Potential and Peril of Human Intelligence

EDITED BY

KURT ALMQVIST & MATTIAS HESSÉRUS

BOKFÖRLAGET STOLPE AXEL AND MARGARET AX:SON JOHNSON FOUNDATION FOR PUBLIC BENEFIT

CONTENTS

THE STATE OF THE DEBATE

INTRODUCTION

At the Engelsberg seminar in 2000 – entitled *Visions of the Future* and held at Avesta Manor in Dalarna, Sweden – the literary critic and historian Harold Bloom said that he feared "a future where everything is known, but no one is wise; all the information in the world cannot compensate if wisdom is lost to us." Bloom's remark, almost 20 years ago, sums up the fear that many participants expressed at the Engelsberg seminar in 2018. The texts in this anthology stem from the seminar, Knowledge and Information, which took place at Engelsbergs bruk in Västmanland, Sweden.

Who should be in control and to whom does the massive amount of information produced today belong? How will this information be transformed into knowledge and wisdom by us as humans and individuals? Knowledge has always been associated with some sort of authority, as Erica Benner pointed out at the seminar. But, alluding to the critical views held by philosophers of the Enlightenment, she also warned about the dangers of authority-based knowledge in the hands, for instance, of priests and other authorities throughout history. Democracy is a relatively recent political phenomenon and control of information can be used and misused by democratic societies and states just as much as by totalitarian regimes – as it is, indeed, also used by global companies which know more about us then we know about ourselves and which put that information to work for purposes that are purely commercial.

In this context, it was interesting to hear Nicklas Berild Lundblad, a vice president at Google, highlighting the role that technology will play in the basic social and political challenges of the future. How do we handle this new wealth of information available to us, with its organised complexity, while with every passing year our attention span grows poorer?

Stockholm, March 2019
*Kurt Almqvist, President, Axel and Margaret Ax:son Johnson
Foundation for Public Benefit*

THE ORIGINS
OF KNOWLEDGE

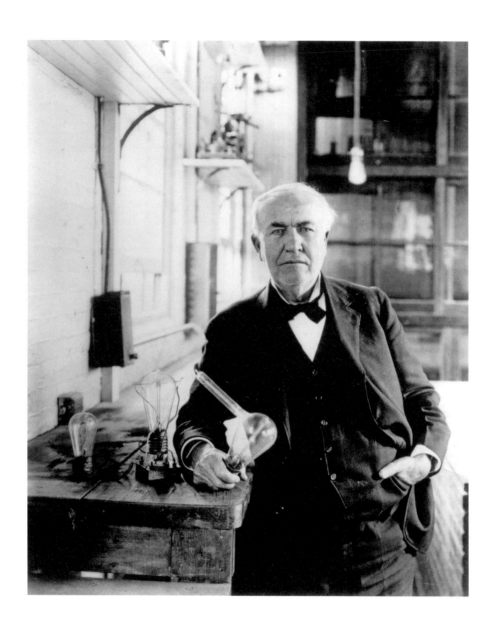

Thomas Alva Edison (1847–1931)
with his "Edison Effect" lamps.

YOU ARE NOT AS CLEVER AS YOU THINK

Mark Pagel

Human beings are the only species with a history. In the brief span of our existence (roughly the last 200,000 years of the 3.75 billion-year history of life on Earth), we have gone from being a species that made just a few simple hand-axes to one that now enjoys soaring cathedrals and breathtaking art, that can make spaceships, smart phones and driverless cars, and which is capable, Prometheus-like, of manipulating its own genetic code. Contrast this with our wretched cousins the chimpanzees who, while sharing with us over 98 per cent identity in the sequences of our genes, still sit on the forest floor cracking nuts with the same old stones as they have for millions of years. In fact, for all species but our own, history really is, as the English historian Arnold Toynbee once remarked "just one damn thing after another", and in the case of chimpanzees the same one thing at that.

Why this difference? Why do humans accumulate ideas, knowledge and technologies while the other animals are seemingly stuck doing the same thing over and over, never really getting any better? The chimpanzees tell us that the answer must be small in genetic terms but at the same time capable of opening up an unbridgeable gap in our evolutionary potentials.

It is a particular human conceit that the usual answer we give to this question is that we are simply cleverer than the other animals; that if we just think hard about something, we will eventually figure it out. Call this the "insight" view of our abilities at innovation. It predicts that our raw wit and ingenuity will produce great leaps in the technological timeline, recording moments of innovation when humanity jumps up a step – or even two – on the technological ladder. It is the view of creativity captured by the "thought-bubble" image of a lightbulb flashing on inside your head.

Of course, we are cleverer than the other animals, but the history of technological progress doesn't include many lightbulbs. The historian George Basalla has observed that the romantic notion of technology advancing owing to the efforts of a small number of heroic inventors, whose insights produce revolutionary leaps with little or no link to the past, struggles to connect with what we observe when we look closely at their deeds. Throughout our history, innovation has turned out to be more a case of trial and error, copying others and chance good fortune than of searing insight.

Thomas Edison, usually credited with inventing the lightbulb, toiled over a two-year period to find a filament that would glow brightly for more than a few seconds. Edison's journals record that he tested "no fewer than 6,000 vegetable growths, and ransacked the world for the most suitable filament material" before finally settling, quite by accident, on a carbonised cotton thread he happened to be rolling between his fingers. James Watt is often credited with inventing the steam engine, but his design was a modification of an engine that Thomas Newcomen had developed. Children learn at school that Henry Ford created the assembly line, but he didn't; he refined existing production methods.

In more modern times we credit the late Steve Jobs as the creative genius behind the Apple brand. Jobs achieved notoriety for the mouse-driven point-and-click operating system that revolutionised how we use computers. But rumours persist that Jobs took the idea from the Xerox corporation – whose premises he had toured – which had developed that operating system years before. Jobs' genius was that, perhaps unlike the Xerox corporation, he recognised the value of this particular innovation.

Even one of the most revolutionary of scientists, Isaac Newton, remarked that he "stood on the shoulders of giants". But we need not confine ourselves to the sciences and technology to be disappointed about our innovative prowess. Damien Hirst, the *enfant terrible* of the Young British Artists movement which arose in the late 1980s and endured well into the 21st century, has recently proclaimed that "I spot good ideas and steal them". Cynics point out that Hirst's habit extends beyond his actual "spot paintings", and in keeping with this sentiment *The Times* (of London) asserts that "the multimillionaire artist has admitted that all his ideas are stolen." The sculptor Auguste Rodin allowed that

"in my spare time I simply haunt the British Museum." He called it the "temple of muses", taking particular inspiration from the 5th century BC-sculptor Phidias, whose efforts are thought to have included the remarkable Parthenon sculptures that the British Museum prefers to call the Elgin marbles.

★

There is, then, a peculiar and cruel irony in a species that refers to itself as *Homo sapiens*, or the wise man. Innovation is hard and most of us if we are honest with ourselves are not very good at it. Think of things that have made a difference in the history of the world – the first hand-axe, the first spear, the first bow and arrow, the first fishhook or basket – and now ask yourself how many comparable ideas you have had. Or perhaps that sets the bar too high. Ask yourself how many ideas you have had that influenced others, something you did that others wished to copy, or that perhaps attracted a patent? Few of us can say we have invented much that has really made a difference to someone else.

Successful inventors and entrepreneurs are rare, and efforts to find them in reality television shows or produce them in the classroom seldom yield results. Our awareness of the value of ideas is illustrated in our reluctance to share them, whether they are old family recipes, knowledge of fishing lures, or scientific or business innovations, but also in the existence of our many patents and copyrights, in the prevalence of business espionage and industrial theft, and even in the insatiable appetites of companies for acquiring each other: it is often easier to buy or steal someone's intellectual property than to create it yourself.

Today most of us live in a world full of objects we don't understand and that are of such utter complexity that no one knows how to build them: objects like smartphones, spaceships and self-driving cars – even a single computer chip – rely on teams of people for their design, maintenance and production. Most of us are also confronted daily with questions we don't know the answers to: which car is best, should I buy that house, what mortgage product should I get? Which pension scheme is best for me?

How did we get here? That is to ask, despite our evident limitations at innovation, how have we managed to accumulate technology throughout our history, technology that has transformed how we lead our lives? The answer probably lies in a new form of evolution that humans introduced

Next pages: Composite image of a digitally generated image of Earth.

to the world when we arose as a species around 200,000 years ago. Until that time all evolution had depended upon genes, that is, upon parents handing down copies of their genes to their offspring. But humans introduced a second great form of evolution that works in parallel to but much faster than genes: the world of ideas. And that new form of evolution turned around and sculpted us, making us good at copying, even if not so good at innovation.

Here is why. Introducing ideas was a true form of evolution because, among human beings, a new idea can arise and if it is a good idea, it can be transferred quickly from one mind to another until everyone adopts it. This is why idea evolution is much faster than genetic evolution: whereas new genes can only be passed vertically from parents to offspring, ideas can leap "horizontally" from mind to mind. You are born and must live your entire life with a single set of genes, but your mind can sample from a sea of evolving ideas throughout your lifetime.

The ability to choose among ideas, retaining the good ones and discarding the bad ones, is sometimes called our capacity for culture, and it is what really makes us human: surprising as it might seem, only our species seems to have the capacity to understand others' intentions and then choose to copy the best of their ideas, objects or actions. If I watch you and someone else making a fishing lure and then notice that one of the lures works better than the other, I will copy the better one. Other animals don't do this. And it is this small difference between us and the rest of the animals that created the unbridgeable gap in our evolutionary potentials: cultural – that is, idea – evolution took care of the rest as good ideas spread and accumulated, one on top of the other.

Copying good ideas makes us sound intelligent, but there is a twist: if I can observe other people's innovations, I don't need to be innovative myself. I can simply take my pick of their best ideas rather than attempting to create something on my own. For instance, if I am trying to make a better spear or hand axe, I could make lots of different shapes and sizes, until I figure out by trial and error which one works well. On the other hand, if I notice that somebody else has made a good spear, I can simply copy it. Plus, the time and energy I save in copying someone else's idea rather than trying to come up with my own, might mean that I get to kill that moose or mammoth, or catch that fish, before they do.

Our capacity for culture leads to a startling conclusion: humans' capability to recognise a good outcome when they see it, and to copy how that

outcome was obtained, can produce technological progress without our species having any insight at all. If we can survey others, if we can sift through a range of others' attempts at innovation, we will eventually find something that works, and this will be true even if these other attempts are, Edison-like, no better than random.

This is a long way from being the "wise man". On the other hand, we might expect in practice that groups with a number of innovators in them would be able to outcompete groups lacking them, and so at least some of us will be innovators. But how many of us? Here again the answer is modest: intuition tells us that the number of innovators can be small because, in any given group, the rest of us can simply copy, steal or plagiarise their works. And, recall from our example of the spear, copying others can often be a better strategy than attempting to innovate on your own.

We can observe our tendency to be copiers rather than innovators whenever we are confronted with situations or questions we don't know how to address. In those circumstances we typically do what others do. So, the answer to what pension product to get, or what mortgage to buy, which dishwasher is best or how to escape from a fire in a large building, is that we often just do what a majority of others do. And there is even a logic in this. In a harsh world, if an idea has survived long enough that large numbers of people are using it, it is probably a reasonable idea.

In most aspects of our lives, then, it could be said that most of us are little more than glorified karaoke singers, or ardent followers of "likes". Our tendency to be copiers rather than innovators is why ideas and technologies accumulate gradually rather than in great leaps. In this regard, cultural evolution is surprisingly like genetic evolution. It has taken around a billion years of genetic evolution to move from single-cell organisms like yeast to the almost unimaginably complex multicellular organisms that we are. Genetic evolution has no foresight. It bumbles along by randomly producing a variety of forms and then relying on natural selection – survival of the fittest – to sift among the alternatives, retaining the best ones. As a consequence, like cultural evolution, the history of life also shows few big leaps.

<p style="text-align:center">★</p>

We live at a curious time in the history of the world, when there are people living a Stone-Age existence in the depths of the Amazon rainforest –

people who have little or no technology beyond bows and arrows, rudimentary clothing and simple shelters – at the same time as there are people wandering around urban city centres enjoying technologies the rainforest people would regard as magical and bewildering.

Why are these people so different to the city dwellers? It is not that they are less intelligent, imaginative or innovative: an infant plucked from one of these uncontacted peoples and brought up in modern society would be no different to you or me. The differences between "us" and "them" come down to the rainforest people not having much to copy. These uncontacted people have lived isolated from the rest of the world. Small groups of hunter-gatherers living in a single area simply do not produce enough new ideas to propel the cumulative cultural juggernaut most of the rest of us (and that surely includes anyone reading this essay) enjoy. If ever there was a demonstration of the power of idea evolution and our species' reliance on others for ideas to copy, these Stone Age people provide it.

There is reason to believe that throughout our history prosperity has been linked to networks of connections among peoples. Palaeontological evidence tells us that 100,000 to 120,000 years ago, someone in present day Algeria wore a decorative necklace of seashells. This alone might not be surprising except that this person lived 120 miles inland. Someone about 25 miles from the sea in Morocco did the same around 80,000 years ago. Both of these people would have been what we might today call "influencers". Both would have been at the height of fashion and probably enjoyed the envy of others. And both of these people had their fashion objects because of someone else's idea and because of networks of trade. Historians sometimes remark that the Mediterranean was, in classical times, the world's first internet. Classical Greek and Roman societies might have owed at least some of their prosperity to their extensive trading links with the societies of the Mediterranean and beyond.

In our modern world, the pace of technological change is accelerating vertiginously. Just in the ten years running up to 2017, at least ten new technologies appeared that would have been fanciful a decade before: smart phones, social media such as Twitter, electronic book readers, household assistants such as Alexa and Echo, self-driving cars, consumer space travel, digital map applications, virtual reality, the so-called "cloud" and 3D printers. Disruptive technologies such as digital cameras, taxi-hailing services and electronic currency transfer schemes have driven older technologies to extinction or nearly so.

Is this modern explosion of technology an indication that we have become smarter? Probably not. Ideas beget more ideas simply because the more there are, the more different ways there are for them to be combined to make new things. The same has been true of biological evolution: as life became more complex, natural selection had more to work with, and it has created a dizzying variety of species. But there is another reason for the acceleration of technological change. We are more connected than ever before, meaning there are more ideas floating around than ever before. Maps of Facebook friendship connections when plotted by their latitude and longitude draw a startlingly good map of the world. Airline routes plotted from take-off to destination do the same. And so do plots of international scientific collaborations.

All this connectivity means that, as of 2018, we have access almost instantly to around seven billion other minds. It might have come at just the time we most need it. We are entering an era – the so-called Anthropocene, the era of human influence on the world – that will call for an even greater pace of innovation to keep up with developments such as climate change, resource depletion, overpopulation, ageing societies and the spread of resistant pathogens. We have to hope that the sharing of ideas that brought us to this point, might just get us out of these predicaments. If we really aren't as clever as we would like to think, we have no good alternative.

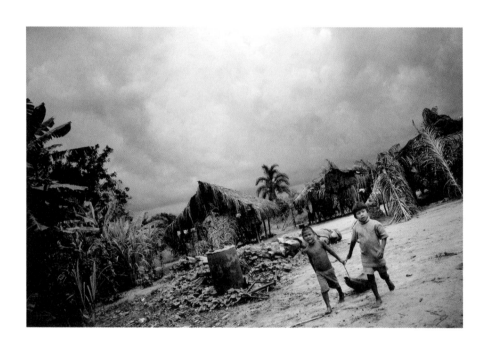

The Nukak people, nomadic hunter-
gatherers from Amazonia, Colombia, were
violently driven out of their jungle territories
and now live in refugee camps.

HOW WE KNOW WHAT WE DO NOT KNOW

Mark Plotkin

The destruction of the Amazon rainforest continues at a rapid rate. Plants, animals, and many tribal cultures face extinction: in the 20th century, 90 tribes disappeared in Brazil alone. Today, we focus on the contribution to climate change from carbon released by forest destruction. Sometimes obscured by this peril is the perhaps incalculable sacrifice in terms of potential new agricultural or medicinal products – in just one example, ACE inhibitors and beta-blockers are based on compounds derived from neotropical species.

In my fieldwork as an ethnobotanist – a scientist who studies how tribal peoples use local plants – I have repeatedly observed that the Amazon's indigenous people know, use, and protect rainforests far better than Western scientists or park guards imported from urban centres. But these tribal cultures – and, in particular, their knowledge – are disappearing far more rapidly than the rainforest itself. Even in the all too rare instances where neither an Amazonian tribe nor its ancestral forests are physically threatened by outside forces – typically, the extractive industries – the culture itself more often than not degrades or disappears when it comes in contact with the outside world.

Perhaps the most fragile of these Amerindian cultures are the isolated groups, those few "lost tribes" who have chosen to avoid contact with the outside world. The recent historical record amply demonstrates that contact can devastate these hunter-gatherer bands: within a few years of making contact, 50 per cent of the Nukak tribe of the northwest Amazon and 80 per cent of the Akuriyo tribe of the northeast Amazon were dead. And these fatalities were not equally distributed among all age groups: the most vulnerable were both the very young and very old. Because they typically are the repositories of tribal knowledge, when the elderly members of a small tribe die, much if not most of the oral wisdom dies with them.

These isolated cultures represent an unexpected and vivid link to the deep past, when humanity was born and survived in seeming simplicity

and relative harmony with nature. In our ever-urbanising and stressed-out world, isolated peoples hold a mystic and almost iconic identity in the continuum of how humans live and have lived from ancient times to the present. We often yearn for a sense of simplicity and clear orientation, and we have linked this gap in our modern lives to romantic perceptions of how life once was, or how it could be again. Our current fundamental detachment from nature creates a yearning in many of us for a reconnection to the earthly ways that we ascribe – fairly or unfairly, correctly or incorrectly – to isolated tribes. Romanticism aside, the study of cultures with an extremely intimate relationship to the natural world may suggest a means to revitalise the spiritually barren aspects of our daily lives and to live in far greater harmony with our environment.

The subject of what constitutes truly "uncontacted" peoples inspires debate. Many argue that every tribal community in the world – no matter how remote – has had some historical contact with outsiders. The website of Survival International, a leading cultural preservation organisation, states: "Everyone has neighbours, even when they're some distance away, and they'll know who they are." They further define "uncontacted tribes" as "peoples who have no *peaceful* [my italics] contact with anyone in the mainstream or dominant society."

The biologist John Terborgh describes these groups as "societies that have no regular [interaction] with the modern world, though they might have second or third-degree contact through trading partners or 'co-linguists'. They live with no or few manufactured implements other than perhaps the odd machete or axe acquired through trade, often isolated by linguistic barriers as well as the physical barriers of remoteness."

Further, any attempt to strictly define "uncontacted" leads down a rabbit hole. If the last Karijona maloca (longhouse) in the Chiribiquete region of the northwest Amazon was seen in 1904, and longhouses are once again being spotted there from overflights in small planes, can we say with any degree of confidence that these people are Karijonas, and that they therefore do not represent an uncontacted group? If a Colombian missionary met a tribe of isolated Indians near the Yari River over 20 years ago, presented them with machetes and pots, and they then fled and he was unable to find them again, can we say that they have been contacted? If a single Trio Indian had a single encounter with two previously undocumented tribes, are those tribes considered "contacted"?

Sooner or later, for still isolated groups, contact with the larger society is all but inevitable. And recent history very likely predicts their future: they will be "civilised" through settlement in large sedentary villages of other tribes. Once there, their changes in diet, lack of agricultural knowledge, and exposure to disease will prove disorienting and disheartening. Through the deaths of the elders and intermarriage into the dominant tribe, their culture will begin to disintegrate.

So how do we know what they know, and what is lost when these tribes disappear? To demonstrate what information may be lost when tribal peoples and their forests disappear, this paper will briefly touch upon the case histories of three tribes: the Akuriyos of Suriname, the Uru-Eu-Wau-Wau of Brazil, and the Matses of Peru.

When first contacted by missionaries in 1968, the Akuriyo tribe consisted of small bands of hunter-gatherers living along the Suriname-Brazil border in the northeast Amazon. They had no agriculture or sedentary villages, only ephemeral housing structures, and carried fire with them from campsite to campsite. Not knowing how to swim or build canoes, they avoided most major rivers but did frequent the banks of these rivers in the dry season to collect iguana eggs, a favourite food.

A striking aspect to all who met or observed them after the initial contact was how vigorous, strong and healthy they seemed. The two neighbouring tribes – the Trios to the west and the Wayanas to the east, both noted for their detailed knowledge of rainforest flora and fauna – were in awe of both the Akuriyos' rainforest knowledge and their abilities as hunters. Employing one of the few means of measuring their ecosystem knowledge, the late anthropologist Peter Kloos documented 35 Akuriyo names for honey. Almost all of the very young and the elderly died within two years of contact – before I began my research with the few who were left. Today there exist fewer than 40 Akuriyos, and less than a handful who remember life prior to contact.

There are approximately 2,000 Matses Indians living along the Brazil-Peru border. Up until 1969, they earned a fierce reputation for killing all trespassers on their land. In October of that year, the indefatigable *National Geographic* photojournalist Loren McIntyre set off in search of the Matses, then more widely known as the Mayorunas. He had a

Next pages: A woman from the Matsés people in Peru.

floatplane drop him off alone near the headwaters of the Javari River, where he made a small camp, which was soon surrounded by Matses men. At their encouragement, he followed them into the rainforest. After a few days, they began a tribal dance, once again inviting the American to join them. At the conclusion of the ceremony, the Matses opened palm leaf baskets, removed green monkey frogs from the containers, made cuts in their forearms, and rubbed the amphibian skin secretions into the wounds.

The frog skin slime was highly hallucinogenic. After the ceremony, the Indians explained to the explorer that they employed the frog exudate for hunting magic – it made the hunter smarter and stronger, and allowed him to see where the animals would be found the next day.

Later lab analysis of the frog skin yielded a host of new peptides, many of which are active in the human body. Several are currently being studied as a means of increasing the permeability of the blood-brain barrier, among the holy grails of modern medicine. Another substance from the skin of the green monkey frog is a novel compound named "dermorphin", a non-addictive painkiller 30 times more potent than morphine.

Thanks to this revelation by McIntyre and those who followed in his footsteps, there is a widespread acceptance that Amerindian knowledge of rainforest compounds is not limited to plants. As a result, scientists have searched for and found new medicinal applications for elements in Amazonian insects and other frogs as well.

★

In 1987, I received a call from the National Geographic Society, asking for my help. The German-Brazilian photographer Jesco von Puttkamer had some interesting photos of a recently contacted tribe and they wanted the opinion of an ethnobotanist.

Von Puttkamer and Loren McIntyre had just returned from Rondônia in southwestern Brazil where they were visiting the Uru-Eu-Wau-Wau tribe. Both men already had extensive experience with Amazonian Indians but were struck by a novel observation. They showed me a photo of a tapir that the Indians had brought down with their arrows, and the animal was covered in blood.

Most Amazonian arrow poisons come from two plant families – the moonseed and the Strychnos families – and kill through asphyxiation.

Based on this photo, it seemed that the animal had bled to death, indicating the use of an arrow poison with strong anticoagulant properties.

Research by other botanists determined that the Indians were extracting this poison from a tree in the Brazil nut family, a group of plants previously not known to contain bioactive principles, and that the active compound was indeed a powerful anticoagulant. Given that the populations of the world's rich nations are ageing, and that the market for anticoagulants is commensurately sizeable, plants and plant compounds that reduce clotting have significant market and therapeutic potential.

To take full advantage of rainforest products, proper means of rewarding local tribes and national governments must be put in place. Further, provisions must be made to protect the forest's peoples, cultures, plants, and animals. Virtually all of this is endangered, with the foremost threats including gold mining, logging, cattle ranching, fires, and roadbuilding. This paper represents a brief attempt to provide a glimpse of what is at stake – and what might be lost.

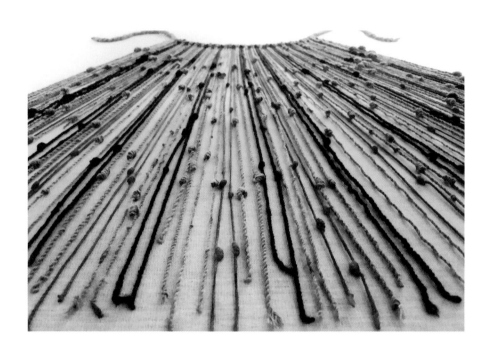

Quipu (also spelled khipu),
or talking knots, were recording devices
fashioned from strings used historically
by a number of cultures in South
America's Andes mountains.

IS MODERN INFORMATION BETTER THAN PRE-LITERATE KNOWLEDGE?

John Hemming

My dictionary defines knowledge as "the facts, feelings or experience known by a person or group of people; awareness, consciousness or familiarity gained by experience or learning." Whereas information is news or data often referring to specific or timely events or situations.

Most of my research and writing has been about the clash of cultures in South America. I have written a score of books about the Spanish conquest of the Incas, the conquistadors' obsession with the myth of El Dorado, and particularly the Portuguese absorption of hundreds of indigenous peoples in the Brazilian half of the continent during the past five centuries. Writing this history has been a peculiar challenge, because the conquering and colonising Europeans had a monopoly of writing. Their books, documents, chronicles and archives gave me a mass of information. By contrast, the native Americans were pre-literate, handing their knowledge down orally. Until recently, all the good quotes have come from the colonisers, not their vanquished subjects. The conquests were one-sided because the invaders had far superior weaponry and horses, and particularly because alien diseases decimated indigenous peoples. Writing this history has been distorted because, although both sides possessed much knowledge, only one monopolised information data and the means to record and disseminate it.

The Incas had a huge empire, stretching for thousands of kilometres along the Andes, and they administered its nine million subjects highly efficiently. But they achieved this without writing as we know it. They did, however, develop a mnemonic device for recording and transmitting information. This was the *khipu*, a comb-like fringe of long knotted cords hanging from a larger primary cord. The cords have different arrangements of knots and can have different coloured threads. After Pizarro's conquest in the 1530s, *khipus* were actually used by Inca officials testifying in Spanish courts but, tragically, Spanish chroniclers failed to record how

they worked. Many *khipus* were destroyed by zealous priests who suspected that they contained diabolical knowledge; but about 400 have survived. There is therefore intensive research into trying to decipher them, particularly by a team led by Professor Gary Urton of Harvard University. Gary recently lectured about this research at the British Museum. Introducing him, the museum's director Neil MacGregor lamented how his personal workload was bedevilled by a mass of civil service form-filling. It was therefore a peculiar pleasure to hear about a great civilisation that functioned so efficiently without any written information! *Khipus* were used to record the quantities of food, llamas, military equipment and other essentials stored throughout the vast Inca empire. They may also have quantified "taxation" – which took the form of levies of workers sent to help the Incas' building, agriculture or warfare. We do know that the Incas had a corps of hereditary knot-record keepers called *khipu-kamayuq* (*quipu-camayoc* in Spanish spelling), experts who could instruct a messenger carrying a *khipu* to another official with the oral information needed to interpret it.

We must remember that *khipus* were just mnemonic devices, used only by an elite of senior officials to convey specific and ephemeral information to one another. The vast corpus of knowledge about Inca society and history was passed orally from generation to generation, by tribal elders or family members. All the early Spanish chroniclers, and government officials conducting *visitas* (a form of census or geographical gazette), consulted local wise men. The chronicler Garcilaso de la Vega learned from his mother, who was an Inca princess, and Juan de Betanzos was married to one.

When I moved my research eastwards to record the Portuguese colonisation of Brazil, my task became harder. I had originally planned to do this in one volume, but it eventually took three volumes, adding up to 2,100 pages. There were four reasons for this inordinate length. Brazil is a gigantic country covering half the South American continent and most of the Amazon basin; there are still over 200 indigenous societies (and were many more), each of which was a separate case study, not just one centrally organised empire; the conquest, attraction or colonisation of these tribes started five centuries ago and is still continuing – with perhaps 20 indigenous peoples still isolated or uncontacted; and lastly, the information for my history was derived from myriad fragmented sources, with very few narrative chronicles.

Brazil's indigenous peoples are often called "Indian tribes", not least by their own members. Each has a slightly different habitat, customs, society, history, and is at varying stages of contact, so it is wrong to generalise about them – but I shall have to do so in this essay. In evolutionary terms, these are hunter-gatherers with rudimentary agriculture, prehistoric, and of course pre-literate. But this is not to say that they are primitive. Far from it. Most have long-established and harmonious societies with elaborate ceremonies, decoration, housing, mythology and spiritual beliefs. They lead good lives, with admirable diets, plenty of exercise, and frequent bathing, so that both sexes are generally fine physical specimens. But they are tragically vulnerable to alien diseases from Europe and Africa, against which they initially had no inherited genetic immunity. This was the main reason why Brazil's indigenous population fell catastrophically from several millions to, at its nadir 50 years ago, 500,000 people.

Like any hunter-gatherers, Brazilian Indians are rich in knowledge but poor in organised information. They of course had no technology to record or transmit information. However, their knowledge of their environment and its resources can be stupendous. A study of the ethnobotany of just one tribe – the Carib-speaking Waimiri-Atroari north of Manaus – found that they had uses for over 300 plants, were utilising 80 per cent of 214 tree and liana species in a one-hectare plot, and were equally knowledgeable about the botanical resources of tall tropical rainforest, of seasonally flooded *igapó* woods, and of dense dry *caatinga*. Other ethnobotanists found that the Gorotire Kayapó (living in savannas in central Brazil) created clumps of woody vegetation by transferring litter fertiliser and the nests of termites and ants to them. In one such "garden island" the Gorotire utilised a remarkable 120 species of plants, with major-use categories including medicines (72 per cent), game attractants (40 per cent), foods (25 per cent), firewood (12 per cent), fertilisers (8 per cent), shade (3 per cent) and other uses (30 per cent). As consummate hunters and fishermen, indigenous people know the identity and behaviour of every animal in the forests, fish in their rivers, and bird in their skies. They can imitate all animal sounds – which, incidentally, is why a newly contacted people rapidly pick up a few words of Portuguese. I have seen this because I have been with four tribes at the time of their first contact.

In most indigenous societies, the men meet every evening to chat outside the men's house in the centre of the village plaza. They might discuss

village affairs, although there is rarely any change or politics or what we would call news; but their favourite topic by far is hunting and fishing. This is how their knowledge is transmitted. Indigenous societies do not share our obsession with numbers as the basis of information data. They rarely bother to count. I was once on a team invited by the Brazilian government to report on treatment of Indians all over that great country. I devised a questionnaire for each indigenous post or territory, and this had numerical questions such as population, breakdown by gender and age, and the number of huts. One question was whether the tribe had enough game food from hunting. With the Ramkokamekra (Canela) of Maranhão in north-eastern Brazil – a people who had been in contact for centuries and are now surrounded by ranches – the chief delivered a rousing speech about wonderful hunts of peccary, tapir, monkeys, tortoises, capybaras and even jaguar. The government agent in charge of the post told us that this was nonsense: they had not caught anything for ages. We put this to the chief and he accepted that it was sadly true, but he then repeated his speech about the glorious hunting of his boyhood. He had not deliberately sought to mislead us. He just saw this as an opportunity for oration and happy memories – and statistical information on a form meant nothing to him.

Geographical knowledge is as acute as that about the natural environment. Everyone who has travelled or hunted with Indians is amazed by their unerring sense of direction. A hunter might leave some arrows or game under one of the millions of tree trunks in the forest, all of which look identical to a stranger. Asked whether he had forgotten his deposit, the Indian would reply that he would of course recover it from under that particular tree – just as a modern city dweller can recall a street corner. Indians travel for days on end through forest too high to see the sun through the canopy, and they know every bend or rapid in rivers with endless unbroken vegetation on either bank. Without maps or clocks, their knowledge of a journey is based on effort involved in each stage. The German Karl von den Steinen was the first outsider to enter the upper Xingu river, in 1884. He asked a Bakairi about the geography of one of its headwaters, and noted the following: "The river was drawn in the sand and the tribes were named and indicated by grains of corn... But what a difference between a printed Baedeker and this gesticulation, this spoken picture, this enumeration of days' journeys that creep relentlessly farther stage by stage! The second Bakairi village is some days' journey

from where we were… First you get into your canoe, *pepi,* and paddle, *pepi, pepi, pepi.* You row with paddles, left, right, changing sides. You reach a rapids, *bububu*… How high it falls: his hand goes down the steps with each *bu,* and the women are fearful and cry "pekoto, ah, ah, ah…!" There the *pepi* must plunge between the rocks – a hard stamp on the ground with his foot. With what groans it is pushed through, and the *mayaku,* the baskets of baggage, are wearily carried overland – once, twice, three times, on the left shoulder. But you climb aboard again and paddle, *pepi, pepi, pepi.* Far, far – his voice lingers *ih*… so far *ih*… and he pushes his mouth out into a snout and pulls his head down hard into his neck. He demonstrates how the sun sinks in the heavens, *ih*… The sun sinks over there, until – he holds his hand out as far as possible and draws an arc towards the west, ending at the point in the sky where the sun stands when *lah…a* – you reach the landing place."

How is this knowledge passed from generation to generation? In an unmaterialistic and pre-literate society, there is of course no formal schooling. Indigenous parents are very loving to their young. They never, ever, chastise, order or scold them in any way. You do not hear shouting or even raised voices by either age group. Children play happily and do small chores if they feel like it. When aged about seven they start imitating their parents, because this is what they passionately want to do. Girls might try some spinning, basketry or grinding manioc; boys shoot little bows at birds, learn to fish at the river's edge and to move stealthily through the forest. Whenever there is a festival, you will see a ragged line of children copying the grown-ups. There is a close bond between fathers and sons, mothers and daughters. But when Orlando Villas Boas (a great indigenist of the 20th century) asked a father whether he was teaching his son, he replied: "No, because I do not know whether he wants it. When he does want to know something, he will ask and I will teach him." Children mature fast in this uncomplicated world. By the time a boy is ten or 12, he has almost an adult's knowledge and skills in hunting, fishing, and other male tasks, as does a girl with women's work. In many tribes, boys and girls undergo puberty initiations in order to qualify as adults. These rites of passage can involve painful ordeals or months of seclusion in a sealed corner of the communal hut, during which they might be instructed by elders.

There is special training for certain categories. Shamans, as with priests in every religion, spend years learning knowledge of the spirit

world and faith healing from an older master. Chiefs have minimal powers in the egalitarian and democratic society of an indigenous village, although they are expected to orate well and to be generous and calm. It helps if they are fine hunters or champions in the favourite sport of wrestling. When the 16th-century essayist Michel de Montaigne asked a Tupinambá chief (who had been brought to France) what privileges he got from his rank, the young leader answered simply: "To march first into battle." In the 1970s, I knew a young man called Aritana, who was being groomed to succeed his father as chief of the Yawalapiti people in the upper Xingu. He explained that because of his status he had undergone years of seclusion, which is "an important period of learning for us, rather like going to school. My father and uncle taught me tribal myths and legends and also how to make things like arrows and bows or [mollusc-shell] necklaces. Above all, they taught me how to behave, how to treat others, and especially how to converse."

Aritana matured to become the genial, gentle and hugely respected paramount chief of the dozen peoples of the upper Xingu. He has often emerged into the cities of modern Brazil, and been a spokesman for indigenous people on a world stage. But, like almost every other one of the over 200 tribes still functioning in Brazil, he does not want to lose his Indian identity. He feels that "the beauty of our lives here is that we still live in the same way as we have always done, with the same legends, festivals and beliefs of our ancestors... Everyone here is the same: we have no rich or poor. We ourselves make most of the things we need, and what we don't make we trade from other neighbouring tribes. We don't like to fight or quarrel. Why should we? What purpose does it serve? We prefer to live in peace in our villages and on friendly terms with everyone. This is why I call this land of ours Paradise."

I recently said to Aritana that I had plenty of pictures of his people naked in only body paint and feather ornaments, but I wanted some of them doing modern activities – in which many are highly proficient. He immediately said "no problem" and posed for me, dressed and in front of a big, clunky computer.

Our modern sophisticated society has seemingly limitless knowledge, and this is partly disseminated by electricity-powered information technology. Thirty years ago the Brazilian government wanted to build a huge hydroelectric dam near the mouth of the Xingu river (1500 kilometres north of Aritana's village). Because the Amazon basin is so flat,

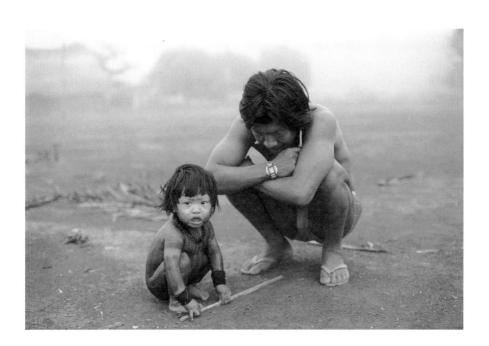

A man and a child from the Kayapo people in Brazil.

the reservoir above this dam would drown thousands of square kilometres of forests and indigenous territories. An engineer from the electricity company sought to "sell" the project to a protest meeting of threatened tribes. A Kayapó woman called Tuíra strode up to the platform, and brandished a machete in an elegant sweep that ended with a tap on the hapless businessman's face. With devastating logic, she told him: "You are a liar. We don't need electricity. Electricity won't give us food. We need the rivers to flow freely – our future depends on them. We need our forests to hunt and gather in. We do not want your dam." The engineer spoke of further studies and of economic benefits. The Indians would have none of it. They pointed out that a nearby frontier town was a horrible place where "conditions are terrible and the people live miserable lives. Is this what you are offering us? Is this progress? Don't talk to us about relieving our 'poverty'. We are not poor: we are the richest people in Brazil. We are not wretched. We are Indians."

Indigenous society has many qualities, but it will never begin to achieve any of the intellectual, artistic or technological marvels of our knowledge- and information-driven world. Hunter-gatherers with rudimentary agriculture are not even Jean-Jacques Rousseau's idealised noble savages. But Villas Boas and many other champions of indigenous people are adamant that our world is not superior or inferior to the indigenous one, just different. In this they subscribe to the views of the great French theorist Emile Durkheim and anthropologist Claude Lévy-Strauss: that these are simply two distinct societies. Nothing is gained by trying to compare or rank them. But I leave you with a final thought. To paraphrase Winston Churchill, rarely have so many owed so much to so few. The "many" are the rest of mankind, the "few" are Amazonian indigenous peoples, and the debt we owe them is that they are protecting a swathe of tropical rainforests and rivers as large as the entire original European Union. Their territories are critically important in generating rainfall, sequestering carbon, tempering climate change, and housing millions of creatures with which we share our planet in its richest terrestrial ecosystem.

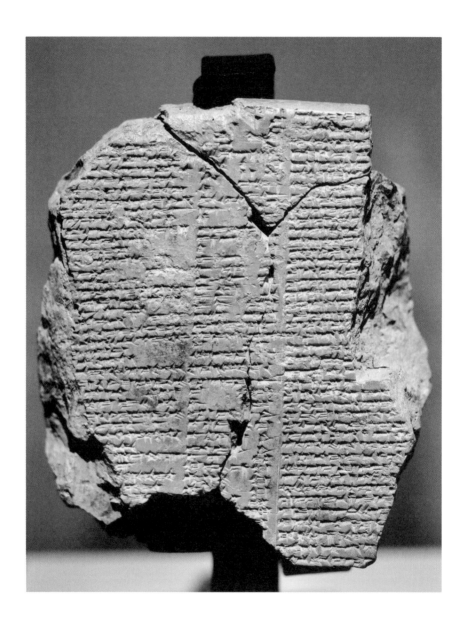

Recently discovered clay tablet with 20 previously
unknown lines from the *Epic of Gilgamesh*.

EPIC NEWS: "STORYING" CURRENT EVENTS IN MYTHIC LITERATURES

Jessica Frazier

Let us start with a story...

Once upon a time there was a curious king: he was detested by half of the people in his kingdom, but beloved by the other half. He behaved as no previous king had done, making allies of the country's enemies and enemies of its longstanding friends. He flouted tradition and did much that had once appalled the people. No one knew whether the king was mad, or was secretly following some clever plan.

The townspeople gathered in the village square to discuss the problem. "If only we knew whether it is madness or wisdom that guides the king." At that very moment an old man, who had been sitting silently by the well, stood up to speak.

"I know!" he said, "We must test the king. First, we find the prettiest maiden in the village, and when morning comes..."

And now let us pause in the middle of the tale.

Hopefully adopting this style has had its desired effect: the reader builds a mental picture of a crisis of governance, and wants to know the solution that can save the kingdom. He enters into what "narrativist" philosopher Paul Ricoeur called the "architecture of historical knowledge": instead of isolated events glimpsed in mid-flow, the tale "gathers together" what we need to know "through a configuring, synoptic, synthetic act". It creates an "architecture of historical knowledge", allowing us to pause, stand, and see more clearly from within the roaring river of history. The reader becomes enraptured, engaged in vivid problem-solving. Whereas the public's attitude towards the news is often one of passive data-consumption, it is imagination, speculation, prediction, and planning that come into play when we tell stories.

★

In the pre-print world of oral tradition, myths and epics were the main vehicles for news about the world at large, yet today we don't tend to associate them with "information". Many of the world's great tales are based on what would at the time have been recent news: Sumeria's *Epic of Gilgamesh* and the Bible's monarchical cycle of the Books of Samuel and Kings both warn of the casual corruption of early kings in the Ancient Near East. India's epic poem, the *Mahabharata,* opens a window on to succession wars and conceptions of governance from the third-century BC empire of the "*dharma*-sovereign" Ashoka onward. The saga of King Arthur tells us much about Britain in the wake of the Romans, and its regional struggle toward the possibility of unified government. Even the *One Thousand and One Nights* contains a *Hello!*-magazine-esque report on the wonders of Haroun al-Rashid's court, while also giving us the tabloid low-down on tricksters, scams and scandals to watch out for in the medieval Middle East.

In many ways such accounts functioned better than the headlines and brief reports that currently shape the public's picture of the world. In pre-print cultures, "storied" information was more portable than lists of data, technical manuals, or detailed histories because it could be easily remembered and retold. News travelled best in the narrative form of folktale, myth, and epic poem, for it was all the more eagerly consumed by audiences for its entertainment value. Ancient Indian epics such as the *Mahabharata* claim that their stories hail from sages in the mythical forest of Naimisa, and that these sages inherited them from seers, who perceived the truths directly in eternal reality. Be that as it may, the tradition of storytelling that has continued throughout two millennia to the present accords some of the same reality-revealing wisdom to its modern bards or *kathakas* (one who is literally, a "story-er"). Many of them still roam rural India today, carrying storyboards, portable theatres, or fabric rolls of illustration that they can use to summon their tales into the present reality of the listener. Their tales moved, expanded to encompass new material, circulated at every level of society, and were transformed in each new version: for most of history such fluid oral texts were the Wikipedia of their day.

It is important to see that their stories did something mere archives of facts cannot do. On the one hand, they did not hold narrative literature to high standards of accuracy; in their fluidity, the stories were susceptible to infection by polemic and propaganda. But on the other hand, they did convey situational knowledge – giving them insight into contexts,

motivations, relationships, chains of events, and the volatile force of human agency that shapes them. We learn about what the population suffered in the grip of capricious rulers; we empathise with the injustice of their situation; and we share in their coping strategies. In some ways, stories convey a deeper truth than the modern information media we know so well. They tell us not what is happening now, but what kinds of things happen over and over again – and how we can intervene to change them.

★

The modern world has, ironically, been fascinated with myth. It was interpreted as the relic of archaic science (JG Frazer), the excrescence of "archetypal" patterns of agency (CG Jung), or the external projection of mental processes within ourselves (Ludwig Feuerbach) that the conscious mind cannot bear to acknowledge (Sigmund Freud). Myth has been taken as the expression of the basic binary structure of all meaning (Claude Lévi-Strauss), a tool of catharsis for humanity's fundamentally violent nature (René Girard), or the way that we codify universal existential problems and their solutions (Joseph Campbell, Peter Berger, Clifford Geertz, etc). Again and again, the *Iliad* or *Odyssey*, the Hebrew epic of *Genesis*, *Exodus* and *Deuteronomy*, India's vast *Mahabharata*, or other cultures' tales of warring gods, quests, and love stories, have been treated as codifying perennial problems in human life. Yet such interpretations tend to favour mysticism and metaphor; they forget that myths also tell us about practical, immediate, current events.

Most of the world's epics are pervaded with historical content, so that they would have felt contemporary to their earlier audience in a way that is archaic to us as modern listeners. The *Epic of Gilgamesh* seems so alien as to appear primeval, archetypal – and it is interpreted as such by many scholars. But to a Sumerian family sitting at the fire in 2000BC, it would have spoken of the perennial problem of bad kings and the dangers to civilised life, foreshadowing the biblical God's warning that if Israel takes a king he will make his people's sons run in front of his chariot, take their daughters as perfumers and cooks, and turn the people themselves into his slaves (Sam.1:8). *Gilgamesh* is also a report on rustic life beyond the city as imagined in the figure of Enkidu, the wild man in the story who teaches new ways to the arrogant king Gilgamesh. In the second half it even reports on intellectual and religious debates, when it airs the idea of immortality

circulating through the Ancient Near East at the time – and rules against it when Gilgamesh realises that he must accept death. Appropriately, one of the key versions of the epic was found in the library at Nineveh; a city with a reputation for misrule and immorality was interested in an epic story about a king learning good moral governance – learning not only to rule the kingdom, but also himself. In this respect, the *Epic of Gilgamesh* combines a tale about public problems, with a reflection on the private psychological processes that can cause, and solve, them.

Such reportage of public events, complemented by diagnosis of their private causes, is also found in the *Iliad*. In some ways, the tale of the Trojan war is an explicit news feature story; reflecting on a broad pattern of Greek expeditions in Turkey around the turn of the second millennium BC. But the angle of the reporting highlights the way personal motivations within a country's leadership can lead to devastating consequences for the wider public. We may read the opening as a headline: its words suggest a ravaged populace calling for news on the distant events that have so direly affected them:

"Sing, O goddess, the anger of Achilles son of Peleus, that brought countless ills upon the Achaeans. Many a brave soul did it send hurrying down to Hades, and many a hero did it yield a prey to dogs and vultures, for so were the counsels of Jove fulfilled from the day on which the son of Atreus, king of men, and great Achilles, first fell out with one another."

Translated into the language of broadcast news, this becomes: "Next on tonight's news: war breaks out following tensions between Trojan prince and Greek soldier: extensive casualties confirmed. Military capacity decimated. Key military personnel confirmed dead. Fears of a breakdown of diplomatic relations prove justified."

Already, this opening gets to work neatly "narrativising" the root causes of the events that caused "countless ills and many good souls sent to Hades". The rest of the *Iliad* analyses the unfolding of this debacle, and looks repeatedly at the moments of decision-making that propelled events. Figures like Odysseus act as mediators, watching and wondering how best to intervene in the causal train.

As a problem-solving text, the *Iliad*'s solutions occur largely through a medium that it naturally affirms being made of it: richly expressive words. While the basic story tells of a tryst and a siege, it is really communication – between Hector, Paris and Priam, or Achilles, Ajax and Agamemnon, and even Zeus and Hera – that moves the tale. Speeches

frequently mark the meeting of characters in conflict, and it is largely through the diplomatic mediating figures of General Odysseus and King Priam that words and strategic thinking allow a group of leaders lost in brutal wars of attrition to extract themselves from the flow and counter-flow of emotions. Compositionally, the insertion of speeches into the broader oral frame narrative may have allowed generations of bards to add their own diagnosis into the overall analysis of events given in the text. This portrait of a communicative community presented good, practical advice to the diverse communities of the region: wordy peacemakers such as Odysseus were the forerunners of modern treaty-negotiators. Hector, the ultimate loser of the story, has been interpreted as failing because he did not really communicate with his men and his wife Andromache, striking a marked contrast to Odysseus' frequent exchanges with others and in reconciliation with Penelope. Above all, in his private night-time visit to the tent of his enemy Achilles, King Priam was perhaps the first to recognise that direct meetings in which language hits home can disperse and divert the passions that impede diplomacy; talk is one of the best tools for building political relationships and overcoming endemic communal conflict.

India's *Mahabharata* offers a different solution to corrupt leadership – a solution grounded in its genesis in oral tales woven together in a communal bricolage, creating a more eclectic fabric of information. The world's longest epic, the *Mahabharata* was composed over more than a millennium from approximately 600BC to 400AD. At one level it served as an archive of public ideas, gathering tales and events, theories and teachings from every region and section of society into its 200,000 verses. We see this flagged in its own self-representation at the start of the epic: like so many Indian texts it starts its narrative at the beginning – the beginning of the world. When the cosmos was destitute of brightness and light, and enveloped all around in total darkness, there came into being a mighty egg, the one inexhaustible seed of all created beings. The text itself is just such an "inexhaustible seed", in which all beings are "contained" in the form of linguistic information. When the deity Brahma asks about the text, the sage Vyasa sings its praises by representing it as a vast encyclopedia of all things:

"O divine Brahma, by me a poem hath been composed which is greatly respected. In it is represented the mystery of the scripture… the cosmic myths and histories of the Puranas named after the three divisions of

Next pages: Illustration from the Mahabharata.
The Pandava and Kaurava armies face off.

पनीअमपरवरोयत्राार ।राजानुधिष्टररीधनादेबेदुरजोधने बीकुक्रबो
कुद्या।।श्रीकीसनत्रजुनहीरखताकुत्रा।।श्रीकीसनत्रजुनरासव रौसब

time, past, present, and future; the determination of the nature of decay, fear, disease, existence, and non-existence, a description of creeds and of the various modes of life; rule for the four classes... an account of asceticism and of the duties of students; the dimensions of the sun and moon, the planets, constellations, and stars, together with the duration of the four ages... the sciences of Logic, Medicine; Welfare and Governance; Ethics and Soteriology celestial and human... the art of war; the different kinds of nations and languages: the nature of the manners of the people; and the all-pervading spirit; all these have been represented."

The passage is an extraordinary list of the kinds of information present in the ancient world, from proto-scientific cosmology to medicine and ethics. What we hear in Vyasa's voice here is the excitement of a culture in the grip of a voracious hunger for knowledge. Innumerable astra manuals and Sutra treatises were being written in the classical period from 600 BCE to 400 CE. Together they have bequeathed India a portfolio of arts and aesthetic styles, mathematical, medical, astronomical and political sciences, as well as a philosophy that still shapes India's shared cultures today.

Of course, Vyasa is exaggerating in his expansive summary of the *Mahabharata*. But his overall assessment is not wrong – it does its best to amass the vast bulk of knowledge available in the cultivated kingdoms of its time. The picture of northern classical Indian that it paints shows life in different regions and classes – for the farmers, homeless ascetics, and forest-dwelling tribal youths caught up in waves of Indian empire-building, as well as the elite. As the historian of religion Anne Monius notes of the Tamil epic, the *Cilappatikaram*, it is by placing truths into epic poetry that the authors hoped to place them in the minds of the people, and it is "only in poetic narrative form that such wondrous events become humanly comprehensible".

But the *Mahabharata,* like the *Iliad,* also fulfils a political purpose: it analyses the causality behind two leaderships warring for a single kingdom. In a region that frequently suffered such conflicts, it again shows how the personal greed of the few led to the deaths of the many. Its political focus is on the contrast between two kinds of king – the good Pandavas (demonstrating honest, orderly, law-abiding rule), and the bad Kauravas (dishonest, self-interested, corrupt leadership). It shows the populace how the individual personalities of the greedy, disrespectful Kaurava brothers lead to problems of succession. As a society still shifting from tribal

communities to kingdoms, people needed to comprehend the distant world of the royal courts – a milieu that was little understood in markets and farms where their laws were beginning to be enforced (a relatively new concept) by the legal clerics and standing military of the time.

The *Mahabharata's* political analysis is distinguished by a focus on the long-term consequences of human motivation, rather than just on immediate actions. The story's retrospective narrative frame lends it the ability to trace slow-building motivations over time, giving a richly detailed narrative texture. Arjuna's frustration with the betrayals of politics and his growing attraction to the purity of the yogic ideal, leads to his famous breakdown on the battlefield in the *Bhagavad Gita*: his growing disillusionment almost scuppers the whole war. Yudhisthira's commitment to honourable *dharma* allows him to be taken advantage of repeatedly in times of war, yet it is also what makes him a promising candidate for a peacetime sovereign. These are not really tales of war, but of desire (the Kaurava brothers' desire for the kingdom and the lascivious Bhima's desire for the good wife Draupadi), of selfishness (one queen's hatred for the sons of her rival queen), and of blind duty (as of good King Yudhisthira's willingness to pay a debt that will enslave his whole family). The drawn-out causality has sometimes been taken as evidence of Hindu fatalism: a man's character is his fate. But in fact its careful account of how internal states prompt influential events signals a culture that, recently discovering the psychology of yogic meditation and ascetic self-restraint, is interested in encouraging us to take control of our agency. The effect of this is that it unravels not merely a single conflict, but the very way that conflict can stem from self-interest and bias at the level of leadership. It is not events but personal motivations that should be under the lens.

★

Other epics describe public failures caused not by self-interest but by miscommunication, lack of empathy, and inadequate understanding. The King Arthur epic, in its various retellings, turns on failures to communicate motivation. In many respects it contrasts the causality of a "prophecies of divine plans" worldview that brings Arthur to power, with the problems that secrecy creates in even the most well-meaning polity. Thus the lie of Uther who seduces Igraine by impersonating her husband, the secret of Arthur's parentage, the hidden identity of his sister leading to

an incestuous bastard heir, and Arthur's willingness to lie about his whereabouts – all of these mendacious situations inspire discontent at court. In the 12th-century *History of the Kings of Britain* that is the earliest Arthurian epic, Geoffrey of Monmouth's probable use of tribal hero tales from the pre-Roman Catuvellauni and Trinovantes contributes a tone of mingled hope and scepticism towards the kings converging on southern Britain in the early centuries CE. Promises and lies abounded, and as Hector loses by not communicating more openly, so Arthur's supposedly just rule fades in a court weakened by bad faith.

Geoffrey of Monmouth tried to counterbalance the secrecy and opacity of the political world, in his short work *Prophetiae Merlini* (Prophecies of Merlin). This little-known text was as influential in its way as the broader history of Arthur, giving Merlin's own (often damning) narrative of political events. It inspired a new genre of subversive literature called "Galfridian prophecy" in which wise figures gave their own commentary on politics, providing a kind of editorial gloss for the people. It is perhaps not a coincidence that an early version of *King Lear* precedes Arthur's story in the *History of the Kings of Britain*: here too the way forward is to listen to truth-givers like Cordelia rather than lying political schemers like her sisters. In Monmouth's separate *Life of Merlin,* the truth-telling prophet finally flees the political world and becomes a sylvan man of nature, like Enkidu in the tale of Gilgamesh.

A more hopeful picture of "storied" truth-telling is painted in the *One Thousand and One Nights*, an epic woven from the collected oral tales of centuries, spanning Arabic, Persian, Turkish, Indian, and Hebrew sources. In a core section that reflects the flourishing of Abbasid society, they dramatise the problem of corruption in leadership for an audience of medieval Sunni Muslims struggling to negotiate the whims of caliphates and viziers at home, kings in foreign lands, and wealthy businessmen. At the same time, they uphold the famed emperor Harun al-Rashid as a virtuous King Arthur-like leader, thus contrasting corruption in contemporary politics with a template for good governance. The narrative frame features a storyteller, cunning Scheherazade, who submits herself to the power of her volatile husband in order to subvert his corrupt court from within: it not only bemoans problems of corruption but also promises a solution to them. In her stories, powerless individuals – the impoverished Aladdin, the hapless Sinbad, women like herself – repeatedly seek a way to challenge the powerful, and often enough they win

some measure of success despite their hopeless situation. Ultimately, cunning is the key to survival, and for Scheherazade specifically, it is storytelling – the power to spin compelling new myths – that enables her to inspire compassion, change minds, suggest alternative routes of action, and ultimately acquire some of her husband's inherited power. The *One Thousand and One Nights* is a fascinating story-cycle, not least because it reads as a manual for minority cunning in the face of majority power. Witty words win. Narrative can solve the problems that science, academia, and the news merely report.

These epics teach their readers to understand the messy situations they find themselves in; they reveal hidden causes within leadership, and they also suggest ways that transparency and communication can help to illuminate political problems that have been kept out of public reach. It is because of this curious power myth can wield, bringing causes normally beyond the ken of the masses within reach, that the deciphering of myth has been one of the great passions of modern thought. In his 1986 work *The Cycles of American History*, Arthur Schlesinger – who served as historian, political speechwriter, and "court historian" to John F Kennedy – wrote: "The law of acceleration hurtles us into the inscrutable future… Rhythms, patterns, continuities, drift out of time long forgotten to mould the present and colour the shape of things to come. Science and technology revolutionise our lives, but memory, tradition and myth frame our response."

Memory and myth, story and epic have a narrative structure that works as a form of reasoning because we essentially have story-shaped minds. Stories almost always entail the situational description of a) a circumstance constructed through some past history, b) an overarching teleological purpose to the characters or events, and c) some action in the present moment that must be decided upon, with a set of consequences. This basic structure of a past linked to possible futures by the tenuous thread of a goal and a chain of actions, is a cognitive schema of agency – that is, of the way we live our lives. As the cognitive scientist and philosopher of mind, Daniel Dennett, has pointed out, we are all "virtuoso novelists" in that we reflect extensively on the past, blending our memories with those of others to create archetypal templates that we then use to analyse data and make decisions.

Paul Ricoeur is one of the thinkers most closely associated with this idea: in his books *Time and Narrative* (1983) and *Memory, History, Forgetting*

(2000), he drew on Aristotle and Augustine to show how our subjective experience of the world is shaped as a story stretching from past to future. Narratives appeal to us precisely because they mirror our lives in a way that no list of facts or scientific treatises can ever do; it isn't just information they give us, but also a map for what it means to be a thinking, acting person embedded in a particular situation. Research suggests that bare information – persons, events, dates – needs to be slotted it into a story we can understand. When looking at the headlines, we may know which policy is being debated or which landscape deforested, yet have no idea of the context that explains the situation. Furthermore, the facts alone do not help us to determine a course of action. But myths, fairytales and epics all set up a situation, tell us what is relevant, present the motivations of different protagonists, and, if we follow the tale, they even suggest a course of action, and explore its possible results.

In this, myths are fundamentally futural – utopian even – in a way that news is not. Mircea Eliade, the influential Romanian writer and theorist, noted in *The Myth of the Eternal Return* that myths have a unique power because they always point to a utopian element – a real or imagined resolution. Unlike factual reportage, they take place outside of strict history, and place events within a floating space of possibilities, a retelling from the beginning in which we always enjoy "finding out" how it ends, even when the tale is well-known. Transferring events into epic reality effects a *regressus ad originem* in which we are perennially able to go back to the beginning as it were, and seek answers; perhaps this time King Arthur will succeed, Hector will save his house and Achilles his lovers, and the *Mahabharata*'s war will be ended with fewer needless deaths and a cleaner peace. The myth may be tragic and thus cautionary – dramatising dangers. Or it may be heroic – suggesting solutions. But in either case, it builds a rational bridge from the present to a future.

This presents the world in a way that lets us see our capacity to change it. As Martha Nussbaum has pointed out, narrative helps to shape our agency in the world by highlighting the values embedded in a situation and making us feel what matters, then showing how individuals act and change the situation in response. Stories are more adept than factual reports at inspiring emotion, because they cast all the protagonists in the light of their basic emotions. We weep over their deaths, more than over statistics. We feel the grief of a decimated community whose journey is narrated, in a way that we do not typically respond to a list of fatalities.

So, too, we are empowered to emulate "storied" heroes, but may not see the same possibilities in an isolated event of success. Narrative is an activist discourse, calling on us to consider alternative possibilities in a way that fact-giving does not.

The American academic Walter Fisher and other proponents of the "narrative paradigm" have also pointed out that communal "storying" draws on templates gathered from the longstanding experience of the community. Through collaborative oral composition and bricolage, myths create agency-maps – combining shared wisdom to make us better informed than we could ever be alone. As novels are tied to the ability of a single mind to record its extended reflection in continuous writing, so myths are intimately bound with the ability of a text to pass across regions and communities, between genders and generations, gathering input as it builds from one telling to the next. Myth and epic build meaning into history in a range of ways.

They add *cognitive order* to the constant flow of events through which we live, isolating specific trains of cause and effect, particular problems and their unfolding.

They map out *human agency* against the background of contexts and values that frame a given situation; as such, they offer templates for our possible action within each situation.

They capture the *communal wisdom* of shared analysis and pooled suggestions, all through the process of collaborative composition.

<div align="center">★</div>

In all of this, epic news offers a welcome contrast to the attempted objectivity of contemporary news media which is comparatively fact-rich, but understanding-poor. Television news reports, and social media newsbites give us events without context. They present a slice of time-specific facts that need to be "storied" to gain meaningful context. If we watched television news in spring 1983, for instance, we were informed that a famine had begun in Ethiopia, but not its government's role in causing it. Nor were we told of any solution other than to send aid, a strategy that later contributed to widespread corruption in the country. In the same year, Ronald Reagan unveiled the space-based anti-missile Strategic Defense Initiative, dubbed "Star Wars" in the media. The box office hit series of movies from which it took its nickname became the main reference for

understanding this complex and expensive weapon of the Cold War, and its broader place in US foreign policy.

These are events that are still little understood, and this is partly because they have not been incorporated into tales about basic food provision in subsistence economies aimed at the public at large, or the ways that weaponry functions within the larger structure of international relations and domestic economy. Epic news is fact-poor (did King Arthur really exist?), but understanding-rich (well-meaning leaders regularly carve out a brief respite from strife, often ended by corruption within the ranks). In addition, "storied" news helps to combat fact-fatigue, the phenomenon in which an audience becomes bored by the flow of disjoined facts, and switches off attention. Narratives appeal to our story-shaped mind; *The West Wing, House of Cards, Homeland* and *Borgen* are all popular TV series that have tried to "story" the news and let us know why institutional corruption, political and cultural struggles, or volatile leadership are happening, and what we can do about them.

Of course, even news media now seems to convey myth to many. In 2016, the history of information entered a new phase in its story, as fake news became a household idea. One of the sources of fake news surrounding the US election was found in a small town in Macedonia, where internet-savvy authors were making money out of sensational, clickable taglines that they had invented. If mass appeal was the name of the game, then alarmist falsities served better than the truth. Pope Francis had endorsed Donald Trump, it was claimed, and FBI agents were being murdered by someone associated with Hillary Clinton's campaign. Masquerading as news, myths took on new power. In the old days an authoritative voice could be heard, but now there were so many voices that only volume commanded the attention of the masses.

Today, fake news has become a lucrative business. In 2017, inspired by creative interpretations of a solar eclipse that year, "flat-earthers" produced more and more outrageous videos, rejecting all modern scientific evidence to argue that the Earth is flat. Refutations sprang up. YouTube flat-earthers gained hundreds of thousands of followers, making up to $7,000 a month. Sensational fictions have never made such big money, and the realisation that, as Hillary Clinton put it, "so-called fake news can have real-world consequences", has prompted governments to look into content regulation. The democratic, participatory nature of information-sources like Wikipedia, Twitter, YouTube, and Facebook should act like a

self-cleaning oven in which false claims are spotted and deleted. But that same structure has proved to undermine itself: our selective confirmation bias means that we consume only facts and fictions that already appeal to our pre-existing outlook. The news can become a modern mythos that is more propaganda than open exploration of a situation's possibilities.

Is there an ancient analogy in this? The bard of old also had to devise tales that would please his audience and elicit payment. This surely accounts for much of the fantastical element in epics, folktales and myth. Stories about farmers who work hard, raise a family, grow old and die added little to the lives of those living precisely that tale. Sensationalism always sells. And propaganda can be found in every epic: the *Mahabharata* affirms Sanskrit-modelled kingship, while the *Iliad* explains the value, and inevitability, of a pan-Hellenic identity, and the tale of King Arthur similarly affirms the value of unitive empires. Yet epics are often less predictable than we might think – bringing to light complexities and ambiguities, much as open-access sites like Wikipedia preserve competing views, in their unedited state at least. Where film and television narratives tend to concretise a particular writer's interpretation, it is perhaps in memes that we see collaborative complexity preserved: Childish Gambino's artistic protest video "This is America" has inspired diverse versions that include Donald Trump singing about his America, a utopian "This is Wakanda", a feminist version, and others dramatising public frustration in France, Nigeria, Sierra Leone, Malaysia, and the violent "peace-keeping" conflicts of Iraq. Each is propaganda, but taken together they point to a tale of disappointed populations appropriating bottom-up media to fight top-down power in the modern world. Where oral epics no longer assimilate public opinion through their retelling, new media are now doing so.

In this global age when data overwhelms us, "storied" news must be revived at ground level if we are to understand our situation and plot the way out of it. In his manual for better public knowledge, *Blur: how to know what's true in the age of information overload,* Bill Kovach asks: "Are people really up to the task of being partners in developing their own news?" It is an open question. What is missing in meme-culture is the gradual accumulation of insights in a collaborative composition that must couch new ideas within existing ones, binding them through a linking rationale, and thereby building meta-insights. Memes can be seen as short-lived disposable cries for attention that sink back into the sea of data almost as quickly as they arise. Epics, on the other hand, emerge from societies used to

slowly absorbing their data in shared contexts of recitation. Perhaps one of the things needed to counter the effects of information-paralysis, news desensitisation, and orphaned facts, is to generate more public literatures that "story" the world collaboratively at grassroots level, not only among the media elite, and integrate fresh possibilities – the very essence of an empowered approach to history.

Finally, what of the story with which we began, concerning the king and the villagers who must figure out whether he is sane or mad? Perhaps here, as in the case of the *Iliad*'s speechmakers, the *Mahabharata*'s sages, or the *Arabian Nights*' storyteller-extraordinaire Scheherazade, the way for the villagers to discover the king's motivations is through story:

"...when morning comes," continued the old man, "we will send her to the castle with these instructions..." The old man explained his plan and the very next day the villagers sent the prettiest and wisest maiden in the village to the castle. The guards took one look at her, and with a whistle and a wink, she was beckoned to the king's chamber. But she refused his advances, and insisted first on telling him a story. She spun a tale about a distant emperor who was loved by some and hated by others. "One summer," she said, "there was a terrible drought in the land. A good fairy came to the palace, and there she asked the emperor to sacrifice his own treasure to save his starving people. The emperor thought carefully, and finally he replied..."

At that, the wise maid stopped suddenly and cried: "Why, I cannot remember the ending of the story!" She turned and asked the king slyly: "How do YOU think the story should end?"

COLLECTING
KNOWLEDGE

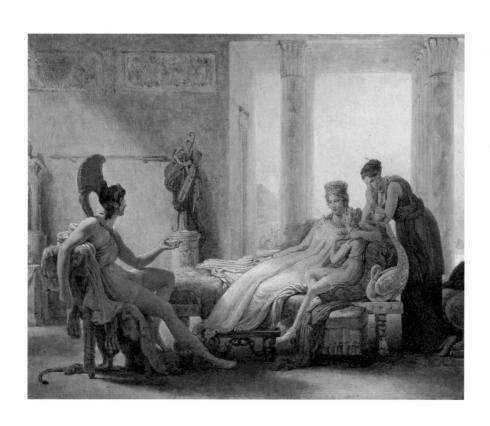

Dido and Aeneas by Pierre-Narcisse Guérin, 1815.

INFORMATION DELETE: THE CASE OF ANCIENT CARTHAGE

Richard Miles

The destruction of the city of Carthage at the hands of Roman legions in 146BC is infamous even by the brutal standards of the ancient world.

After breaking into the city following three long years of siege, the Roman forces under their general Scipio Aemilianus launched a final assault on the Byrsa, the citadel of Carthage and the religious and administrative heart of the city. The legionaries were, however, forced to fight every step of the way on the narrow streets that led up the hill as desperate defenders rained missiles down on them. Painstakingly, Scipio ensured that those who had sought refuge in the tall houses that flanked the streets were flushed out by setting fire to them.

The main surviving historical account of the fall of Carthage, written by Appian, was based faithfully on the eyewitness testimony of his fellow Greek historian, Polybius, who as a member of Scipio's entourage acted as an "embedded historian" on the Roman side. His account of the horrors that subsequently unfolded do not spare the reader from the brutality of this form of warfare as men, women and children were slaughtered, their corpses dragged out of the way by the hooks of the Roman cleaning squads.

The slaughter continued for a further six days and nights, with Scipio rotating his troops so that he could maintain the attack at a high tempo. Eventually the morale of most of the remaining Carthaginian defenders was broken and, after a negotiated truce, 50,000 or so of them, we are told, surrendered and left the city for a life of slavery. Those that remained – the Carthaginian commander-in-chief, Hasdrubal and his immediate family, and 900 Roman deserters who could expect no mercy – took refuge first in the temple of Eshmoun on the summit of the Byrsa Hill, before making a final stand on the roof of the building after they had set it ablaze.

The siege ended in fittingly dramatic fashion with Hasdrubal losing his nerve and sneaking off to surrender to Scipio. It was left to his wife to have

the final word as she heaped scorn and abuse on her husband for his cowardly behaviour before throwing herself and their children into the flames, in full view of Hasdrubal and the Roman army below.

The brutal destruction of Carthage by the Romans has retained its power to both shock and provoke up to the present day. For instance, when the poet and playwright Bertolt Brecht cast around for a historical metaphor to remind his fellow Germans about the dangers of remilitarisation in the 1950s, he instinctively turned to an event that had taken place over two thousand years before: "Great Carthage drove three wars. After the first one it was still powerful. After the second one it was still inhabitable. After the third one it was no longer possible to find her."

Brecht has certainly not been alone. Comment pieces in newspapers across the globe were awash with references to Carthage during both the first and second Iraq wars. The American sociologist and historian Franz Schurmann noted: "Two thousand years ago the Roman statesman Cato the Elder kept crying out, '*Delenda est Carthago*'. Carthage must be destroyed! To Cato it was clear either Rome or Carthage but not both could dominate the western Mediterranean. Rome won and Carthage was levelled to the ground. Iraq is now Washington's Carthage."

The lasting infamy of Carthage's destruction has little to do with its bloody nature but the cool and methodical totality of its execution. After the initial ravaging of the city by the legions, the senate sent a ten-man commission from Rome to supervise a series of measures designed to ensure that Carthage remained uninhabited. Although the story of the site being ploughed with salt is a modern fabrication, Scipio was ordered to raze the remainder of the city to the ground, and a solemn curse was put on any persons who might in future attempt to settle there.

Just as shocking as the destruction of the city and its people was the care taken by the Romans to delete over half a millennium of Carthaginian learning. Those of Carthage's libraries that survived the fire had their contents scattered across Africa. Only one exception was made. After the capture of the city, the Roman senate ordered that all 28 volumes of a famous agricultural treatise by the Carthaginian Mago be brought back to Rome and translated into Latin.

Tantalising clues remain. Within the burnt-out structure thought to have been the temple of Apollo that was ransacked by Roman soldiers in 146, were the remains of an archive thought to have contained wills and business contracts, stored there so that their integrity and safekeeping

were guaranteed by the sacred authority of the son of Zeus. The papyrus document was rolled up and string wrapped around it before a piece of wet clay was placed on the string to stop the document from unravelling, and a personal seal was imprinted upon it. However, in this particular case, the same set of circumstances that ensured the seals were wonderfully preserved because they were fired by the inferno which engulfed the city also unfortunately meant that the precious documents they enclosed were burnt to ashes.

There is of course always a danger of over-romanticising the corpus of lost knowledge housed in the libraries of Carthage, when compared to the great intellectual centres of Babylon or Athens. However, in their chilling decision not even to spare Carthage's past after obliterating its present and future, the Roman senate was surely making a powerful warning to those who chose to resist its relentless rise to supremacy. Rome was also casting its conflict with Carthage as being a struggle between civilisation and barbarity, and between faithfulness and deceit, rather than a mere imperial land grab.

The dispersal and destruction of Carthage's own knowledge did not mean the end of Carthage. It would just be rewritten by Rome. The spoils of war included not only the ownership of Carthaginian territory, resources and people but also its past. Carthage was indispensable to Rome because of the central role it had played in Rome's rise to imperial greatness. Roman historians such as Sallust claimed, in the first century BC, that Rome's defeat of Carthage at the end of the Second Punic War had been the apogee of Roman success, and that its subsequent decline resulted from the loss of Carthage, the whetstone on which Roman greatness had been sharpened. The struggle with and eventual victory over Carthage in the Punic Wars was once what generations of Roman writers repeatedly revisited as they examined the causes of the rise and later the perceived decline of their city and empire.

In the annals of Roman history and literature, Carthage would live on as a foil to Roman greatness and as an antitype to Roman virtue rather than as the great mercantile superpower that it had been long before Rome had achieved any kind of prominence.

Carthaginian faithlessness, barbarity and greed were portrayed as the mirror images of Roman fidelity, civilisation and integrity. As with many aspects of Roman culture, the hostile ethnic profiling of the Carthaginians originated with the Greeks, who had long been rivals of Carthage

Next pages: Ruins of an old Roman villa in Carthage, Tunisia.

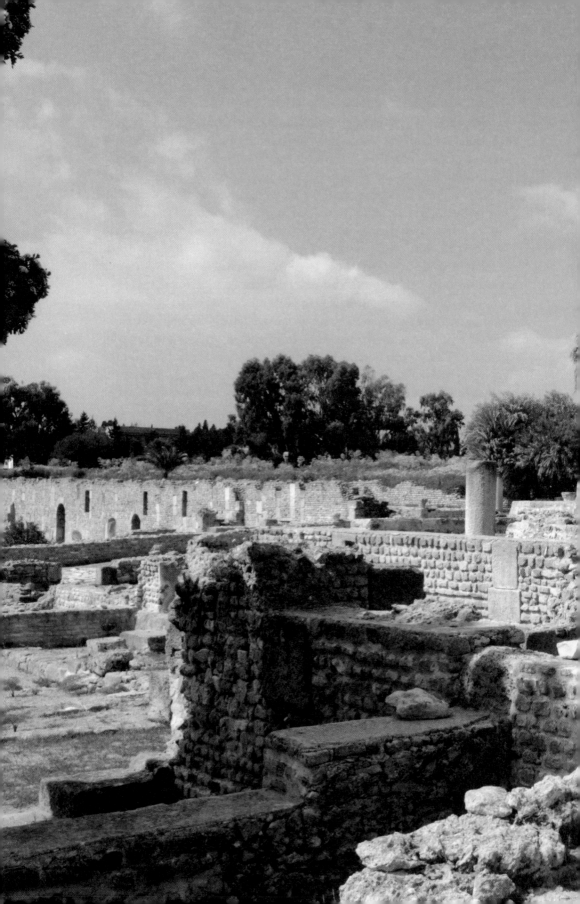

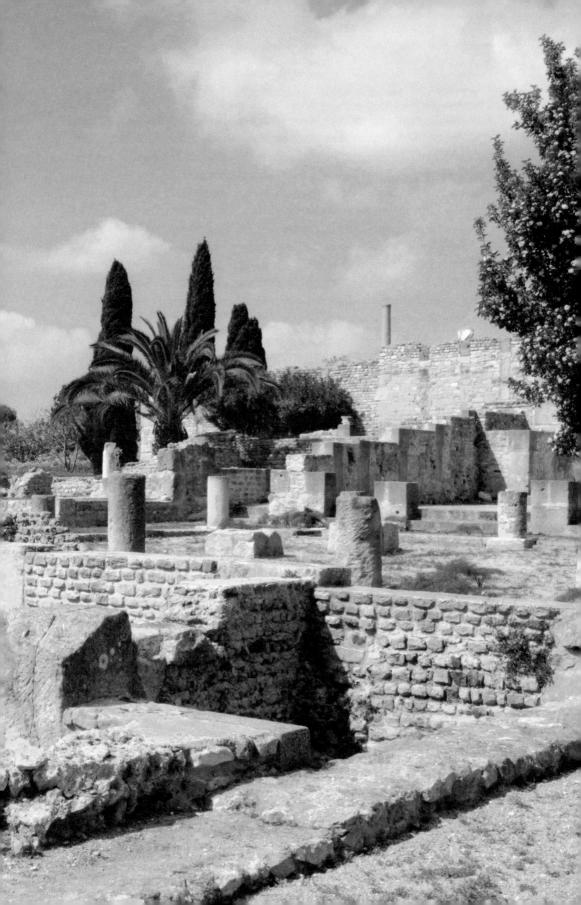

in the western and central Mediterranean, but such was the emphasis placed by the Romans on Carthaginian treachery that the Latin idiom, *fides Punica,* literally "Punic faith", became a widely used ironic expression denoting gross faithlessness. The Carthaginians would now be commemorated in the annals of their mortal enemies as mendacious, greedy, untrustworthy, cruel, arrogant and irreligious.

Carthage's most celebrated sons and daughters were recast – or even invented – as foils for Roman greatness. Carthage's greatest general, Hannibal Barca, who so nearly captured the city of Rome and brought the Romans close to total defeat in the Second Punic War, was presented as an inspired commander but one with fatal flaws that eventually sabotaged the Carthaginian war effort. In particular, the Roman historian Livy portrayed Hannibal as a general whose genius was impeded by his impiety, cruelty and treachery. Hannibal also suffered the indignity of being unfavourably compared with Scipio Africanus, the young Roman general who had finally defeated him at the battle of Zama in 202 BC. Unlike his moral disposition, Hannibal's reputation as a general was never denigrated because the glorious reputations of Scipio and Rome, as the victors, depended upon it. Greatness can only be secured by defeating greatness, not mediocrity. Yet the victor often undermines the heroic status of the loser through small indignities. A good example of this can be found in Apsley House, the London residence of Arthur Wellesley, the Duke of Wellington. In the entrance hall stands a colossal 11ft-high statue of Napoleon by the celebrated Italian sculptor, Canova. It was not originally commissioned by Wellington but by the pocket-size emperor himself. After Napoleon's defeat, the statue was placed in the Louvre, from where the British government acquired it in 1816. It was then presented to Wellington by the Prince Regent as a gift from the nation. Napoleon never liked the statue, as it depicted him as a muscular heroic nude with just a vine leaf preserving his modesty. Was Wellington mocking his adversary by placing the statue in such a prominent position? Or was the huge, well-muscled, long-legged frame meant to emphasise the scale of Wellington's achievement in vanquishing Napoleon? The answer was both. The position of the noble vanquished brought with it both praise and humiliation in equal measure.

The famous romance of Dido and Aeneas, often used by early modern and modern writers to chide the ruthless ambition of Rome, was in fact the invention of the great Roman poet Vergil, long after the destruction of the

city. Dido herself, although the product of an earlier Phoenician or Greek Sicilian story, was only fully developed as a character by later Roman writers, particularly Vergil, in the first century AD. In his *Aeneid*, the Roman imperialism and militarism that led directly to the Punic Wars and the final destruction of Carthage was replaced by a much older enmity founded on the doomed love affair between Dido, the Carthaginian queen, and Aeneas, the Trojan prince and forebear of the Roman people. In one of the poem's most powerful scenes, the jilted Dido, preparing for her own impending death by suicide, issued a curse that explained the Punic Wars in terms of Carthage's appetite to extract revenge for their founder, rather than Roman geopolitical ambitions. Vergil wrote:

> Then, O Tyrians, pursue my hatred against his whole line
> And the race to come, and offer it as a tribute to my ashes.
> Let there be no love or treaties between our peoples.
> Rise, some unknown avenger, from my dust, who will pursue
> The Trojan colonists with fire and sword, now,
> Or in time to come, whenever the strength is granted him.
> I pray that shore be opposed to shore, water to wave,
> Weapon to weapon: let them fight, them and their descendants.

Thus, the deletion of Carthaginian history was followed by its recreation as an aide memoire for generations of Romans to bask in the glorious deeds of their forebears and the might of their imperial destiny.

Such was the Roman commitment to the rebirth of their age-old enemy that Rome's first emperor ignored the curse placed on the site and built a new city of Carthage in the last years of the first century BC. The administrative and religious centre of the new foundation was built on top of the Byrsa, the heart of the old Punic city. The summit of the hill was now crowned by a series of magnificent monumental buildings and grand spaces, including a huge civil basilica, temples and a forum. This dramatic reshaping of the physical landscape not only proclaimed the absolute supremacy of Rome, but also the capacity of the Augustan regime to bring peace and concord even to Rome's most bitter of enemies, sorely needed after decades of civil war. Carthage was reborn as Colonia Iulia Concordia Carthago.

The most extraordinary aspect of the foundation of the new city of Carthage was the extent to which the perceived negative attributes of the

Punic Carthaginians – such as mendacity, faithlessness, impiety and cruelty – were transferred to the residents of the new city, most of whom were settlers from Italy with no African heritage. Roman texts from this period consistently questioned the loyalty of the new Roman Carthage and its inhabitants, despite the fact it was the administrative capital of the Roman province of Africa, as if the enmity of the ancient city had somehow seeped into the new foundations. The point was clearly made by the geographer Pomponius Mela: "Now it is a colony of the Roman people, but it was once their [the Romans'] determined rival for imperial power. In fact, Carthage is now wealthy again, but it remains more famous for the destruction of its ancestors' claims than for the wealth of its present inhabitants."

However, the development of a Punic identity for Roman Carthage did not remain as a canon of knowledge exclusively curated in a top-down fashion by Rome's imperial authorities, but one which would be increasingly authored by those to whom it referred – the citizens of Roman Carthage themselves. They actively embraced the new Punic identity in their patronage of their guardian deity, the goddess Dea Caelestis, whose sanctuary and festival were the most prominent in Carthage, and whose figure was a common motif on the coins of the city. Although the rites and much of the iconography associated with the goddess were as unmistakably Roman as those who worshipped her, the antecedents of Dea Caelestis was the Punic deity Tanit, who had been the patron goddess of Punic Carthage.

Such was the tenacity of this new Roman-authored Punic identity for Carthage that it survived the collapse of Roman imperial power in North Africa and continued to develop in new and interesting ways. In 424 AD, the Vandals, a powerful barbarian confederation, had managed to cross into North Africa from Spain and, over the ensuing decade, overran much of the coastal belt of the Maghreb before finally capturing Carthage in 434 AD and establishing their own kingdom there. The Vandals were quickly portrayed by Latin poets based in the rump western Roman Empire of Gaul and Italy as the new Punic menace sent to ignite a "Fourth Punic War":

For war and for a fourth bout of strife,
The perfidious bugles of Dido's Byrsa sound forth.

However, intriguing evidence exists that the Vandals themselves might have played an active part in their representation as the heirs of Africa's Punic inheritance, and used it as a propaganda tool against the Romans. The Vandal king, Geiseric, appears to have quickly reopened the mint at Carthage after the capture of the city, and over time produced coinage that used motifs last seen on Punic coinage nearly half a millennium before. Prominent was the horse's head, a reference to the foundation myth of Carthage in which Elissa/Dido's followers dug up a horse's head on the site of the future city, and the palm – a symbol of fertility.

This coinage reveals a bold and partially successful attempt to seize control of the traditional Roman imperial narrative that highlighted the antagonistic relationship between Rome and Carthage. By claiming the mantle of Punic Carthage, the Vandals skilfully laid claim to the role of traditional protectors of Africa against Roman aggression. The ghoul of Punic Carthage that had for centuries acted as the ventriloquised foil to Roman greatness had once more acquired its own independent voice. Carthage, it proclaimed, was no longer in thrall to Roman oppression, and it could once more set its own independent course. It was a message skilfully aimed as much at creating solidarity with the Vandals' new Romano-African subjects, who had long embraced their Punic identity, as it was at antagonising what remained of the Roman Empire.

To conclude, Rome's obliteration of the physical fabric and citizenry of the ancient city of Carthage – and the deletion of the knowledge it had generated over the 500 years of its existence – stands as a testament to the brutal destructive force that underwrote the most successful empire of the ancient Mediterranean world. The subsequent recreation of a body of Roman-authored knowledge that typecast one of the great Mediterranean superpowers as little more than a foil for Roman imperial greatness stands as an even more chilling exemplar of Roman power. However, the most important historical lesson from the destruction and subsequent rebirth of Carthage, provided by the group of Germanic invaders who ended Roman control over the city, is a more hopeful one – namely that "knowledge", however carefully created, manipulated and propagandised, will always break free eventually from its authors and develop in surprising and often subversive ways.

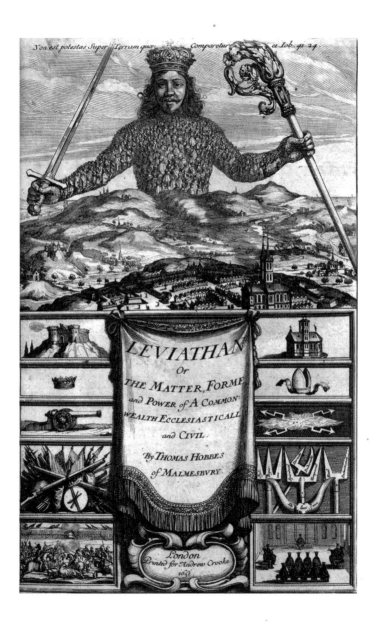

Leviathan by Thomas Hobbes.

KNOWLEDGE WITHOUT AUTHORITY

Erica Benner

W hat is knowledge? Socrates poses this question to a budding young mathematician in Plato's dialogue *Theaetetus*. Their conversation never yields a clear answer. But it does interrogate several flawed accounts of what knowledge is and how to acquire it, and distinguishes promising lines of enquiry from mere "wind eggs" – Socrates' term for arguments that come up hollow when you crack into their robust-looking shells.

Most of these dead-end accounts, it turns out, are bound up with problematic views about the proper role of authority and authorities in transmitting knowledge (*epistēmē*). The commonest view – one still widely held today – is that we can identify well-founded knowledge by picking out some wise man or men (and the occasional wise woman, even in ancient Athens) who can tell us what's true or false, right or wrong. To some extent, Plato's dialogue admits, such reliance on epistemic authority is unavoidable. This is most obviously true in matters of practical know-how or *technē*: not everyone can have, or have the time to acquire, the special skills of cobblers, lyre-players, shipbuilders, or doctors. The more complex our world gets, the more we all find it necessary to rely on specialists or highly educated generalists to filter and process information for us, and to help us make well-considered judgements about its implications. But when people rely on others in matters that call for less technical kinds of knowledge, especially in matters of moral or political judgement, authority-dependence carries grave risks.

One danger is epistemic overconfidence on the part of those who regard themselves, or are widely regarded, as authorities. Such overconfidence thrives in societies that give science and higher education an exaggerated prestige, elevating those who have these things to the status of elites and distinguishing them sharply from the less educated "non-knowers". Overconfidence increases the risk of dogmatism, an unquestioned faith in certain facts, investigative procedures, or beliefs

that can breed dangerous errors, in natural sciences and human affairs, theory and practice. And dogmatism may lead to epistemic authoritarianism, which arises when "knowers" arrogate excessive authority for themselves, both within knowledge-seeking circles and in society at large. In a vicious cycle, authoritarian attitudes harden dogmatism when authorities discourage enquiries that might threaten their own knowledge-claims, since that would also threaten their privileged social position.

As Plato's Socrates points out, epistemic authoritarianism is seldom just a top-down affair, imposed by authorities on helpless subjects. Those who defer to authorities are often complicit in their own mental subjection. Unwilling to think for themselves, they rush to take conventional or spurious signs of superior wisdom – higher degrees, titles, a reputation for shrewdness – as sufficient grounds for trusting others' judgements. Their credulity further tempts would-be authorities to cultivate appearances of superior knowledge for their own gain. One of the most corrupting authoritarian relationships takes the form of a commercial transaction where both buyers and sellers treat knowledge as a kind of merchandise that anyone with a bit of money can acquire. The sellers hawk their meretricious knowledge for financial gain, winning a name for wisdom among consumers eager to possess apparent knowledge without doing the hard work needed to acquire the real thing.

Plato calls these self-serving knowledge-merchants "sophists", an epithet that translates roughly as "the so-called wise". Feeding on their admirers' trusting naiveté, intellectual self-doubt, or laziness, sophists cast an epistemic fog over entire societies, as Plato says happened in Athens before the Peloponnesian War. Under the spell of orators and politicians like Pericles, whose teachers were skilled in sophistry, Athenians began to question the very distinctions between truth and falsehood, just and unjust. In Plato's *Phaedrus*, Socrates describes how misplaced trust in reputation can corrode people's natural capacities to discern simple truths:

> They used to say, my friend, that the words of the oak in the holy place of Zeus at Dodona were the first prophetic utterances. The people of that time, not being so wise [*sophois*] as you young folks, were content in their simplicity to hear an oak or a rock, if only it spoke the truth. But to you, perhaps, it makes a difference who the speaker is and where he comes from. For you do not consider only whether or not his words are true.

Reverence for spurious wisdom made Athenians lose their moral bearings and sense of political reality. Demagogues skilled in sophistic rhetoric persuaded people that political prudence meant shedding traditional moral constraints – taking advantage of others before they pull one over you – and expanding Athens' empire by hook or by crook. The upshot was a drawn-out war that ended in disaster for Athenians and the rest of Greece.

All this suggests that some sort of scepticism about the claims of self-styled "knowers" is good for both epistemic and political health. Especially since the Enlightenment, philosophers, natural scientists, and other thinkers have made us keenly aware of these risks of authority-based knowledge. Yet compared with ancient writers, modern Enlightenment thinkers said far less about another risk, one that looms large in today's world. This is that epistemic authoritarianism can have long-term, profound effects on human faculties of thinking and judging – effects on people's brains, we might say, not just on particular opinion-forming processes. When people glean information and form judgements by deferring to authority, their own faculties of thinking and judging remain stunted. They become, to use a familiar figure of speech, "sheep". And ironically, the most educated among those who are educated in this way are often the most deferential to authority, and fiercely protective of their own high status once they've earned it by conforming to established knowledge-seeking hierarchies.

This problem is central to a very old tradition of cautious anti-authoritarian knowledge-seeking – cautious because it doesn't merely rebel against authority, but questions its claims in a discriminating spirit, in the hope of invigorating the quest for knowledge rather than declaring it futile. Plato and his friend Socrates are key figures in this tradition, though it has its roots in even more ancient Greek literature. Writers like Xenophon, Plato's contemporary, and later Plutarch also carried the tradition through the centuries. They were rediscovered in the early Renaissance, translated into Latin, and widely read. One of the tradition's carriers was Niccolò Machiavelli, who in 1513 wrote in his *Prince*:

> There are three kinds of brains: one that understands by itself, another that discerns what others understand, the third that understands neither by itself nor through others; the first is most excellent, the second excellent, and the third useless.

Next pages: The School of Athens by Raphael.

We find similar passages about the "three species of brain" in Aristotle, and behind him the much earlier poet, Hesiod. The 17th-century English philosophers Francis Bacon and Thomas Hobbes make comparable arguments about learning to think and learn without too much top-down "teaching", as does Jean-Jacques Rousseau – and to some extent Immanuel Kant, a great admirer of Rousseau, with his credo *Sapere aude* (Dare to know!) – in the 18th century. One of the best kinds of education, they all thought, comes through dialogue among equals or friends. Plato's Socrates famously refuses to set himself up as a superior knower or a teacher, and insists that he lacks knowledge, constantly questioning his own conclusions. At best, he tells his young partners in dialogue, he is like a midwife who helps bring to light the thoughts of those who already carry them inside. He cannot plant the thought-seeds for them, do the hard work of labour, or guarantee that what comes out won't be a wind-egg; all these things depend on them. The thoughts that occur to them will not truly be theirs, nor will they know how to examine or defend them, if they take them on authority.

Dialogue has knowledge-affirming value because it allows all parties to question everything, from all possible angles. Socrates argues in the *Phaedrus* that oral discussion is a far better way to get closer to the truth than the written word, because:

> Writing, Phaedrus, has this strange quality, which is very like painting: for the creatures of painting stand like living beings, but if you ask them a question, they preserve a solemn silence. And so it is with written words. You might think they speak as if they have intelligence, but if you question them, wishing to learn from what they say, they always signify only one thing. And every word once written down gets bandied about, both among those who understand and those who have little interest in it, and it knows not to whom to speak or not. When ill-treated or reviled it always needs its father to help it, for it has no power to protect itself.

It might then seem odd that Plato took the trouble to write down dialogues that future readers were bound to misunderstand, revile, or use in self-serving ways – as indeed they have. But the difference between discussing knowledge, virtue, politics, or the soul through written dialogue or in non-dialogic form is that dialogues – at least Plato's – do not claim to

set out settled truths about any of these subjects. They merely expose fallacies in various ways of thinking about them and, as Socrates says in the *Phaedrus*, plant more constructive thoughts that are "not fruitless, but yield seed from which there spring up in other minds other words capable of continuing the process forever."

Beyond dialogue, there are other ways to educate through writing without lecturing readers from a podium. In his essay "How to Read Poetry", Plutarch asks what can be done to educate people who "like unfledged nestlings are always agape toward the mouth of another, wanting to receive everything ready prepared and pre-digested". His answer: write and speak in ways that help them to grasp the main points, then allow them to "put the rest together by their own efforts, and… think for themselves and, taking the discourse of another as a germ and seed, develop and expand it. For the mind does not require filling like a bottle, but rather, like wood, it only requires kindling to create in it an impulse to think independently and an ardent desire for the truth."

This non-judgmental style of writing is especially apt for exercising and training readers to reflect more deeply on moral and political questions. Plutarch's biographies of famous Greeks and Romans provide some good examples. While sometimes offering his own views on each outstanding man, Plutarch more often reports what various contemporaries said about them, while pointing out that few of these reports are trustworthy: those who chronicle the deeds of the famous, after all, tend to be either their flatterers or foes. So Plutarch's readers learn that they have to take whatever they hear or read with a generous pinch of salt. If they read closely, they might also learn how to form their own non-dogmatic judgements by comparing divergent appraisals of a man's character with whatever can be known about his motivations and actual deeds, and with the conspicuous effects of his policies on future generations.

Thucydides' magnificent history of the Peloponnesian War furnishes us with another example of this kind of non-authoritarian education. In his English translation of the work, Hobbes praises Thucydides for not passing direct judgements on many of the decisions that fuelled the war. Instead of praising one policy as wise or just and denouncing others as unsound, the historian "so clearly set before men's eyes the ways and events of good and evil counsels, that the narration itself doth secretly instruct the reader, and more effectually than can possibly be done by precept."

In their own creative ways, then, all these ancient and early modern authors sought to weaken the link between knowledge and authority. While criticising specific epistemic authorities – whether priestly, poetic, or canonical – they didn't want to become authorities themselves, but developed moderately anti-authoritarian views of what knowledge is and how people should pursue it. Their concerns were partly "scientific": they were interested in the disinterested search for truth, while remaining hypersensitive to how easily truth-seekers can be led astray by their own emotions, interests, and ambitions. But as we've seen, epistemic anti-authoritarians also had strong political concerns. Well-ordered politics, they believed – including the right kind of respect for political authority – depends on citizens who think, judge, and check facts for themselves.

This might seem unlikely in the case of Hobbes whose *Leviathan* defends a sovereign's absolute authority to decide matters of state. Yet one of his core arguments, in that book and others, is that each human being has a sacred duty to be "one's own" judge and to scrutinise sovereign authorities, even if Hobbes gives them no political right to revolt against them. He also insists on the natural equality of human beings in their capacity to think for themselves, though that capacity may be crippled or corrupted. In his *Behemoth*, a historical dialogue about the English Civil War, he has one speaker say: "What silly things are the common sort of people, to be cozened [conned] as they were so grossly!" His interlocutor replies: "What sort of people, as to this matter, are not of the common sort? The craftiest knaves of all the Rump [Parliament] were no wiser than the rest whom they cozened. For the most of them did believe that the same things which they imposed upon the generality, were just and reasonable." He continues that it is "not want of wit, but want of the science of justice" on the part of both more and less educated people that drove them to political disaster.

What about Plato, whose *Republic* has Socrates and his young friends imagine a state where a caste of super-educated philosopher kings and queens rule the rest? It's important to remember that this is a thought-experiment, not a blueprint for practice – and to notice how Socrates casts quiet doubts on whether "epistocracy", the rule of the knowing, could ever work. The education needed to create supremely wise rulers is so rigorous that only a few could get through it. And those who do might still succumb to the risks of epistemic arrogance and the dogmatism it breeds. Since these tendencies can produce intellectual and political

tyranny if unchecked, human beings might have to settle for a "second-best" kind of state that doesn't try to eliminate ignorance from political life, but works with it and tries to limit its dangers.

Some of the worst consequences of authority-centred learning can be seen in democratic politics, in ancient Athens and our own times. Bombarded with too much information, citizens often let leaders or parties or ideological team-mates make decisions for them, thus avoiding hard questions about the wisdom of leaders or policies. Certain educated people might imagine that they're less prone to error than people who lack their education. Plato and other epistemic anti-authoritarians show why this attitude is dangerous for democratic health. Even the educated, after all, are only human, and vulnerable to the kinds of overconfidence that feed into dogmatism and authoritarianism. One of Plato's recurring themes is especially worth recalling in our times of tension between so-called elites and the rest: namely, that the worst form of ignorance – worse than mere lack of education or undue faith in another's wisdom – is an inflated opinion of one's own wisdom.

The Gutenberg Bible, ca 1483, in Mainz, Germany.

THE POLYMATH IN THE AGE
OF SPECIALISATION

Peter Burke

In the last few decades, scholars have been taking an increasing inter-est in the history of knowledge, fuelled by debates about our "know-ledge economy" or "information society". They have discovered that today's anxieties about the "glut", "flood" or "overload" of information had their parallels in earlier periods. The amount of knowledge available has expanded continuously since the 15th century, if not before – indeed it has exploded, in the double sense of rapid expansion and fragmentation.

This explosion has produced a crisis of knowledge. By a crisis I do not mean any dramatic event that might make the headlines in a newspaper. I prefer to use this over-employed term in a fairly precise sense, close to its original, medical meaning: in other words a tipping point, the moment when the patient either dies or recovers, or more generally a time of turbulence that is followed by a change in structure.

In what follows I shall suggest that there have been three major crises of knowledge since the end of the Middle Ages. There was one such crisis in the "order of knowledge" in the West in the 17th century, a second in the 19th century, and we are confronting a third, worldwide, in our own time. Somehow, polymaths have survived all three crises, at least so far.

Each of the three crises is linked to a revolution in communication. The first crisis is inseparable from the Gutenberg revolution, and the increasing number of books printed with moveable type. The second crisis is linked to the rise of cheap journals and newspapers, thanks to the invention of the steam press and the use of less expensive paper. The third crisis could be seen coming in the later 20th century: the phrase "infor-mation overload" was coined in 1970.

However, the digital revolution that is still in progress has led to the accumulation of information on such a huge scale that new units of mea-surement, each larger than the one before, have been invented to keep up with it, from gigabytes to terabytes, petabytes, exabytes and now – but for how long? – to zettabytes. There is even a glut of books on the glut of

information, otherwise known as a flood, deluge or more recently a tsu-nami.

In the first case, a period of gradual change led up to the 17th-century crisis, a kind of run-up to the high jump. The years around 1650 and 1680 in particular reveal what has been called a "crisis of consciousness" or a "crisis of the European mind", forming part of what historians have chris-tened the "general crisis of the 17th century". In the second case, change was more rapid, while the third is of course the most rapid of all.

Each crisis has led to cries of "too much to know" and has been followed by increasing specialisation, both inside and outside the academic world. One response to specialisation has been a certain nostalgia for the age before knowledge was fragmented, divided into departments and parcelled out among an increasing variety of experts or specialists.

This nostalgia has expressed itself in various ways, including the recent publication of four books about polymaths, all of which happen to bear the same title, *The Last Man Who Knew Everything*. Curiously enough, they concern four different individuals living in four different periods. The first "last man" is the 17th-century German Jesuit Athanasius Kircher; the second is Thomas Young, a Cambridge don (and a fellow of my college, Emmanuel) around the year 1800; the third is Joseph Leidy, a mid-19th-century American professor of anatomy and natural history; while the last "last man" – at least so far – is the Italian physicist Enrico Fermi. The difference in dates between these four men, from the 1650s to the 1950s, suggests that a general study of polymaths over the long term might be illuminating. At the moment, I am engaged in writing such a study.

I should explain right away that I follow the traditional definition of the polymath as a scholar who has mastered many (or at least several) academic disciplines, rather than the more general recent use of the term, at least in English, to refer to any kind of all-rounder, in art, for instance, or in sport. I don't want the book I'm writing to turn into nothing but a gallery of intellectual portraits. The thread that I believe will sew the study together is the story, or the problem, of increasing specialisation. As an intellectual species, the polymath is threatened by the rise of specialisation. I nearly said "the irresistible rise of specialisation" – but in fact the process *has* been resisted, not only by attempts at collective interdisciplinarity, including the foundation of new universities in the 1960s and 1970s in Sussex, Bielefeld, Linköping and elsewhere, but also, heroically, by single individuals.

★

The 17th century was both the age of a few intellectual giants (vividly described at the time as "monsters of erudition") and an age of crisis.

Today, we usually remember these giants for only a small proportion of their achievements, a phenomenon that says more about us than about them. Isaac Newton, for instance, not only made his well-known contributions to mathematics, optics and mechanics but also studied and wrote about alchemy, theology and chronology.

Newton's rival in the study of calculus, Gottfried Wilhelm Leibniz, is now remembered as a philosopher but also contributed to the knowledge of history, languages, law and theology. His manuscripts reveal that Leibniz also took a lively interest in astronomy, botany, geology and medicine.

Athanasius Kircher, the first "last man", wrote on subjects as different as China, ancient Egypt, acoustics, optics, language, fossils, magnetism, music, mathematics, mining and physiology. The Swedish giant, Olaus Rudbeck (actually a big man with a loud voice), ranged from anatomy to linguistics, music, botany, ornithology, antiquities and what we now call archaeology. The French giant Pierre Bayle, a Protestant pastor who went into exile in the Dutch Republic, wrote mainly about theology, philosophy and history, but also edited a learned journal, the *Nouvelles de la République des Lettres*, and compiled an encyclopaedia, the *Dictionnaire Historique et Critique*, in which the footnotes took up more space than the text because he filled them with critical remarks of his own. All these "monsters" not only mastered but also made original contributions to a number of different disciplines.

Looking back from our own time, the 17th century appears to have been a golden age of polymaths, but there was also a dark side to the period. Complaints about what we call information overload and about the fragmentation of knowledge multiplied at this time. For example, the Oxford don Robert Burton made the point about overload in dramatic fashion when he wrote in his *Anatomy of Melancholy* (first published in 1621) about the "vast *Chaos* and confusion of Bookes": "We are oppressed with them, our eyes ache with reading, our fingers with turning." Another well-known complaint came from the French librarian Adrien Baillet, who feared the return of barbarism as a result of "the multitude of books which grows every day in prodigious fashion", making it increasingly

difficult to identify what was really worth reading. Even the widely-read Leibniz wrote of the "horrible heap of books that is constantly increasing" [*horrible masse de livres qui va toujours augmentant*].

The problem was not simply the multitude of books, which had, after all, been proliferating since the mid-15th century. More and more information was becoming available in 17th-century Europe, thanks to the invasion of other continents and the consequent discovery of their fauna, flora, peoples, languages and so on. For example, the 500 species of plants described by the ancient Greek physician Dioscorides had expanded by 1623 to the 6,000 described by Caspar Bauhin and by 1682 to the 18,000 described by the English botanist John Ray.

Like printing, this process had been going on since the 15th century, but a tipping point was reached in the 17th, partly because the new inventions of the telescope and the microscope gave access, like the expansion of Europe, to new worlds of knowledge.

Unfortunately, what Francis Bacon called "the advancement of learning" had its downside. The proliferation of books and discoveries encouraged the fragmentation of knowledge, about which complaints were already expressed at this time, notably by Comenius, who wrote: "Metaphysicians sing to themselves alone, natural philosophers chant their own praises, astronomers dance by themselves, ethical thinkers make their laws for themselves, politicians lay their own foundations, mathematicians rejoice over their own triumphs and theologians rule for their own benefit." Comenius dreamed of reuniting the fragments into what he called *pansophia*, a universal wisdom that would lead to the reform of the world.

All the same, polymaths did not disappear. A few were even able to emulate the giants of the 17th century and make original discoveries in very different fields.

Take the case of the Russian Mikhail Lomonosov, professor of chemistry in the Academy of Sciences in St Petersburg. For a long time, Lomonosov was viewed by posterity as essentially a man of letters: a poet and the author of a history of Russia and a grammar of Russian, despite the publication of works such as *The Elements of Metallurgy or Mining* (1763). However, the discovery of his manuscripts revealed his interest in the origin of heat and cold, the elastic force of air, the theory of colours, electricity, navigation, optics and other fields.

Again, the Comte de Buffon, remembered today for the huge enterprise of his *Histoire Naturelle*, published in 36 volumes, was also active in

the fields of mathematics, physics, demography, palaeontology and physiology. Other individuals were still able to master a wide range of disciplines, even if they did not make original contributions to many or even to any.

The new ideal was the man or woman of letters. A famous example of the man of letters is Denis Diderot. Diderot was able to edit the famous *Encyclopédie* precisely because his interests were encyclopaedic. Indeed, besides editing this massive work, Diderot contributed several hundred articles on philosophy, literature, acoustics, biology, art, music and the crafts. However, the remainder of the *Encyclopédie* was the work of a team of nearly 140 contributors.

Again, the Spanish monk and professor Benito Jerónimo Feijóo, known in his day as a "monster of erudition" in the 17th-century style, was more exactly a man of letters who kept up to date with discoveries in a number of fields and wrote about them all in an agreeably conversational style, without making any serious original contribution to knowledge. The nine volumes of his *Teatro crítico universal* dealt with "every sort of subject", as the title-page proclaimed, while the prologue declares that the author planned to arrange the essays by discipline but desisted, "either because they did not belong to any discipline, or participated equally in in all of them".

By the early 19th century, a second crisis of knowledge was becoming visible. The problem once again was that of overload, as scientific expeditions brought back more and more information, experiments became ever more numerous, the public archives were opened to scholars and the steam press and the shift to paper made from wood pulp reduced the price of printed matter, including newspapers and journals as well as books.

Information anxiety revived. The institutionalisation of specialisation in universities, especially from the later 19th century onwards, may be regarded as a kind of defence mechanism, building dykes to contain the deluge of information. In Germany, the United States and elsewhere, new institutes, faculties, departments and courses for undergraduates proliferated. In Cambridge before 1870, for instance, undergraduates could only choose between classics and mathematics, although students with wider interests, such as Charles Darwin, could study subjects such as botany

Next pages: Susan Sontag directing
Duet for Cannibals in Sweden, 1968.

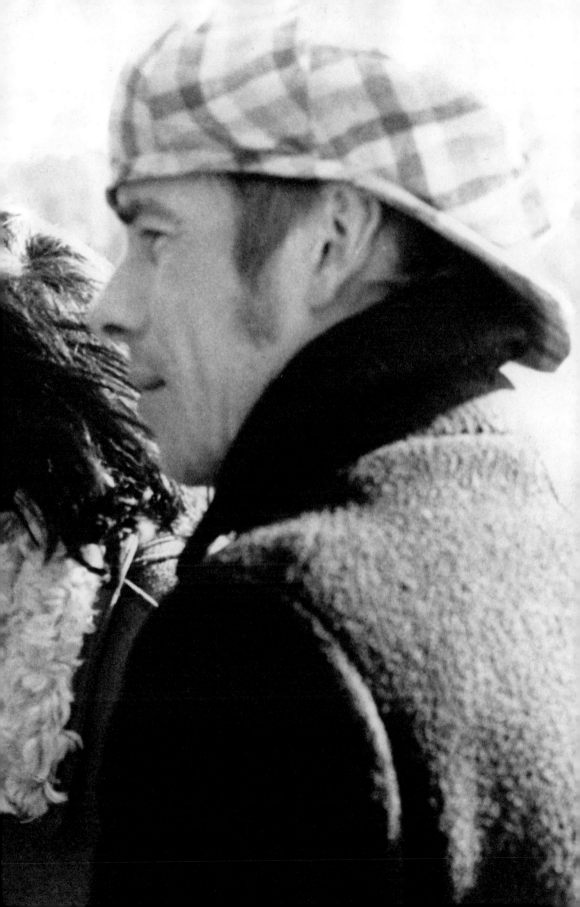

and geology informally. After 1870, new courses (known locally as "triposes") were rapidly established: in law, for instance, modern history and natural sciences; by contrast, it was necessary to wait until 1917 to study English literature.

New words are often signs of new trends. In English, the word "scientist" was coined in 1834, as specialists in the study of nature began to separate themselves from specialists in the study of the humanities. In French, the term *spécialité* came into use in the 1830s, the term *spécialiste* was coined in 1848, while, ironically enough, the polymath Auguste Comte coined the term *spécialisation,* adopted into English by another polymath, John Stuart Mill.

By the end of the 19th century, teamwork in the laboratory had become a feature of what was already becoming known as "big science" [*Grosswissenschaft*], a collective production of knowledge that was compared at the time to the mass-production of goods in factories. Even so, it is not difficult to find individuals in the 19th and early 20th centuries whose interests and knowledge ranged widely across the disciplines. To return to Thomas Young, for instance, the second "last man to know everything": he was trained in medicine, but his interests expanded to include physiology, physics, optics, acoustics and ancient and modern languages. He was making good progress in the decipherment of hieroglyphics when he was overtaken by a more specialised French scholar, Champollion. No wonder that he was known in Cambridge as "Phenomenon" Young.

Still more spectacular were the many contributions to knowledge made by Alexander von Humboldt, a true monster of learning comparable to Leibniz. Humboldt made original contributions to the disciplines of geography, geology, botany, zoology, anatomy and astronomy. He also studied and wrote on archaeology, ethnography and demography.

As specialisation became the norm, wide-ranging achievements provoked suspicion as well as admiration. Thomas Young published some of his contributions anonymously so that his medical colleagues and his patients would not lose trust in his work, while Humboldt noted that some people complained that he was interested in too many things at once.

It must be admitted that polymathy comes at the risk of superficiality. From the 17th century onwards, some wide-ranging scholars have been described as "charlatans", in other words people who promise what they cannot perform, like the early modern vendors of miraculous medicines. For example, Descartes described Kircher in this way, not without reason,

since Kircher claimed to have succeeded in squaring the circle and deciphering Egyptian hieroglyphs, whereas he actually failed in both attempts.

A second risk run by polymaths is what might be called "Leonardo syndrome", in other words leaving projects unfinished because new ones seem so enticing. This was the case for Leibniz, for instance, as it was for Young, to whom a colleague once wrote about the "universal regret that your versatility is so widely engaged in the sciences… that you are unable to press on with your discoveries and bring them to that pitch of perfection which we have the right to expect from a man of your conspicuous talents". One might have thought that the institutionalised specialisation of the later 19th century would have marked the extinction of the polymath. It didn't. Paradoxically, polymaths became a new kind of specialist, the "generalist", specialising in connecting different parts of the fragmented world of learning (the term generalist was already in use by the 1890s).

Particularly effective generalists are what I call "serial" polymaths, on the model of the serial polygamist. They migrate from one discipline to others. They often notice unexpected connections because they examine problems in their second or third discipline with the mental habits formed in their original training. Vilfredo Pareto, for instance, who began his career as a civil engineer working on Italian railways, took the idea of equilibrium with him when he moved first into economics and then into sociology. A former colleague of mine at the University of Sussex, John Maynard Smith, who was one of the leading British biologists of his time, explained his success by the fact that, as an undergraduate, he had not studied biology but engineering. Writing a dissertation on the evolution of the flight of birds, he regarded the subject from the viewpoint of an aeronautical engineer, interested in the tension and the possible trade-off between stability and manoeuvrability.

One unfortunate consequence of specialisation has been much debated since the 1960s, in Italy, Germany and Sweden, as well as in Britain, thanks in particular to a lecture given in Cambridge in 1959 by Charles Snow, a physical chemist who became a civil servant and finally a novelist. Snow complained about the growing gap between what he described as "two cultures", the natural sciences on one side and the humanities on the other. All the same, some individuals in Snow's generation – he was born in 1905 – were still able to cross the frontier between the two cultures. One remarkable example from this generation is the Russian Pavel Florensky.

Florensky wrote of himself that his "life's task" was to continue along "the path toward a future integral world view". This serial polymath began his career as a mathematician and went on to study philosophy and theology, becoming a Russian Orthodox priest. When he studied religious art, he focused on the representation of space in icons (revealing the habitus of a geometrician). Mathematics also led Florensky to electrical engineering. Imprisoned in the course of Stalin's purges, he was working, before he was shot, on a new topic, the production of iodine from seaweed.

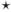

Today, as we are all too well aware, the gap that Snow lamented has widened still farther. We should surely speak of many cultures rather than two cultures of knowledge. Once again, then, one might have expected polymaths to have become an extinct species, along with so many other species in the world of today. All the same, a few individuals have continued to resist specialisation, apparently with success.

The late Umberto Eco began his career by studying medieval philosophy, writing a dissertation on the aesthetics of Thomas Aquinas. He moved into the comparative study of languages, literature, art and music as forms of communication, and in this way he arrived at semiotics, a new discipline in which he became one of the pioneers. This serial polymath was also a novelist and a cultural critic, writing in *L'Espresso* and other Italian journals on an amazing variety of subjects, from the Red Brigades to comics and *candomblé*. In similar fashion, Susan Sontag wrote on a regular basis for the *New York Review of Books* and other journals. Her essays, which filled nine volumes when they were republished, were concerned not only with literature and philosophy, the academic disciplines in which she had originally been trained, but with art, photography, fashion, dance, illness and politics, from the war in Vietnam to the attack on the World Trade Centre in 2001.

A living example of a serial polymath is the American Jared Diamond. He was trained as a physiologist but moved into ornithology. Visiting New Guinea to study the birds there, he became interested in biogeography, ecology, linguistics and anthropology. He is perhaps most widely known today for his essays on world history, notably *Guns, Germs and Steel* (1997) and *Collapse* (2005). Diamond's books on history have often been criticised

by specialists but they have also been taken seriously. One might say that, whether or not one agrees with his answers, the questions that this outsider to the discipline has asked have been original and fruitful ones.

We surely need not only a history but also a psychology and a sociology of polymaths. To begin with the psychology: becoming a polymath – sowing the seeds, one might say – requires a combination of qualities. Polymaths obviously need an overdose of curiosity, a formidable memory, and both the ability and the desire to work long hours. They are often competitive, driven to succeed. They are able to concentrate their attention, a capacity that observers often describe in a negative manner as absent-mindedness. Polymaths also have a gift for drawing analogies, seeing connections between apparently distant fields, as in the case of Young, who studied tides and imagined "waves" of light.

However, for the seeds to bear fruit, polymaths need to find a social niche that will give them the leisure to study, think and write. Religious orders have often provided polymaths with such a niche. Feijóo was a Benedictine monk, while Kircher was a Jesuit and so were two leading 20th-century polymaths, Pierre Teilhard de Chardin, who was a geologist, palaeontologist, philosopher and theologian, and Michel de Certeau, whose fields included theology, philosophy, history, psychoanalysis and sociology.

Other polymaths, such as Buffon, inherited wealth. Humboldt, for instance, was an independent scholar whose wealth gave him not only leisure but also the opportunity to make the famous expedition to South America, where he made most of his discoveries. After inheriting a fortune, Vilfredo Pareto gave up teaching in order to devote his time to writing. Universities have often offered a niche for polymaths and a few have been astonishingly flexible, in the sense that some serial polymaths have been able to move from one department to another as their interests changed. The Hungarian exile Michael Polanyi became professor of physical chemistry at the University of Manchester, but as he wished to concentrate on philosophy, he was allowed to keep his chair and was simply moved along the campus. More recently, Jared Diamond has spent his whole teaching career at the University of California in Los Angeles, beginning in the Department of Physiology and ending up, so far at least, in the Department of Geography.

The post of librarian has appealed to a number of polymaths, notably Leibniz, who exercised this profession at Wolfenbüttel and elsewhere. As

Plato said of kings, it might be argued that either librarians should be philosophers or philosophers librarians, as in the case of Leibniz, reforming the classification of knowledge as well as the classification of books.

Another niche, from the late 17th century onwards, has been the cultural journal in which polymaths such as Bayle, Eco, Sontag or Aldous Huxley (who was notorious for having read the *Encyclopaedia Britannica* from A to Z) were able to publish articles on a wide variety of subjects.

However, all these niches are at risk in the age of the digital revolution. It is now rare for intellectuals to have a private income. Librarian has become a profession that requires specialised training and concentrates on management, leaving little or no time for reading the books. Universities are less hospitable to polymaths than they used to be as teaching loads increase and meetings multiply. Speaking on this topic recently at the University of Manchester, I asked the audience: "What would happen to Polanyi today if he asked the vice-chancellor for a transfer from one department to another?" A roar of laughter provided a clear answer. Cultural journals, happily, still exist, but they are losing readers and also advertising.

To conclude. There have been and still are different regimes of knowledge. It might be argued that the polymath belongs to an old regime that is obsolete or at least obsolescent. The only living polymaths known to me have all left middle age behind. Diamond is 81, Bruno Latour, who has made important contributions to philosophy, sociology, anthropology and the history of science, is 71 and Slavoj Žižek, who seems to have written about almost everything, is 69 (at the time of writing, in June 2018). They are all too old to feel the full effects of the third crisis. I am unable to think of any polymath born later than the 1950s – can you?

Will the digital generation produce polymaths? I certainly hope so, for within the division of intellectual labour there remains an important role for generalists, individuals who are able to perceive unexpected connections. The problem is that we are making life increasingly difficult for these remarkable individuals. We are destroying their niches at a time when we need these people more than ever before.

The *Tree of Life* diagram in the Jewish Kabbalah.
Illustration from 1516 by Paul Ricci.

FROM HONEST IGNORANCE TO DISHONEST IDEOLOGY IN SCIENCE

Nathan Shachar

At the northern tip of the autonomous region of Valencia, overlooking the Mediterranean sea, lie the ruins of Sagunto, the most spectacular remains of Greco-Roman Hispania. In 218 BC the Phoenicians of Carthage took the city after a long siege. It was from there that Hannibal launched the remarkable blitz which took him almost to the gates of Rome.

We all know this, or at least we do once we've learned it. But when the celebrated Arab scientist Al-Udri saw the ruins, around 1030, he was mystified. Who could have erected such colossal walls? Sagunto, he concluded, must have been created by gods or by giants. Al-Udri, one of our chief sources on medieval Iberia, did not know about the Romans. Perhaps he had heard of them, but he didn't understand that his country had been a part of their empire and, without the necessary prior knowledge, he had no way of connecting those Romans to the extraordinary evidence before his eyes.

Therein lies one major difference between the scholars of our time and those of the medieval period: that they had such a limited perspective looking backwards. An expert often did not know all there was to know, even in his own field. Muslim scientists admired Aristotle, but their "knowledge infrastructure" was meagre compared to that of the ancient Greeks. Aristotle knew all there was to know in the several fields in which he was a leading light. In that respect he was like today's specialists; as soon as anything new happens in their field, they'll hear about it. In 1143 the Englishman Robert of Ketton made the first translation of the Koran into Latin. But 70 years later, when Mark of Toledo set to work on his translation of the book, he had not heard of Robert of Ketton's work, and believed himself to be a pioneer.

Shortly before Al-Udri's time there had been a marvellous state library in Umayyad Cordoba, but in his time it was destroyed and scattered. Books were expensive and their owners rarely let them out of their homes.

Often those who most needed to see a book didn't know it existed or where to find it. Of course, there were people alive in 1030 who knew about the Romans in Spain. The Christian priests in Syria knew, some rabbis surely knew, and others. But Al-Udri didn't know, and it is hard to blame him. Back then, when you didn't know something, you often went on not knowing it, unlike today, when we can gauge our ignorance in an instant with the push of a button.

Al-Udri's cluelessness about Sagunto is an instance of what Donald Rumsfeld famously called "unknown unknowns". Rumsfeld, then US Secretary of Defense, was trying to account for US disappointments during the Iraq War. That wasn't the first time unknown unknowns have decided wars and changed history. In 1798, when French forces landed in Egypt, the local Mamluk generals were not only ignorant about light field guns, they barely knew what France was or where it was located.

In science, unknown unknowns are often related to heroic feats. We admire Gregor Mendel for discovering the basic laws about heredity without knowing about genes, and we admire Darwin even more for turning out his theory of evolution without an understanding either of heredity or of genes. Aristarchos of Samos, without telescopes, proposed Copernicus's theory, that the Earth revolved around the Sun and not the other way about, some 1,700 years before Copernicus. Ignaz Semmelweis, the Hungarian doctor, by a series of brilliant deductions, accounted for the work of bacteria decades before the germ theory of disease had been established by Robert Koch and Louis Pasteur. (The germ theory was first proposed by another lonely genius, the Veronese polymath Girolamo Fracastoro in 1546, but met with scorn.)

Honest ignorance is different from pretending to know. Al-Udri didn't lie when he suggested that Sagunto was built by aliens. He made a wild guess. Cold-blooded lying in science is different: for example, the city of Madrid has an Arab name and was founded by an Arab king. Many Christians were unhappy about that, including the 17th-century historian Jeronimo de Quintana. In order to purge his city of any Muslim associations, he constructed a proof that Madrid had in fact been founded by the Babylonian king Nebuchadnezzar. This didn't sound as strange then as it does today. At the time it was believed that Lisbon had been founded by Ulysses and that Hercules was the begetter of Seville. In 17th-century Sweden, the scientist Olof Rudbeck came up with a proof that Sweden was the lost continent of

Atlantis and that Paradise was located near his office at the University of Uppsala. The Swedes were really the descendants of Noah, from the book of Genesis. All knowledge, all virtue and all of the arts were Swedish gifts to humanity. Something similar happened in our time, when Mustafa Kemal Atatürk ordered his scientists to prove that all the great peoples who had left their glorious ruins in Turkey, including the Greeks, had in reality been Turks.

While growing up in the last century, most of us gained the impression that science had for much of history been steered by superstition and bullied by clerics, but that things had improved since then and the scientific mission was now a much more serious enterprise. We soon realised things were neither that idyllic nor that simple. The sheer volume of knowledge and the access to that knowledge have exploded, but the ethics of science has not soared in any corresponding way. There are theories and claims today, in sociology, in psychiatry, in gender and post-colonial studies, that are every bit as unserious as astrology or the reading of tea leaves. Some of these ideas, such as the theory of recovered memories, have remained dominant in the public sphere long after they were refuted scientifically.

There is no linear, moral progress in knowledge and science. There are highs and lows. Compared to charlatans like Quintana or Rudbeck, whose motives and methods were disgraceful, the scientists of medieval Cordoba were models of rigour and intellectual honesty. Around 1130, two remarkable thinkers were born in Cordoba, only a few years apart: the Muslim Muhammad Ibn Rushd, known by Westerners as Averroës, and the Jew Moshe Ben Maimon, known to us as Maimonides. They both spent their lives doing the same thing – reconciling their religion with scientific method, which then meant Greek logic and empirical research. When the holy scripture collided with reason, Averroës and Maimonides did not tweak the logic or tamper with the evidence. Instead they demanded and carried out a reinterpretation of religion. Averroës advised: "Those sections of the Koran which appear to be contrary to evidence or to logical reason should be reinterpreted." You will not find many Muslims prepared to say that publicly today, yet Averroës was a *qadi*, a judge at the sharia court. When the thoughts of Averroës and Maimonides reached the Christians of the late Middle Ages, the urgency to bring faith into line with science became a Christian concern and one of the impulses behind the first universities.

Ludwig Wittgenstein: "Whereof one cannot
speak, thereof one must be silent".

The Jews and the Muslims in southern Iberia were on to something big. But then everything changed. The tolerant culture where Averroës and Maimonides had been able to study logic and science was destroyed by a fanatical jihadi sect from Africa, the al-Muwahhidun or "Almohads". Northern – Christian – Spain became the new centre of Jewish learning. But it was not the rational Judaism of Maimonides, but a mystical, superstitious Jewish philosophy, not based on the study of nature but on magic and obscure numerological calculations – what we now know as the Kabbalah. (The central work of the Kabbalah – the Zohar – was written in Aramaic in the town of Guadalajara, a small town outside Madrid, around the year 1300, by a local rabbi.)

We must not, although many do, blame all the hardships of science on the church and religion. Organised religion often feels threatened by science, but it doesn't always attack it. Giordano Bruno was murdered by the church and Galileo Galilei was silenced, but a century earlier Copernicus had been praised by the pope, Clement VII, for the very same theory that got Bruno and Galilei into trouble.

Secularisation has been liberating, especially in countries like Sweden, where writers were put on trial as late as the 1890s for mentioning sex or joking about Christ. We all know how Galilei was humiliated before the Inquisition, but few know what really happened to Ignaz Semmelweis. Many have heard of his brilliant way of bringing down the numbers of deaths from childbirth fever at the general hospital in Vienna. He realised that doctors and students coming from performing autopsies in the morgue to the maternity ward somehow contaminated the new mothers. Semmelweis made them wash their hands and instantly brought down the fatality rate. This was in the 1840s, a generation before Koch and Pasteur proved the role of bacteria in the spread of disease. Semmelweis couldn't justify his conclusion biologically, but he was correct, and his method worked.

You would have expected every colleague and maternity ward to pick up on this breakthrough immediately and save lives. But no, they all attacked Semmelweis. Not only his envious colleagues in Vienna, but the foremost professors of London and Paris all ganged up, called him a crank and wrote treatises denouncing him. Those were scientists! In the

end, Semmelweis was taken to a madhouse where he died soon afterwards following mistreatment at the hands of the guards. The "experts" all went on not washing their hands for another 20 years. There are similar cases today, in psychiatry, where entire healthcare systems have adopted theories with no empirical evidence at all, such as the theory of mental ailments being caused by genetically conditioned chemical imbalances in the synapses of nerve cells.

Science, like capitalism and democracy, is not a natural state. Like them, it is a hyper-vulnerable, rare equilibrium requiring constant protection and courage. As the Swedish philosopher Benjamin Höijer put it: "Seek the truth. If truth brings you to the gates of Hell, knock on those gates!" Höijer, in the early 19th century, was persecuted by the state and could not make a living. Two centuries later, his university, at Uppsala, still prefers fashionable ideology to reality and truth. Some years ago, the theologian Eva Lundgren, a professor of sociology and a gender-theory feminist, claimed that large numbers of children had been murdered in Swedish forests by devil-worshippers. There were no missing children and the professor provided no names, dates or locations. But many of her colleagues and a majority of opinion-makers supported her.

Professor Lundgren was disgraced after large-scale fraud in her research was revealed. There was a storm, but eventually the university sided with her, apologised for ever having doubted her results and granted her many millions of kroners to be spent on further investigations of male structural violence.

You would be excused for assuming that the Lundgren case was the low-water mark of Swedish anti-science. But you would be wrong. In the early 1990s, at a mental asylum in Säter in central Sweden, a petty criminal called Thomas Quick was subjected to recovered memory therapy. Quick, who was smarter and a better judge of character than his psychiatric minders, soon realised that any recovered memories he produced during therapy caused euphoria among the staff and resulted in favours and privileges for him. The more salacious and violent his revelations, the better the drugs and the longer the leaves were for Quick. He laid it on thicker and thicker until he told them that his baby brother had been ritually murdered and eaten by the family.

That was a hard story to beat. In order to top it, he began to confess to murders. While away on leave from the asylum, he scoured old newspaper archives for unsolved murder cases, to which he then confessed.

He admitted having killed more than 30 people, and was found guilty of eight murders. Quick could not show the remains of any of his victims. He could not lead investigators to the crime scenes. There was no evidence, there were no witnesses, and no discovery of murder weapons. Nevertheless, the criminal justice system, the police, the courts, most psychiatric experts and most of the media were happily duped. Recovered memory therapy was celebrated as the cutting edge of science and the (very few) experts who swore that Quick was a mythomaniac were ignored or vilified. The epitome of this collective madness was reached when forensic doctors certified that a piece of wood was a splinter of bone from one of Quick's victims.

The state, the police, the courts and the psychiatrists would happily have carried on, convicting Quick of whatever he confessed to. The ideological feeding-frenzy was not stopped by anyone involved, but by two courageous freelance journalists, Hannes Råstam and Dan Josefsson, who exposed the truth in two books. In order for them to reach the wider public, they were forced to publish their findings in book form because the mainstream media were so reluctant to elucidate the issue from any other angle than that of the consensus: Quick was a mass-murderer, and recovered-memory therapy was an unequivocal blessing – these were not merely empirical claims but axioms.

Such cases of irrational hysteria used to be the study objects of experts in the psychology of religion. But since the arrival of post-modernism and relativism, the truth-criteria of many academic fields have less and less to do with research, and more and more to do with the preferred opinions of believers. The philosopher Ludwig Wittgenstein famously said about psychoanalysis that its only truth-criterion was the patient's readiness to accept it. Weirdly, much of this cultish superstition goes under the name of "theory", or even "critical theory" – even though its proponents deny or ignore the most elementary requirements of scientific theory.

Faculties which were once models of sobriety and empirical research are today hotbeds of the most egregious nonsense. News items reporting mob attacks, in several cases near-lynchings, against controversial visiting lecturers at American universities are no longer headline events. Teachers have lost tenure after daring to challenge articles of multicultural faith. This happens more often at Ivy League and prestigious institutions than it does in regional seats of learning. When ideological firestorms break out, the management of the schools usually prefers to

appease the zealots, rather than defending freedom of expression, pluralism and the other core values they advertise in their marketing.

Any scholar or researcher who studies or even speaks about biologically determined differences between the sexes will get into trouble. The Swedish neuroscientist Germund Hesslow, long a bête noire of the gender-righteous lobby, was denounced by students at the University of Lund in September 2018, for saying, during a lecture, that some differences between men and women were biological. Instead of rushing to his defence, the university, ominously, declared that it had "opened an investigation". This, apparently, is the future. The Enlightenment may not be over yet. But its position in our seats of learning is no longer self-evident but, increasingly, a controversial minority position.

COGNITION

Brain.

WHY 16 BILLION CORTICAL NEURONS SET HUMANS APART FROM OTHER ANIMALS, BUT ARE NOT ENOUGH

Suzana Herculano-Houzel

I am in awe of technology. As I travel the world for work, I can communicate in real time with colleagues in the United States and family in Brazil from almost anywhere through devices placed in orbit by man that relay our voices and messages. I jump on a metallic bird and soar the skies for over 100,000 miles a year, mostly sound asleep, to exchange recently acquired bits of information and newly formed knowledge with peers and the public in different countries. If I don't speak the local language, I can ask a small handheld metal gadget for help – one that gets the information I need through waves that surround my body but are invisible to the eye. Hardly any physical effort is required of me to go places or have my voice carried over, much less my own understanding of how airplanes, satellites and antennas work, or how to put one together.

How did we, and we alone, arrive at our current state of cognitive prowess sufficient to create and accumulate such technology? The short answer, both directly and indirectly, is biology. We may not like to think of ourselves as primates, much less as animals, but that's exactly what got us to where we are now. We are the primate species which invented a kind of cheat that allowed us to develop the brain with the most cortical neurons – while remaining just that: primates.

Neurons are the information processing units of the brain – our mental Lego blocks, as it were – and, as with Lego, the more the blocks that are available, the more complex and intricate the assembled building can be. Not all neurons are made the same; their function depends on their pattern of connections, which defines from where they get their information, and to where they send the result of their receiving, combining and processing that information. Some neurons in the brainstem mostly receive signals from the body, and pass that on to other neurons that mostly make things happen in the body, whether muscular or chemical actions. Strictly speaking, those are the neurons that operate the body. But neurons in the cerebral cortex, riding on top of the brainstem, get a copy of everything

that comes in, and are organised in a way that allow those copies to reverberate, bounce around, echo, and form associations with each other – all before intervening in the actions of the body and modifying them. Acting on the rest of the brain, the cerebral cortex has an opportunity to endow the actions of the individual with complexity and flexibility. Without a cerebral cortex, one lives ever in the present; but whoever has a cerebral cortex gains a record of the past and the capability to use the past to forecast and prepare for what lies ahead.

Whoever has the most neurons in the cerebral cortex, then, should have the most flexible and complex cognition. That species, it turns out, is us, even though the human brain is not the largest one around. Because our brain is built like any other primate brain, it has the advantage of packing a much larger number of neurons into the same volume as other brains. It thus follows that, as the largest-brained primate, we have the most neurons in the cerebral cortex of any species: 16 billion of them, on average. That, as we have established in my lab over the last ten years, is three times as many neurons as the African elephant harbours in its cortex, despite that cortex being twice the size of ours.

How we came to be that primate species with the most neurons is an interesting story along the lines of "rich-gets-richer". Our ancestors of some three million years ago had brains about the same size as the modern chimpanzee – which is to say, already with a respectable seven billion neurons or so (judging from the size of fossilised skulls), brains that we know to be capable of using tools and even crafting simple ones, like poking-sticks made out of branches. But unlike the modern chimpanzee, that ancestor had straightened up and walked upright on its hind limbs only, which cut in half the amount of energy required to go places, and therefore multiplied by two the distance that they could roam a day.

Going the distance is important for animals because it enhances the ability to find food. And food, which is crucial for keeping the brain functional (it is the second most expensive organ in the body in terms of daily energy requirement after the liver), must have been at a premium. Chimpanzees spend six to seven hours a day eating; gorillas and orangutans, over eight – and if that is not sufficient time to gather and ingest enough calories, they simply lose weight. If human beings ate like other primates do, we would have to spend about nine-and-a-half hours a day eating, every day of our lives. Just imagine what your life would be like. Forget

college, school, or work; finding food and ingesting it would consume most of our waking lives.

What changed our evolutionary history – perhaps aided by the bipedal posture that freed the hands to craft and carry and allowed the body to go twice the distance – was that more and more neurons became affordable to our ancestors. With enough energy available and hands free to manipulate, our ancestors of some three million years ago started carving tools out of stone that could kill and cut through prey much faster than any still respectable teeth; they could then also modify that meat and whatever else might serve as food, crushing, cutting and pounding, before ingesting it. Our ancestors of three million years ago thus invented the first human technology, stone tools, and put them to use to craft the second: cooking.

In the modern world, cooking is associated with heat, but the word should really be applied to any kind of food preparation, whether or not it involves heat. Cutting, crushing, mincing, pureeing, juicing or tenderising with acids are all types of cold cooking and they achieve the same important modification: they greatly increase the amount of energy that the body can obtain from the same food. Using stone tools on meat or roots was therefore the earliest form of cooking, a technology that reduces the amount of time and effort required to chew and then swallow the food, which has been made softer. This process increases the energy that is transferred from food to the body by 30 to 100 per cent, as once completely digested (instead of swallowed in chunks) every last bit of cooked food is captured by the body. If anything distinguishes us, it is that we are the only species that pre-digests its food so thoroughly. The extra energy harnessed by that early technological trick seems to have shaped our evolutionary history, liberating our crafty ancestors from the energy constraints that continue to apply to all raw-food-eating primates, and affording them an unprecedented number of energy-hungry neurons in the cerebral cortex. With more cortical neurons came greater cognitive capabilities, but cooking was the gift that kept on giving, for once laborious and wasteful chewing became easy and efficient, those newly available neurons also had a benefit of their own to enjoy: free time.

Cooking must thus have given us both the brain and the time that allows for taking an interest in problems, noticing patterns, elaborating hypotheses about the world and setting out to test them, as well as crafting tools that help solve those problems faster. Our biology is capable of creating

technology, whether in the form of knowledge, methods, or instruments. But left to its own devices, that brain would have to learn everything from scratch, over and over again. The largest number of cortical neurons of any brain would not suffice if young human beings had to retrace the steps of every one of their ancestors and their discoveries before finally adding their own discoveries to the list: from stone tools, fire, and spears all the way to the latest smartphone and jet engine. That every new generation does not have to start over is a testament to another achievement of our biology: longer lives that foster the cultural transfer of science and technology down the generations, be it through direct personal instruction, through mentoring or schooling, or through the indirect handing down of ideas and know-how in physical repositories of knowledge. However it happens, the increased number of cortical neurons brings (as for other warm-blooded species) extended childhood and even more years of life after sexual maturity, during which each generation has an opportunity to reanalyse what was passed on to it, to add more knowledge to that corpus, and to create a new synthesis that can be transmitted to the next generation.

Cultural transfer, or learning from others, is not just useful, but fundamental. Lego blocks have to be assembled before the whole conveys any meaning, and our brains are no different. In adulthood, already accomplished creatures, it is easy to forget that we started life full of possibilities, just as a pile of Lego blocks can be used to build most shapes, but at that point aren't much more than promising yet disorganised building blocks. Moreover, most of the "assembly instructions" for the brain, the information that shapes neurons into complex meaningful networks that can achieve wonders, are not even written in the genes (there are not enough of them for that), but assimilated through experiencing the environment.

As we go about life, the brain interacts with the world and learns by trial and error what and who is important, and what works or doesn't. Unlike plastic Lego blocks, it undergoes self-organisation, which comes naturally to our neurons and to biology as a whole. Those blocks that assemble circuits which chance to make something useful happen are preserved, the connections that stitch them together strengthened; others, found to be useless, are destroyed and their materials repurposed, as new circuits form haphazardly, generating new possibilities that will be exposed to the test of use. The brain is born with about as many neurons in the cerebral cortex – that part of the brain which generates complexity

A bonobo, also called pygmy chimpanzee, at the
Sanctuary Lola ya Bonobo, Democratic Republic
of the Congo.

and flexibility – as it will have as an adult, but until it gets there it under-goes a rollercoaster ride of gaining and then losing neurons, then gaining some more, throughout which process new circuits are tried and tested. And so, over time and as a function of life experiences, each of us develops a brain that has the capability of speech, but forms to learn only those particular languages that it hears; that has the capability of controlling the body – but becomes as clumsy or agile as we demand of it, and as is useful and meaningful for our lives. Our brain is thus born full of capabilities, but those have to be shaped into actual abilities by use: we are a combination of the brains we were born with, and what we make of them – and that takes a lifetime. It is no wonder that having a variety of opportunities in early life is so enriching. It is also no wonder that we become more and more ourselves over our lifespan, better and more finely tuned versions of what we grew up doing and thinking and feeling.

That is where science and technology and education as a whole come in, guiding our natural curiosity about the world into organised experimentation, in schools and labs and beyond them, generating knowledge which is then applied to new objects, systems and procedures that make problem-solving easier: technologies. This knowledge about the world and our bodies, harnessed by centuries of critical thinking and inquiry and systematic investigation, shapes our minds as it is passed on from generation to generation. Formal education and cultural transmission of *know-what* and *know-how* have played such a fundamental role in shaping those 16 billion cortical neurons into our able minds over the last million years that we need to be reminded of it.

This is why I am fascinated by post-catastrophe science fiction stories and their speculations about what life would be like if we still had the same biological brains as our ancestors from the last Ice Age, the time of early farming, ancient Greece or the medieval period probably already had – but no longer had the information to feed them. Any epidemic that eliminated some 90 per cent of the population would have devastating consequences that go way beyond the personal tragedy of lives lost. First would come the shock of living in a world where electricity and digital information trading no longer existed for lack of fuel. We would go back to producing and annotating knowledge with our hands and writing implements, to climbing long flights of stairs on our own, to being restricted to the immediate couple of miles of land – and communicating only with those around us.

Next would come the realisation that we depend on food supply chains that involve thousands of hands and minds; backyard farming would have to be learned all over again. Then, as useful objects break or wear out, would come the shock of discovering that, as well educated as we may have been, we no longer dominate the know-how nor have the skills required to craft our own technology. I have a PhD in neuroscience, but would not know how to fashion a pen or press paper on which to write. Perhaps I could mould new pots and plates out of clay, but I would have to figure out by painstaking trial and error how to fire them so they didn't crack and spill my food. Making my own knives? Forget it. I have learned about steel forging, but I would not know how to operate a steel plant or forge my own blade into shape – much less mine the required primary materials when that time came. At best, I could probably crack some rocks into the right shape for use as hand-held sharp blades, like my Stone Age ancestors could. We do have the same underlying biology, after all.

We have become so good at putting our 16 billion cortical neurons to good use that, at this point, no one person could acquire, much less retain, all of the know-what and know-how that our species has developed. Humankind has far surpassed what any individual could achieve. And all the while, we have remained as much a primate as any other: our brain is no different than could be expected of a generic primate with as many neurons as we have acquired.

Thanks to that biological advantage, we have become so accomplished at investigating our own world, generating and updating knowledge, passing it on and applying it to technological development, that we have become dangerously dependent on our advanced technology. It is a good problem to have – one that brings with it the safety of temperature-controlled housing, refrigerators, drugs and vaccines, anaesthesia and surgery, and the wonders enabled by metallurgy and electronics. But it relies completely on us remembering to use our brains to keep alive and well the science and the technology that shape our biological capabilities into the modern abilities that we prize so highly – and to pass it on through education. Just as I have learned to bow to my kitchen and knives in gratitude to our ancestors who came up with those first technologies, I have also learned to prize and respect teachers, professors and instructors in all crafts and fields of knowledge. Without them, we are on our own: biology unaided by culture.

Refractor telescope at the Pulkovo Astronomical
Observatory near Saint Petersburg, about 1900.

LANGUAGE: A PRIVILEGED WINDOW
INTO THE MIND

Mariano Sigman

Science is about making visible the invisible. The discovery of telescopes allowed scientists in the Renaissance era to observe for the first time the most remote and distant corners of the solar system – and with this, to solve fundamental questions which for centuries had been a matter of speculation alone. In recent years, the instruments and vessels of science have also transformed our capacity to observe human brain activity. This, in turn, has solved controversies about the human mind which had been until then exclusively a matter of philosophical debate. For example, we can delve into the dreamer brain, decoding the content of dreams in real time, establishing concisely that dreams occur in real time and are not just figments of memory of the awakened mind. Or, from a more medical perspective, it has become possible to decipher the thoughts of patients in a vegetative state, asking if they may have residues or preserved forms of consciousness which might not be expressed overtly. Human thought has never been so transparent.

But all this technology is of course useless for investigating one of the most mysterious aspects of human thought: how it came to be what it is. How and in what ways did our ancestors think? We know that their brains were almost identical to ours. But were they conscious in the same way that we are today?

There are different intuitions about this long-standing philosophical question. On the one hand, it is natural to think that the deepest aspects of human thought – our ability to be conscious, to form memories, to imagine or to dream – have always been the same. Another possibility is that the social transformations that have so radically shaped our culture may even have forged these structural columns of our thoughts. Even with the capacity to use all our technological paraphernalia to investigate brain function, is this question even amenable to science?

The solution to this conundrum lies in the traces that our ancestors have left, not only of what they did – of how they lived or fought – but also

of how they thought. In the same way that we can reconstruct how the cities of ancient Greece would have looked, based on the evidence of a few blocks of stone, the writings of a culture provide a kind of archaeological record, representing the fossils of human thought. Indeed, in the 1970s, performing a kind of psychological analysis of some of the most ancient books of human culture, the American academic Julian Jaynes came up with a wild and radical hypothesis, namely that, at about 3000 BC, the world was a "garden of schizophrenics".

Jaynes conducted an exhaustive reading of human writings in the Axial Age – that period between approximately 800 and 200 BC which marked a radical transformation in Chinese, Indian and Western civilisations. It was during this period that the religions and philosophies that form many of the pillars of modern culture were produced. Studying these foundational texts, Jaynes argued that, during this period, human consciousness also underwent a radical transformation.

He argued that the first humans described in these books behaved – in different traditions and in different parts of the world – as if they were hearing and obeying voices that they perceived as coming from gods or muses, what today we would call hallucinations. And then, only as time went on, they began progressively to understand that they were the creators and owners of these inner voices. And with this, they acquired introspection: the ability to think about their own thoughts.

This may seem quite strange, even paradoxical at first, but as with most human abilities that we take for granted, upon reflection it becomes clear that they ought to be forged in a learning process, either through the span of life, culture, or evolution. We all produce inner voices, inner thoughts. Most of us understand that we are the authors of these inner voices. But what if, as often happens during dreams, we did not make that distinction? Chris Frith, the cognitive neuroscientist, has argued that such an inability may lie at the heart of schizophrenia. In this view, hallucinations do not result from a vast excess in fuelling mental creations so much as through an incapacity to recognise the authorship of such creations.

According to Jaynes, consciousness, prior to Homer, lived in the present and lacked introspection: what we now call primary consciousness, and which is today characteristic of schizophrenia or dreams (except for lucid ones). With the proliferation of written texts, consciousness transformed into what we now recognise – a form of consciousness in which we perceive we are the authors and protagonists of our inner thoughts and

Greek pillars and columns.

actions, and are responsible for them. A consciousness which has the richness and complexity to interweave with what we know of the past and what we predict or hope for the future.

Jaynes and others have argued that the appearance of written texts was at the heart of this psychological revolution, because it allowed thought to be consolidated on paper instead of being entrusted to the more volatile medium of memory. We should remind those who now reflect so intently on how the internet, tablets, cell phones and the unceasing flow of information can change the way we think and feel, that the Information Age is not the first material revolution to radically change the way we express ourselves, communicate and, almost certainly, think.

In summary, Jaynes' theory is that consciousness, at least in the way that we perceive it today – when we feel we are the pilots of our own existence – is a quite recent cultural development. This conjecture remains one of the most polemical, controversial and speculative in cognitive neuroscience, among other reasons because it relies on very specific examples and subjective interpretations. It was difficult, if not impossible, for Jaynes (and others at that time) to establish these claims in a quantitative and objective manner. And the reason for that is quite simple: the word introspection (or self-consciousness), that Jaynes argued appeared throughout the Axial Age, is not mentioned a single time in the books he studied.

Things would have been much easier for Jaynes' theory if Plato had woken up one day and written: "Hello, I'm Plato, as of today I have a fully introspective consciousness." But this, of course, did not happen.

The development of introspection must therefore be read "between the lines". And here is where psychology meets philology, computer science and linguistics. Doing so requires a more sophisticated mathematical entity than simply counting words: the construction of a "space of words". This is a huge, complex and high dimensional space that contains all words in such a way that the distance between any two of them is indicative of how closely related we feel they are. So one would want in this space the words "dog" and "cat" to be close together, but the words grapefruit and logarithm to be very far apart. And this has to be true for any two words in this space.

Computational linguistics has shown us that this space can be built quite easily using a simple but effective premise: when two words are related, they tend to appear in the same sentences, paragraph or page

when aggregated over a very large body of text. One can then formally define the proximity of any two given words as their likelihood of appearing together in a vast summary of all human linguistic expressions, compared to how often they would appear together simply by pure chance.

Once this space has been constructed, establishing which of two texts is closer to a given concept is not just a qualitative argument but instead a concrete, objective and quantifiable argument. And with this one can inquire about the history of any concept, including introspection, asking how it grows, fades in or out, vanishes or changes over time. A text becomes a stream of words, a stream of words becomes a trajectory in the space of meanings. And then, using simple geometry, one can ask whether this trajectory approaches any given concept.

And when this is done, after digitising the books of Ancient Greece, ordering them by time, measuring the proximity of each word of this stack of books to introspection, one finds that, as Jaynes had conjectured, these texts become closer with the passage of time to the concept of introspection. There is a slow progression for the older Homeric texts: the *Iliad* and the *Odyssey*. And then, about 600 years before Christ, throughout the development of the ancient Greek culture, it begins to ramp up very rapidly to an almost fivefold increase, with writings becoming closer and closer to introspection.

A fundamental virtue of an objective and quantitative analysis is that one can replicate the exact same results in a different case, asking whether these results are also true in a different and independent tradition. And, indeed, when this analysis is repeated for the written works of the Judeo-Christian tradition, or for a whole set of traditions throughout the Axial Age, one obtains essentially the same pattern.

With this exercise in quantitative philology, using computational tools in humanity's historic archives, scholars such as Carlos Diuk, Guillermo Cecchi, Diego Slezak and I could all test Jaynes' "soft" hypothesis: that there is a change in the narration of Homeric and biblical texts that reflects an introspective discourse. In our view, however, it is not possible to examine the "hard hypothesis", settling whether this change reflects the filter of written language, censorship, narrative trends and styles, or whether, as Jaynes conjectures, it expresses the way our ancestors thought. Resolving this dilemma requires ideas and tools that we have yet to even imagine.

Representation of an Ultimatum Game.

DIGITAL INFORMATION: A SPLASH
IN THE COGNITIVE SPACE

Martin Ingvar

T he evolution of human language was driven by the need for co-operation. In each child, language development springs from the urge to develop the individual's social footprint. Mastering language is to master a rules-based system that reflects the mind and is built on a mixture of explicit and implicit rules plus a myriad of exceptions. This is computationally a great challenge and it is a wonder that the slow machinery in the brain can handle language in real time. Speaking the same language contributes substantially to the capacity for social co-operation and thereby to the contextually bound social capital. As our social context is moved to the virtual level, local social negotiations decrease in importance. We therefore run the risk that the socialisation process, the process that shapes the responsible, predictable and co-operating adult, will contain far less friction than hitherto and therefore not prepare the individual for adult life.

Our individual social footprint is based on communication where language is the key. Our rules for social interaction are nature's own illustration of game theory, ie the modelling of conflict and co-operation between intelligent, seemingly rational decision-makers. Social interaction is a complex dynamic process with multiple factors that influence the quality and quantity of the phenomenon. The thesis that there is a unitary rationality based on self-interest underlying social interaction is flawed: several experimental studies have shown deviation from such rationality, expressed in a preference for long-term stability and trust over maximal immediate reward. This lack of single-dimension egotism has been demonstrated in the Ultimatum Game. In that game, a bidder is given a fixed one-off amount of money and instructed to share a portion of it, the sum to be determined by the bidder, with the other player. If the bidder's offer is rejected, neither the bidder nor the other player gets to keep what is proposed, but if the bid is accepted both keep their respective cut. If the proposed split is 50:50, the rejection rate from the second player is

generally 0 per cent, whereas the rejection rate tends to increase when the bid-fraction dips below 30 per cent. It should be noted that to reject a bid is costly for the second player, and since the game is a one-off game only, the short and long-term rational response is to always accept the offer – €2 is after all always more than €0, even if the bidder does go away with €98. Thus, there seems to be a general willingness to punish others at one's own expense in order to maintain and develop stable social norms on reciprocity.

Many psychological experiments have demonstrated the confabulatory tendency in seeking to explain one's own irrational behaviour as rational. We demonstrated that it was possible to pharmacologically manipulate and increase the acceptance rate to unfair offers in spite of the fact that the description of the rating of the experienced unfairness was the same. Thus, the immediate "fast" reaction (delineated under System 1 in Daniel Kahneman's *Thinking, Fast and Slow*) seems in this case isolated from the slow thinking (under Kahneman's System 2) that language tends to reflect. The rapid rejection response arguably reflects the evolutionary value in upholding norms of reciprocity in the social context, especially when resources are scarce.

This "hierarchy of needs" – as defined by the American psychologist Abraham Maslow –reflects the cognitive organisation of the brain in the order of its evolution. Immediate responses to strong and emotionally anchored stimuli stem from the phylogenetically older regions (the limbic system), whereas language and other higher order functions are more related to the upper levels in the hierarchy. When there is a threat to "basic needs" (including a threat to social norms), corrections are prioritised above and beyond all others. Studies have clearly demonstrated that social stability and the upholding of norms for social interaction also belong to the area of basic needs as they were anchored in phylogenetically ancient brain systems that maintain essential survival mechanisms. Thus, reciprocity as a basis for survival is anchored not only in higher order moral concepts, but also in early evolutionary mechanisms, with representation apparent in the older anatomical regions of the brain. This conclusion predicts that the upholding of norms on reciprocity can be found also in social co-operating animals.

The Ultimatum Game yields similar results across the world, including in pre-literate cultures. In such cultures, all norms are upheld locally and are of core importance for the survival of the group. Several of these

described norms, for example sharing, are very similar between different cultures almost to the point of being universals. In his book, *The Blank Slate*, Steven Pinker effectively argued that innate mechanisms lay behind such universals and hypothesised that human behaviour is substantially shaped by evolutionary psychological adaptations. The alternative concept of the newborn baby's mind as a "blank slate" would pose too great a risk for survival, implying that the principles for human interaction would have to be worked out for each relation. Language is part of the transfer of knowledge and behaviour within social groups and also across generational boundaries, as Pinker posited in *The Language Instinct*. It also shows structural similarities right across the world. Pinker argues that language acquisition can almost be equated with an instinct, driven by an individual's ability to control and understand his or her immediate environment. A further argument is that children spontaneously invent a consistent speech even if they grow up among a mixed-culture population speaking an informal mix of languages with no consistent rules. These signs suggest that, rather than being a cultural invention, language is an innate human ability. Pinker thereby supports Noam Chomsky's concept of a universal grammar, a meta-grammar into which all human languages fit. A universal grammar is instantiated in specific structures in the human brain that recognise the general rules of other people's speech, such as whether the local language places adjectives before or after nouns, and begin a specialised and very rapid learning process not explicable as reasoning from first principles or pure logic. This learning machinery is most effective during a specific critical period of childhood and later loses its capacity. The brain's social systems drive this development, and when the social drive is low – as it is for instance among individuals with an autism spectrum disorder – a marked slowing of language development is often observed. An important conclusion is that language and human interaction are intertwined and have a powerful role in shaping an individual's social circumstances. The decreased plasticity that comes with age that is observed in the language system is true also for other brain systems including the social norm system.

The quantum leap of the Gutenberg printing revolution generated a huge increase in the language-based spread of cultural patterns. The pattern of communication was maintained in that only a fraction of society produced the material for the masses. General knowledge was made accessible by means of books, and the development of cultural values was

AI robot.

firmly established by that technological development. Technology has evolved, and half a millennium after Gutenberg the structure of information availability has changed radically. The last 30 years have empowered everybody to both publish and access information about everything. Nowadays, with ubiquitous computing power and much of the global population being online, more or less continuously, what had been a scarcity of information has turned into an overflow of information. This overflow is having a radical impact on our social and cultural patterns as well as posing challenges to our cognition and health. The important effects of the change in the availability of information about everything on individuals and on their cultural patterns are ever more apparent.

The stability of cultures, including social patterns for co-operation, is in the midst of an upheaval as a result of the extension of the social footprint of each individual. The need to nurture one's immediate surroundings by acting as a socially polished agent becomes less important as the self-reported narrative only has to *resemble* the truth in order to make new social connections. A decade after the introduction of mass tools for the extension of an individual's social reach, the first trans-generational effects are emerging. Pinker's argument that peer-to-peer influence outweighs parental influence in the shaping of the individual has been amplified in the era of social media. Parental influence is in decline, in spite of the fact that children are leaving home at a later age than they once did.

The social arena has changed. Howard Rheingold's seminal book of 2007 on the social impact of modern technology – *Smart Mobs: the next social revolution* – predicted the social effects of breaking up hierarchical information structures within a generation. He defined a "smart mob" as a group whose coordination and communication abilities have been empowered by digital communication technologies. Smart mobs are particularly known for their ability to mobilise quickly and without the use of pre-internet democratic structures. Essentially such mobs could be described as democracy on steroids and be perceived as high impact destabilisers of established hierarchical models for power distribution.

Nearly all of the predictions in Rheingold's book have materialised, which is remarkable as they were essentially made before the impact of Facebook, Twitter and Instagram was evident and the only mass-market technologies that existed were internet web pages and SMS text messaging. With the advent of ubiquitous computing and multi-peer chatrooms,

the local social realm has lost its boundaries and thereby also important social control mechanisms.

<p style="text-align:center">★</p>

How do you build a reputation in order to become a successful individual when social interaction has moved online? It is virtually impossible to verify any statement or effectively retaliate against the breaking of norms when, at worst, such transgression leads to the blocking of communication channels with an individual? The ability to shape the norms for co-operation is rather limited for an individual. The online use of very strong language, that would be unacceptable in other contexts, involving racism, sexually explicit language, brutal accusations and blatant lies, is a direct effect of the absence of immediate reciprocity across the web. Growing up in and being exposed to such a social landscape will clearly affect the next generation.

An important concept that Rheingold introduced was the ability to co-operate over long distances and without any social connection beyond what the internet enables. This makes the mob less stable when it is evolving and also renders it prone to manipulation as negotiation for reciprocity is diminished. Hence, such mobs are expected to be short-lived and will often fade quickly away.

Trust is the hard currency in any social relation and it is built on sameness, reputation and experience, as Francis Fukuyama suggested in *Trust: the social virtues and the creation of prosperity*. Any evolving social relation is based on continuous evaluation of the trust at the heart of it. Moving from local to remote relation-building makes this evaluation far more difficult. In spite of this, explicit negotiations in combination with third parties that guarantee the identity of the negotiators mean that large-scale social and economic interactions between individuals who didn't know each other previously continue to develop. People share their houses and cars with complete strangers purely on the reputation of the internet-persona they have met online and whom they know only from that stranger's self-presentation. This is in line with Robert Putnam's concept of how to build and maintain social capital, as outlined in his book, *Bowling Alone: the collapse and revival of American community*. Putnam's concept has three components: moral obligations and norms, social values (especially trust) and social networks (especially voluntary associations). The sharing

economy seems to follow suit, with the introduction of explicit rules for obligations, communicated values and recommended behaviours – and concluding with the results of each transaction being communicated in the form of a two-way review. Thus, even reputation-building is made explicit in the digital arena.

Putnam's central (pre-internet) thesis is that if a region has a well-functioning economic system and a high level of political integration, these are the result of that region's successful accumulation of social capital. As social networks move to the internet, the dimension of locality diminishes in importance and it becomes difficult to tie social capital to any one place. As local reputation-building becomes less important, altruistic activities such as caring for the local community or participating voluntarily in local democracy are at risk of receiving less interest.

<div align="center">★</div>

Much has happened since Rheingold's book was published in 2007. The effects of the broken information monopolies have eroded institutions, radically changed professions and influenced politics. The president of the most powerful nation in the world seeks daily social approval via Twitter. With dominant parts of the population being online constantly, social patterns for learning and knowledge-finding have changed. The world is now available at the touch of a finger. The health effects of constant availability and self-propelled demand for split attention have started to take their toll. It is now possible for an individual to display their entire social persona to the world around the clock, while the separation of work time from private life is no longer possible for many. This taxes several cognitive processes simultaneously. The most vulnerable cognitive functions are the first to suffer. It has become a disease with many names and with common symptoms. Practically all cognitive functions are affected.

First and foremost in the line of fire is the ability to focus – and to maintain that focus and concentration over time. A simple thought that leads to a conclusion and insight takes a matter of several minutes, especially if it also includes information gathering by reading. Constant interruptions lower cognitive efficacy quite markedly. This in turn affects learning, specifically the consolidation of factual and procedural memories. Our brain is comparable to our social world – a complex dynamic

system in constant change, based on its interaction with the environment. Today, most people do not allow themselves to be "undisturbed by themselves" and a substantial fraction of the population is clearly feeling the health effects of this. The short-term reward mechanisms provided by the social mechanisms in the brain challenge the focus and endurance ("grit" or "resilience") needed to conquer the unknown. The decline of academic performance in schools in the industrial world can most probably be attributed, at least partly, to this emerging phenomenon.

Everybody has experienced the effects of too much information and many realise that the rationing of social media or mobile phone use would increase focus and productivity, yet most tend not to do so. The key explanation is the manipulation of relevance that is built into the information. Tabloid newspapers have used this method for years. Choosing to use a word like "fuming" instead of "angry", or "dying" instead of "ill", is designed to grab attention and increase the likelihood that the content of the publication will be consumed. We are just as likely to look for the good stuff, because it is cute, as we are to look for the gory stuff in order to experience the relief of not being affected by it. Both yield the hard currency of reward – dopamine and endorphins. Social media has an extra advantage in terms of grabbing our attention because, as a result of evolutionary mechanisms, we find it unbearable to be excluded from a social community and will do practically anything to be part of the in-group. Conversely, participation in social communities drives the reward system. In that sense social media suffocate an important evolutionary system for the building of stable social connections by smothering it with pro-forma shadow connections with shallow reach.

★

The ability of software to communicate based on the ability to collect and classify knowledge, learn from it and recode itself, is growing quickly and challenges the idea that the human mind contains the most advanced intelligence on our planet. Threatening that pecking order today are chatbots which use language and reasoning in ways that make them indistinguishable from human beings. Another invention that challenges our trust is "deepfake" technology, so far confined mostly to movies, by which an apparently "real" actor is merely a composite fake. The scary thing here is that certain media which could previously be seen as broadly

Mutual *peer-to-peer* idea exchange.

speaking trustworthy may nowadays be completely false, thereby insert-
ing distrust into yet another channel of communication.

Adaptive computing, with endless processing power, will be able to
track the communication habits and preferences of any individual. When
logging on to Facebook, for instance, a user's entire digital profile – all
behaviours, preferences, patterns of search and contacts – is instantly
identified. The profiling is extended if a mobile phone number is supplied,
giving away travel patterns, social connections, social and commercial
habits. The adaptive profiling of individuals is made possible only by the
value that an individual perceives it to have, and the hard currency that is
negotiated is the enlargement of the individual's social footprint. The
same mechanism is hidden in Gmail, Twitter, Instagram, Tumblr and
LinkedIn, to name just a few. Make no mistake, information leaks
between these applications as well. Most mass-market technological
advances that have spread rapidly are more or less based on this offer of a
larger social footprint – be it the telephone, the fax machine, SMS,
WhatsApp or social media in general. The mass application of standard
deep (machine) learning on social data makes it possible that, in the very
near future, individually assigned "omnibots" will be constructed with
the capacity to serve every individual for the "small" cost of leaving all
information about yourself – including all those personal quirks and
deviances – to transnational data-collecting giants.

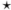

Four trends arising from the revolution in global society's information
structures will affect the social and cognitive systems in our brains. All
derive from the change of social structures around an individual as tech-
nology has evolved. The drivers for these developments are generally
based on the evolutionary mechanisms that advance social interaction.
The four trends are:

1. A decrease of local social capital in favour of boundless peer-to-
 peer networking in social media.
2. Stress from the difficulties of determining reciprocity in social
 connections. Stress-related disease and behavioural influence from
 the sheer overload of information.
3. Very different adaptive formation of the social mechanisms in the

brain in the next generation as training in reciprocity will take place in circumstances where the ability to form lasting social norms based on reciprocity will be less evident than before.

4. The now emerging AI-based adaptive tools will flood our brains with even more information. Such tools will learn all about the individual and have an almost endless power to manipulate on a grand scale.

We need a clearer characterisation of these phenomena in order to understand the societal rules around them. Otherwise, the dystopic tendencies that have been touched upon in this chapter may self-amplify.

KNOWING YOUR ENEMY

Prisoners of war from the Chinese Communist
and North Korean armies in Korea, 1951.

READING THE RUSSIAN MINDSET

Michael Goodman

T
he Joint Intelligence Committee (JIC) is one of the longest-serving Whitehall committees. Its origins can be traced back to a decision in 1936 to remedy the lack of co-ordination within the secret world. Sitting at the top of the intelligence pyramid, the JIC comprises the heads of the main intelligence agencies and the leading civil servants in the policymaking departments, including the Foreign Office, Ministry of Defence, and Home Office. It looks down upon a multibillion-pound intelligence community, setting requirements and assessing performance, and looks upwards towards policymakers, producing an array of intelligence assessments. It is defined by its deliberate mixture of intelligence and policymaking officials, and the fact that consensus lies at the heart of everything it does.

In this brief paper I would like to look at the British experience in producing intelligence assessments of the Russian leadership during the Cold War. In particular it will focus on the difficulties in trying to produce assessments when intelligence is limited and where the analytical paradigm is that those in the Kremlin are irrational actors, yet to provide an assessment on future intentions it is necessary to assume a certain level of rationality. The paper will also focus on the balance between assessing intentions and capabilities in producing forecasts of Russian behaviour. To illustrate the difficulties faced in preparing these assessments and in gauging their accuracy, the paper will use a number of case-studies spread throughout the Cold War. It will conclude with an examination on the lessons that emerge from Britain's Cold War experience in attempting to read the Russian mindset.

Since its creation the JIC has been a body principally designed to assess strategic intelligence. During the Cold War its major preoccupation was to identify trends in Soviet behaviour (intentions) and monitor their advances in research, development and deployment of weapons (capabilities).

One of the problems in arriving relatively late at a consensus that the Soviet Union was now priority number one, was that the intelligence coverage of Russia was seriously limited. This was an issue that the JIC frequently addressed in the late 1940s and early 1950s. One result was a study produced in December 1951, in which the JIC reviewed its assessments of Communist intentions that it had made since January 1947. In the period 1947–51, the study concluded that 33 different assessments had either proved to be correct, or at least not yet proven to be incorrect. In comparison only three had proved to be wrong, and for these the JIC considered what had caused the errors.

So what had gone wrong? In the example of the Korean War, the JIC had concluded that the Chinese would not "embark on operations". The reasoning behind this conclusion, supposedly based not on intelligence but rather a reading of the Communist leadership, was that the Chinese would not dare risk war with the UN. In reality, just a few weeks after the assessment was approved, the Chinese army swept into Korea and attacked the UN forces based there. How had the JIC managed to get their assessment completely wrong? Once more the 1951 review was very honest in its examination of the intelligence community's failings, and in which two factors were prevalent:

That our intelligence about Communist intentions in the Far East is even less adequate than our intelligence about the Soviet Union, largely due to the fact that we obtain less intelligence on China.

That we do not yet understand the mind of the Chinese Communist leaders.

How, the JIC wondered, could you produce a forward-looking assessment, which had to be based on some level of rationality, when you believed that the focus was essentially an irrational actor?

One event in 1968 served to highlight the JIC's warning role. The JIC had always produced assessments of Soviet intentions towards both Western and Eastern Europe. In September 1967, the JIC issued the latest revision to its regular paper on "Warning of Soviet Attack on the West". As the committee had concluded over the preceding two decades, the paper began with the unequivocal view that "the Russians will not deliberately initiate general war". This conclusion was not based on any hard and fast intelligence, but rather a reading of the "Russians' political and military posture and the disadvantages to them of taking such action". The three elements to this assessment – gauging intent, monitoring

capabilities, and reading the Russian mindset – would be central to the intelligence process in assessments of the Czechoslovak crisis the following year. Attempts to assess all three aspects, as the JIC readily conceded, were tremendously difficult, and intelligence of one could not be used to impute another.

In Czechoslovakia the first stirrings began with the economy: specifically in attempts to liberalise it from the strictures of central, Communist planning. In the spring of 1968 Alexander Dubček, the First Secretary of the Czechoslovakian Communist Party, took things further with a widespread change in the senior echelons of the party and the publication of the "Action Programme", which referred to the necessity of reforming the entire political system in Czechoslovakia. For the leaders of the Soviet bloc, this was a step too far. Beginning in late March, the leaders of East Germany, Bulgaria, Hungary, Poland and the USSR held a series of meetings to discuss Dubček and to pressurise the Soviet leader Leonid Brezhnev into doing something to bring him under control. The four satellite states urged the Soviet Union to intervene to halt the Czech liberalisation.

Initially this pressure was to be felt in a series of Warsaw Pact military exercises, culminating in a large command-post exercise on Czech territory in late June 1968. Prior to the start of deployments there had been no Soviet troops based on Czech soil. By its culmination the military manoeuvres were to result in the arrival of over 25,000 troops. Most, but by no means all, of the Warsaw Pact forces withdrew from Czech territory by July 19, with the final divisions leaving on August 3. These moves were complemented by a widespread KGB disinformation campaign.

Monitoring the political and military developments, the JIC concluded that "while the possibility of Soviet military intervention cannot be altogether excluded, we consider it unlikely". In the absence of direct intelligence, the JIC could only apply its logic to the situation: in hindsight it would be a classic case of applying transferred judgement and mirror imaging.

While Brezhnev had the means to crush the Czech counter-revolution, there was no intelligence to suggest one way or the other whether he would do so. The JIC's conclusion, which was mirrored by the Foreign & Commonwealth Office (itself newly formed in 1968), was that a military response was a less viable option, on the grounds that it would generate a negative reaction worldwide. What the JIC did not consider in its

Next pages: Mikhail Gorbachev and Ronald Reagan at the White House in December 1987 after signing the Russian-American INF Treaty.

assessment was whether Brezhnev would be forced to choose this option and disregard the possible worldwide reaction if reasserting control was deemed more important.

In late July, Dubček was given one final chance to stop the "counter-revolution". Meanwhile, new Warsaw Pact exercises began. The troops that had taken part in the exercises of the previous month in Czechoslovakia had been withdrawn, though they remained stationed on the periphery of the Czech border. Joining them were a number of additional troops; the result was a vast array of military force concentrated around Czechoslovakia. For the JIC the military exercises were part of the continuing war of nerves, a means of exerting psychological pressure on Dubček.

The final decision to invade was taken by the Politburo on August 17, 1968. The following day preparations were made to start the attack. The timing was significant: it was a Sunday, when Soviet military activity was normally light; in addition, August 18 was Soviet Air Force Day, traditionally a holiday within the air force. The invasion itself began at 2030 local time on August 20, 1968. Within a few hours a quarter of a million Soviet bloc troops crossed the border and marched into Czechoslovakia. The Czech army, whose leadership had been changed by Dubček months earlier, offered no resistance. Dubček was arrested and, together with a number of other leaders, transported to Moscow. Within 24 hours the Soviet Union had achieved the total military occupation of Czechoslovakia and, within no time, the liberal changes wrought by Dubček were slowly but surely reversed, and Czechoslovakia returned to its former position as a faithful ally of the Soviet Union.

Immediately afterwards the JIC conducted a post-mortem into what had gone wrong. The JIC found it tremendously difficult to grasp the perspective of those in the Kremlin, judging that the likely public response would be too damaging to allow that an invasion might be a realistic prospect. This, together with the assessment that Brezhnev's overall outlook prioritised détente with the West, led to a belief that a military option would be unlikely. Thus the JIC underestimated the lengths to which the Soviet Union would go to maintain its control of the Communist bloc in Eastern Europe.

A separate study by the Ministry of Defence concluded that if evidence of military capabilities had been considered in isolation, then the novel and unusual nature would have suggested that this was more than just a

troop exercise, but this view was tempered by a judgement of the political intentions. It would be interesting to compare this episode, for instance, with the more recent mistakes in the run-up to the Russian annexation of the Crimea.

Failures like this led, in 1980, to the secondment of Douglas Nicoll, a veteran of the British intelligence community, to produce a series of case-studies involving foreign acts of aggression, and to assess how well the intelligence community had done in predicting and monitoring the progress of events. Surveying seven detailed case-studies, Nicoll identified the central role of the JIC in both intelligence and wider governmental responsibilities, commenting that "the provision of warning of possible aggressive action by the USSR against the West must be the highest priority requirement laid upon the JIC."

The major importance of Nicoll's study was his examination and depiction of the various traps awaiting analysts – of which they needed to be constantly aware. In doing so he highlighted six different pitfalls which could lead to errors of assessment or judgement, and which are just as important now as they were in the early 1980s:

- Mirror-Imaging – the view that your adversary would act in the same way as the UK would if faced by exactly the same scenario.
- Transferred Judgement – the assumption that a foreign aggressor would make the same calculation of the military balance, and therefore of their chances of victory, as the UK would in the same position.
- Perseveration – the likelihood that assessments made in the first stages of an event will affect subsequent judgements, even when evidence to the contrary is discovered.
- War as a Deliberate Act – countries do not simply slide into war, at some stage a conscious decision is taken to initiate hostilities.
- Coverage – assessments are difficult to produce in areas where the intelligence priority is low.
- Deception – the adversary will be doing everything possible to sow seeds of doubt and confuse you.

The Nicoll Report was discussed by the JIC at its meeting on March 4, 1982, declaring itself "alert to the lessons to be learnt". Within a few weeks a copy of the report had been sent and received by the prime minister, Margaret Thatcher. The timing was critical: just a few days later the

Argentine military junta authorised the invasion of the Falkland Islands. The subsequent review by Lord Franks as to what had gone wrong led to considerable criticism of the JIC for its failure to warn of possible Argentinean intentions. One of the impacts of the Falklands War was to lead the JIC to create a new Deputy Chief of the Assessments Staff role focused on early warning. That person would prove to be instrumental the following year in spotting that the Russians had over-reacted to a Nato exercise – Able Archer.

The main topic concerning the JIC throughout the late 1980s was the Russian leader Mikhail Gorbachev and his reforms. Towards the end of the period, change in Eastern Europe and the Soviet Union had reached bewildering proportions. Much of the analysis in 1989, for example, was on whether *perestroika* (his restructuring reform programme), and indeed Gorbachev, would survive. The judgement on Eastern Europe was that although there was a long way to go before stable democratic systems were in place, most countries were firmly on a reforming path. And all of a sudden the Cold War ended.

In this last point, I'd like to consider what lessons emerge from the JIC's warning function, arguably its most important one. To predict any event, several key questions need to be addressed: what, when, why, where, and how. As a predominantly strategy-focused body, the JIC faced an unenviable task: analysts had to issue a strategic warning far enough in advance of the feared event for officials to have the opportunity to take preventive action, while also imbuing the warning with enough credibility in order to motivate them to do so. Perhaps even more difficult is to provide a detailed, tactical warning, not least given the limitations of intelligence.

The JIC had to be satisfied by three factors to conclude that a country was preparing for an act of aggression:

That the country would have the political will to undertake such action.

That military action would achieve a desired political end.

That specific military preparations to that end have begun.

But high-level, reliable intelligence in these areas was almost always lacking, so analysis and interpretation became vital.

Consideration must also be given to the JIC itself in assessing its performance. One underlying issue is that of consensus: the JIC system is predicated on producing a unified, agreed report, yet it is not always possible to reach consensus. This can lead to a report with the lowest common denominator, often offering the blandest, most vague assessment; another

outcome is that a paper might be issued in the JIC's name but without the unanimous agreement of the committee members. Related to this – and something that Lord Butler commented upon in his report on Iraqi "weapons of mass destruction" – is the tone of the assessments themselves. The majority of the JIC's Cold War strategic assessments are so equivocal in content and tone that any number of events would have been possible within their parameters; very rarely are explicit statements or points of view expressed.

I don't have any prophetic words to end on, so let me finish with a quote from one of the Foreign Office's research analysts, who worked there for most of the first half of the 20th century: "Year after year the worriers and fretters would come to me with awful predictions of the outbreak of war. I denied it each time. I was only wrong twice. It's just a shame that those two errors were in 1914 and 1939."

An ice sculpture spelling out the word "truth" by the artist duo Ligorano Reese, with the US Capitol in the background, in Washington, DC.

DISINFORMATION IN THE INFORMATION AGE

Gill Bennett

Disinformation is a term currently in common use in the media and in academic and political discourse, along with related concepts like "fake news". It almost always carries a negative connotation (particularly, in the West, in relation to Russian activities). There are a number of investigations going on in various countries into alleged disinformation campaigns and their impact, and the term is often used as a shorthand for ideas we do not like or think are dangerous. Methods of disseminating disinformation can range from feeding stories to journalists, using state-controlled media, setting up fake websites and social media accounts, using automated bot accounts, or making prank phone calls.

But what does disinformation really mean? How does it differ, if at all, from misinformation, propaganda, deception, fake news, or just plain lies? Is it always a bad thing, or can it be a useful and indeed necessary tool of statecraft? And if we are targeted by disinformation, what can we do about it? There are no easy or straightforward answers to these questions, but tackling them is a useful way of learning to navigate the stormy waters of the oceans of information disseminated constantly, globally and at lightning speed in the 21st century.

Dictionary definitions generally agree that, at root, disinformation is false information disseminated intentionally to deceive; it may seem truthful, relevant and based on objective fact, but it is designed to mislead the recipient in order to obtain advantage, whether electoral, military, monetary or political. Misinformation might sound like the wrong information put out by mistake, but disinformation sounds bad, untruthful, malign, a deliberate strategy of deceit. Is it really that simple? Every day, stories are put out, either intentionally or because of incomplete information, that are false, but judging them on the basis of a simple description seems a risky strategy. It involves a possibly premature value judgement of the intent of the individual, organisation or state propagating the information.

Defining propaganda can be tricky, too. It may be perceived as material intended to promote a point of view or to persuade, a little exaggerated maybe, but essentially truthful, and therefore seen as benign or at least harmless. Alternatively, it may be regarded as an attempt by a political party or interest group to try to win people over to its viewpoint, persuasive possibly, but also clearly recognisable for what it is. In the late 1940s, the British Foreign Office created a whole department, the Information Research Department (IRD), in order to combat Communist propaganda from the Eastern bloc; both sides' activities were semi-clandestine, in order that the recipients of its product could not necessarily distinguish its official origin. Yet the difference between propaganda and disinformation is not easily pinned down. A brief put out by the National Endowment for Democracy states that some define propaganda as "the use of non-rational arguments to either advance or undermine a political ideal", while disinformation is a word for undermining such propaganda. Cynthia Grabo, the former CIA analyst, says that propaganda can be either true or false, or somewhere in between: if the information being disseminated is true, it counts as public diplomacy; if false, it is disinformation. These distinctions plunge us into very deep water indeed: truth and falsehood can be subjective concepts in the age of social media and the 24-hour news cycle. Both the Russian and US governments, for example, in the business of setting their own narrative, talk a lot about fake news and its use by the "elite" media: as the Sigrid Rausing Trust puts it, "First you make fake news, then you establish the concept, then you accuse the media of creating it." Distinguishing between propaganda, fake news and disinformation is clearly not straightforward.

As for deception, although by definition it would seem to differ little from fake news or lies, when the term is used in a military context its connotation is sometimes positive, even celebratory. One of the most famous successful deception operations of the Second World War was Operation Fortitude, intended to make Hitler and his generals believe that the Allied invasion in June 1944 would land in the Pas de Calais rather than Normandy. A more recent example, with the same objective, was Operation Desert Deception, executed in the run-up to the First Gulf War in 1991 following the Iraqi invasion of Kuwait, to convince the Iraqis that the main Coalition attack would come through the Kuwaiti-Iraqi western border rather than through the desert to attack from the rear. Both operations were elaborate, involving subterfuge, media

manipulation and decoy tactics – lies, in fact. It is very difficult to see how this differs from disinformation, even if it was disseminated by the "good", rather than the "bad" guys. And as soon as we accept that disinformation can be used for good purposes, we stray even farther into the realm of subjective judgement, as illustrated by the recent episode in May 2018 when a Russian dissident journalist, Arkady Babchenko, faked his own death with the connivance of the Ukrainian authorities.

There is a tendency for those commenting on these issues to slip into hyperbole, talking about an unprecedented threat to democracy, as if the use of disinformation were something new (some even insist it originated in Soviet Russia, with the tactic of *dezinformatsiya* adopted in the 1950s). Yet there is nothing new about disinformation: governments, organisations and individuals have always employed it, even if they did not call it by that name. Indeed, as we have seen, it has sometimes been regarded, particularly in wartime, as a perfectly legitimate tool of policy. Examples of disinformation can be found throughout history, in the Roman Empire, in religiously-motivated information battles in the 16th and 17th centuries, in the development of news and popular literature in the 19th century, in both Bolshevik and anti-Bolshevik activities in the interwar period, and in contemporary right-wing populist movements, as well as in more recent cases such as Russian stories put out during the Ukraine conflict.

In fact, disinformation is an ancient concept. Professor Neville Morley of the University of Exeter argued, in his evidence to the UK's parliamentary Culture, Media and Sport Select Committee investigating fake news, that the underlying issues can be traced back to ancient Greece. Thucydides, he said, identified the "deliberate manipulation of information in order to influence decision-making, but also the distorting effects of political polarisation on cultures of truth and democratic discourse, and the cognitive biases of the mass of citizens"; a pretty good description of disinformation and the reasons it causes concern in the 21st century. Plato took a rather different approach. In *The Republic*, Socrates makes the argument that the "noble lie" could be used by rulers (the good guys, he meant) in order to secure the stability of the state and the wellbeing of its citizens: "Is it not useful against enemies, and a good remedy to divert so-called friends from any evil intention they may form in madness or folly?" If, he says, the rulers "make the falsehood as near the truth as possible, is our action not useful?" Can this be classed as disinformation? It certainly seems like it.

There are two points about Plato's thesis that are very relevant to disinformation in the information age. One is that the justification for using the noble lie is that it assumes the person employing it knows "what is best" for the people to whom the lie is being told. While there are clearly dangers in this – that it is fine for those who "know best" to spread disinformation for the benefit of those less knowledgeable – this line of argument is worth pursuing, since it underlines the importance of trying to identify the intent of the source of the disinformation. For example, when looking at alleged Russian disinformation activities, it is vital to try and see how things look from Moscow, to understand the motivation without necessarily accepting the premise. The same applies to any perceived disinformation activities, whatever their source.

The other relevant point about Plato is that the reason why he considered that the noble lie should be used was because contemporary Athenian society was in the process of a social revolution. With the rise of democracy and individualism causing a severe strain on society, the old constraints of religion and magic weakening, people felt the dislocation of life in a more open society, pressure to think for themselves, to be rational and accept responsibilities, to live and cooperate with different kinds of people. In particular, this dislocation arose from the development of faster sea communications and international trade, leading to increased immigration, an influx of new people and new ideas, competition for scarce resources and with other trading nations. The Athenian oligarchs felt their authority and the foundations of their society threatened by these developments. In other words, Plato, born in the 5th century BC, argued that disinformation became necessary because of a loss of social cohesion, a breakdown in the old patterns of trust and deference, and a more international world. It is an argument strikingly analogous to those made about use of disinformation in the age of the internet, social media and the 24-hour media cycle.

Another example of the historical use of disinformation illustrates the complexities of getting to grips with it. This one is rather more modern, though still nearly a century old: the Zinoviev Letter of 1924. It was a letter ostensibly written by Grigori Zinoviev, head of the Executive Committee of the Comintern, the Bolshevik propaganda organisation, to the Communist Party of Great Britain, in September 1924 (at the tail end of the first ever Labour government in Britain), exhorting them to greater revolutionary effort. The text of the letter was leaked, published in the

Russian Communist leader Grigory Zinoviev
speaking to a Moscow gathering, 1921.

Daily Mail, and used to discredit the Labour Party during the campaign leading up to a general election in October 1924. The letter was almost certainly forged, though it is not certain who forged it. The British security services were implicated, possibly in the forgery but more likely in the leakage and political manipulation; other possible candidates include both Bolsheviks and White Russians, Polish and German intelligence and the British Conservative Party. Even if the letter had been genuine, it was used as part of a disinformation campaign, to influence the British electorate against the Labour Party (and the letter has been brought up in the course of British election campaigns ever since).

The Zinoviev Letter was a classic piece of disinformation; by whom, targeted against whom and at whose expense is by no means certain, but it was used for political purposes, by a number of different interest groups. One aspect of the affair brings us back to the present day, and illustrates the dangers of disinformation. In October 1924, the British Foreign Office drafted a letter of protest to the Soviet government, in response to what the Labour government called an unwarranted act of provocation and interference in the British political process. The evidence (including Russian evidence) suggests that when the protest arrived in Moscow, the Politburo initially had not the slightest idea what the British were talking about (one of the reasons to believe the letter is a forgery). But the Soviet leaders decided very quickly what the proper course of action should be: first, to deny everything; secondly, to suggest that the British themselves must be responsible for the forgery. This response to disinformation is a classic response, today as well as in 1924. Denial of guilt and an attempt to deflect blame back on the accuser is no guarantee of truth or falsehood in any disinformation campaign. Historically, it is a recognised tactic that, apart from anything else, is intended to convince the domestic audience of what a state wishes its people to believe. Obviously this is easier to bring off in an authoritarian state, where the media may be constrained, but it can be adopted anywhere.

Disinformation may be employed for well-intentioned reasons, to reassure the populace, to shore up the authority of the state or to strengthen it against what is perceived to be an external threat: disinformation as a tool of policy. The danger is that this can mask both truth and falsehood, undermining public trust in authority and encouraging the idea that truth is a subjective concept – whatever those in power say it is – leading to a situation of "post-truth". In turn, this can alienate ordinary citizens from

the political system and encourage the development of intolerance and extreme views. It can also exert pressure on decision-makers, with potential for premature or unwise courses of action. Ted Sorensen, special counsel to President JF Kennedy, later argued that if during the Cuban Missile Crisis of 1962 Kennedy and his team had been subject to the kind of media pressure exerted today, they would never have been able to keep confidential for a week the presence of Soviet missiles in Cuba. That would have made it more likely that the response favoured initially by the US military – an air-strike followed by invasion – would have been selected, possibly leading to a nuclear war.

In the information age, the speed and ubiquity of communications, social media, combined with international and political instability, together with a range of other factors including climate change, the proliferation of nuclear weapons and religious intolerance, all combine to create an environment in which disinformation can flourish and be embraced by a range of actors as a tool of policy. How, then, should we deal with it? There is no point in throwing up our hands in outrage and pretending that only the bad guys use disinformation. It is, in one sense, part of strategic communications, a pervasive part of contemporary statecraft. But we need to be able to detect it when it is used against us, and have some strategies for handling its impact. We should be educating people to recognise disinformation, even if they are unable to discern the "real truth". Recently the BBC has developed a new game, iReporter, in which young teenagers take on the role of a journalist and are challenged to make decisions on which sources, claims, pictures and social media comments should be trusted, while Facebook is hosting a game, devised by Nato's Strategic Communications Centre of Excellence, to teach people how to spot disinformation. These are positive developments, as well as indicating the level of concern prevalent in official and commercial circles. But what tools are available to those people already involved in policy making, foreign affairs, or external communications?

One way of looking at this is to consider disinformation in the same way that we consider intelligence (whether from secret or open sources). Like intelligence, disinformation is only ever a small part of the overall picture on which decision-making is based, and it is only significant if detected and made use of in the wider context of policy. We know, for example, that disinformation, or at the least ambiguity about information, can be a tool in a state's strategic toolbox: witness the Russian

hybrid attack on Estonia in 2007, and disinformation campaigns during the annexation of South Ossetia in 2008 and Crimea in 2014. Or to take a different kind of example: the US Department of Defense disseminated stories about UFO sightings in the 1980s, to conceal the trials of high-tech weapons whose existence they did not want to reveal. Some of these uses of disinformation are examples of "deflection" or "perception management", when governments or organisations disseminate information that will attract attention and distract from what is actually happening. Sometimes this can be from apparently benign motives, for example to reassure the public or prevent unnecessary panic, or to prepare them for unpleasant news. Alternatively, the motive might be to project uncertainty, either to warn against a potential threat or conceal its nature.

If we are going to think of disinformation as a tool in the strategic toolbox, the first thing is to recognise it as such. This means treating disinformation the same way as intelligence: interrogating sources, avoiding mirror imaging and confirmation bias, and trying to look at the situation from the point of view of the source of the disinformation. It means separating capability from intent: just because a particular state or organisation has the capability to use disinformation to interfere in, or affect outcomes in another state, does not mean that they did so. (And even if it can be proved that they did, measuring impact is extremely difficult.) Nevertheless, to take a military approach to the problem, capability plus intent equals a threat, and combined with vulnerability that adds up to risk. The first element in defence against disinformation must be the acceptance of that risk. Former intelligence professional Sir David Omand, in his seminal work *Securing the State* (2010), argued that the best way for governments and their advisers to reduce risk and protect the state was to "sustain a supportive public opinion and a proper understanding of the intelligence community and its constituent parts", to develop a "modern citizen-centred approach to national security strategy". The same approach must be adopted for disinformation.

This may be a counsel of perfection, but it is vital, not just for leaders and policymakers, but for the wider public as well. In the ancient world, philosophers argued that political authority depends on citizens who think, judge and fact-check for themselves. This is absolutely true for disinformation. Defence against disinformation means understanding what might happen if information is compromised, collaborating with

others to identify the risk and working together to mitigate it. Recognition of disinformation, and accepting shared responsibility for the risks it brings, is an essential tool in the box of those seeking to protect themselves against it.

Sir Arthur Wellesley, first Duke of Wellington.

THE OTHER SIDE OF THE HILL

Simon Mayall

The Duke of Wellington famously once said: "All the business of war, indeed all the business of life, is to endeavour to find out what you don't know from what you do: that is what is called 'guessing what's on the other side of the hill'." Wellington was not the sort of commander who was comfortable with simply guessing what was on "the other side of the hill", but he did understand that he might have to make life-and-death decisions, with serious political and military consequences, on incomplete knowledge. In order to reduce the gap between ignorance and certainty he invested a great deal of time, effort, and even money, in trying to turn a "guess" into something much more tangible, and therefore militarily useful. All commanders, before and since, have attempted to achieve the same. Those that succeeded in creating an information-based decision-making process have had military success, those that have neglected this vital aspect of warfare, or have been thwarted in trying to gain greater degrees of certainty, have often been defeated. On such success or failure, empires have risen or fallen.

Much of any success, in any walk of life, starts with the acquisition of knowledge, defined as "facts, information, skills, awareness and familiarity acquired through experience and, or, education". This capability to absorb facts and experience and to draw lessons from them, mark out the higher animals, most obviously man. Increased experience – for much of history dependent on the capacity of an individual or community to survive – breeds confidence and, with it, the familiarity that influences behaviour. In the military sphere we speak of war's "enduring nature", which is as a brutal, volatile, dynamic human activity, with uncertain outcomes. Given that war, a large-scale, organised phenomenon, distinctly different from simply "fighting", only takes place periodically, this knowledge of what war can be like is easily neglected, forgotten, and often lost in peacetime. The great Athenian historian, Thucydides, opined that, while fighting and conflict were endemic to the human

condition, the three primary causes of organised war between formed polities were honour, fear and self-interest, and his proposition has proved to be remarkably resilient. By the 19th century, given the historical development of empires, states and nations, the Prussian general and military theorist, Carl von Clausewitz encapsulated the harnessing of war to a higher, or more structured, purpose, in his great maxim: "War is not merely an act of policy, but a true political instrument, constituting a continuation of political activity by other means."

Western military academies also contend, however, that while the nature of war is enduring, the character of war does change, and that experience, technological advance, economic growth and societal development all lead to wars, as an extension of political activity, being fought in different ways, at different times and in different circumstances. Therefore, in this balance between the nature and character of war, British soldiers fighting in Iraq in the early 21st century would have no difficulty empathising with legionaries engaged in Rome's imperial adventures in the Euphrates River valley in the 3rd century, albeit the strategic context may have been radically changed, and the weaponry appeared alien. That said, both sets of soldiers, sweating in the desert sun, encased in helmets and breastplates, shouldering heavy packs, and conscious of daily hardship and threat would have felt that "brotherhood of arms" that transcends geography and history. They would both have applauded Robert Gates, a US Secretary of Defense, who said that military and civilian leaders alike should "look askance at notions of future conflict… where adversaries can be cowed, shocked or awed into submission, instead of being tracked down, hilltop by hilltop, house by house, block by bloody block." Or General "Vinegar Joe" Stilwell who warned: "No matter how a war starts, it ends in mud."

Roman legionary and British "Tommy" would both have relied upon their own knowledge, and that of their commanders, for tactical success in fighting, but would also have sought, and benefited from "intelligence" to prosecute the overall campaign successfully. In this context, intelligence constitutes those facts that are accurate, timely, specific, organised for a purpose, and presented in context. This is the intelligence that helps commanders know or assess, rather than guess, what is on the other side of the hill. It decreases uncertainty and permits purposeful activity, in time and space, in order to achieve battlefield advantage. Needless to say, any opposing commander worth his salt is attempting to achieve the

Painting of Sun Tzu, author of *The Art of War*.

same results, and both commanders have a strong vested interest in thwarting the other's efforts: by stopping the enemy knowing what is on your side of the hill. To this end, serious armed forces invest enormous resources in intelligence, in its widest sense and at all levels, because, when the stakes are so high, the investment is deemed to be worthwhile. This investment has grown exponentially in recent decades, as technology has offered ever newer ways of determining what is on the other side of the hill. To intelligence staff, who relied for centuries on those long-standing elements of human intelligence – knowledge, experience, traitors, collaborators and spies – we have now progressively added signals intelligence, image intelligence and electronic intelligence. The huge, exponential advances in technology clearly have made the intelligence "battle" even more complex and sophisticated. We are still trying to guess what is on the other side of the hill, we just have more tools to help us do so.

The other, commonly understood meaning of the word intelligence is that of general, cognitive problem-solving skills. To say that someone is highly intelligent is a mark of approbation and distinction, and is a quality to be found in the best leaders and commanders in all fields of human endeavour. What all leaders are consistently attempting to do is to apply intelligence, as a cognitive skill, to "intelligence" – that timely and accurate, contextualised knowledge which drives informed decision-making. As this process has become more complicated and complex, so the development of military intelligence as both a branch of the armed forces and a sophisticated military process in itself, has grown. It has become a vital, resource-intensive, military discipline that drives information collection, and then delivers considered, informed analysis, in order to provide the guidance and direction that assists commanders in their decision-making.

It is intelligence that drives what is often referred to as the "decision-action cycle", whereby information is turned into situational awareness that in turn allows a commander to choose a course of action from several possible options, and to give clear orders for his forces to execute. There is no magic about this, and all armies try to go through the same cycle, but an experienced, intelligent commander, served by a competent staff, who have all trained together, can make this into a very well-oiled process that, at its best, rapidly gets inside an opponent's own decision-action cycle. In doing so, it increasingly makes the enemy's responses to your

own movement and manoeuvre incoherent or irrelevant. Allied to this are good communications that allow the rapid passage of orders, preferably without those messages being intercepted or read by an enemy. This was at the heart of the German *blitzkrieg* success in the opening years of the Second World War. This process was later captured in the mnemonic OODA: Observe, Orientate, Decide, Act. This was a way of helping people visualise a cycle of cognition and action that was developed in the American air combat school in the 1950s by a Lieutenant Colonel Boyd, in order to restore US supremacy in aerial dog-fights over Korea. While the "OODA Loop" was initially aimed at fighter pilots in single-combat, its generic relevance at much higher levels of war and conflict was quickly understood. Adopted and taught across most Western militaries, the OODA Loop was deployed by Special Forces in the conflicts of Iraq and Afghanistan and developed to serve another sophisticated intelligence-driven cycle known as F3E: Find, Fix, Finish, Exploit.

Given Clausewitz's exhortation to always acknowledge that war is a political activity, the importance of intelligence, in terms of both information and analysis, at every level, and through every phase of a war, is evident and paramount. Given the hard experience of recent conflicts, it is clear that guessing what is on the other side of the hill is as vital in informing the political decision to use war as a policy tool, and in bringing the campaign to a successful and positive political conclusion, as it is to actually fighting the conflict itself. Clausewitz, in another of his timeless observations, noted: "The first, the supreme, the most far-reaching act of judgement that the political statesman, and the military commander, have to make is to establish the kind of war on which they are embarking; neither mistaking it for, nor trying to turn it into, something that is alien to its nature." The US General, David Petraeus, who commanded Coalition forces in both Iraq and Afghanistan, often used to say that military commanders needed to ask their political leaders "Tell me how this ends?" in order to ensure that all military activity, not simply the fighting, is conducted in a manner that serves the political objectives.

This political-military interface, and sometimes tension, therefore drives a requirement for strategic intelligence, analysed and assessed by both the military and political leadership, which should profoundly influence any decision to go to war, or not. This will be driven by an assessment of the geopolitical situation in which a state finds itself. This will include treaties, allies and obligations, lack of resources or the appetite for

more, relative economic and military strengths, ambitions, inspirations and grievances, and issues of government, governance and the historical interplay of personalities. Much will depend on whether a state plans or fears aggression, is prepared for war, or has the capacity, depth and willingness to be invaded and to strike back.

Whether a state plans or fears aggression, the military commanders need to take the political decision, or assessment, and prepare their own operational intelligence, primarily focused on the range of military activities anticipated in an offensive or defensive campaign. This will be needed prior to the outbreak of any hostilities, and throughout a campaign once hostilities commence. This requires detailed understanding of terrain for manoeuvre – of rivers, mountains, coastlines, urban centres, airbases and ports – and of the relative strengths and capabilities of one's own forces, and those of allies and potential opponents, and knowledge of civilian attitudes and potential response. In large-scale warfare this operational intelligence is crucial for the effective correlation of forces, in the air, land and maritime domains, in both time and space. It helps determine the "design for battle". The effective use of operational intelligence, and the operational-level excellence that can flow from it, was well demonstrated by the German army's actions against the formations of the Soviet Union in the Second World War. The Coalition forces at the outset of the Gulf War in 1991, and the invasion of Iraq in 2003, also demonstrated an outstanding operational capability based on good operational intelligence. However, like those early German military successes in Russia, the disconnect from a well thought-through, achievable political strategy and end-state, meant that all of this activity could not rescue a military campaign from eventual political failure, as judged by Clausewitz. The failures of strategic intelligence, let alone the motivations of the protagonists, severely undermined the efficacy of any local military success or individual bravery.

The third level of intelligence is that of tactical intelligence which, in time frame and scale, is more directly related to the tactical activities of the formations on the battlefield. This level of intelligence is often literally related to the requirement for a commander or soldier to try and guess what is on the other side of the hill, and to take whatever information they can get in order to achieve their tactical objectives.

Sun Tzu, the great Chinese military philosopher and thinker, was attributed as saying: "Strategy without tactics is the slowest path to

victory. Tactics without strategy is the drumbeat before defeat." Both strategy and tactics need sound intelligence, and intelligent assessment, and history is littered with examples of the failures of one or the other, or both. History also has many examples where strategy and tactics have been well-informed by intelligence and, as a result, have been effectively and successfully harnessed to the achievement of sustainable political outcomes.

War is a political act, and statesmen, politicians, and military commanders all require knowledge and intelligence and, with those, the capacity and means to understand, analyse and assess both. Judgement, and even wisdom, both political and military, is vital in this equation, given the strategic consequences of failure. Intelligence reduces uncertainty, and it allows a better and more objective assessment of risk, benefit and cost. However, it is prone to information overload, to "heroic but false assumptions", to poor judgement, to reinforcing prejudices or to what is known as "paralysis by analysis". This is where the desire to maximise certainty delays critical decision-making, and the "best" intelligence becomes the enemy of "good enough" intelligence. All of which is to say that intelligence is an absolutely vital part of leadership and command, at every level, and that its management, as a product and as an asset, is critical in all phases of war, and peace.

When I was the Coalition's Deputy Commander in Baghdad, back in 2007, I worked for General David Petraeus. On the wall in his office he had hanging a classic picture of the Wild West in which cowboys were racing alongside charging cattle that had clearly been panicked into a state of frenzy by a lightning storm. It was titled *Stampede*, and General Petraeus likened the situation in Iraq at that stage as akin to a chaotic stampede, with the Coalition forces attempting to corral the conflicting elements bringing chaos to Iraq. "What I need around me", he said, "are people who are comfortable in a stampede." Good intelligence, and the capacity to use it properly, is an important capability in helping to deliver that sense of comfort.

ADDICTED TO INFORMATION

Sophia: robot and Saudi citizen.

TIME TO REGULATE THE DEVELOPMENT OF AI

Maria Borelius

In 1975, a select group of renowned scientists, lawyers and journalists met at Asilomar, on the Monterey peninsula of California. The reason for this meeting near the mighty Pacific Ocean was to discuss how a new emerging science could be tamed to ensure its harmonious usage for the benefit of humanity. This science was recombinant DNA technology.

A few years earlier Paul Berg, a young Stanford biochemist, had built on the discoveries of the DNA helix by James Watson and Francis Crick, and further structural and biochemical understanding of gene replication and expression, to invent a method performing what no one had done before. In the simplest of terms, he cut out a segment of ape DNA and inserted it into a new entity – a bacteriophage lambda – a transporting vector that can inject itself into a bacteria and force that new host to express its own bacteriophage lambda genes.

Since the ape DNA contained proteins for a potent virus, the SV40 virus, staff working with Berg became concerned. Having a bacterium expressing large amounts of ape viral proteins, with a potential risk of infecting human beings, could result in uncontrollable biohazards. They convinced Berg to leave the last steps of his experiments to the imagination alone. But the successful experiment set off alarm bells among interested scientists.

This new technology could, they now realised, be used to express genes in new settings with unforeseen consequences, and at the extreme create mutant beings never seen before: hybrids between species where normal reproductive barriers would have stopped such genetic mergers in natural surroundings. The discussion lit a fire under the scientists involved in recombinant DNA, who realised they were not only developing a new technology for precise gene modification, but that these tools could also alter the parameters of life itself in a laboratory setting.

At the Asilomar summit, Nobel laureates and future laureates mingled with lawyers, journalists and policy activists. Their discussions

became the starting point for developments in the West, where a debate about recombinant DNA technology spilled over into the political-legal spheres, leading to the subsequent development of new codes of ethics and conduct. A broad spectrum of competencies was used. Biochemists, medical doctors, ethicists, politicians, philosophers, business leaders, spiritual leaders and other representatives from the general public were all invited to discuss the moral implications of the new science. These debates led to the establishment of new agencies, authorities and regulation of methods.

Scientists and pharmaceutical companies working with recombinant DNA now had to imagine the worst possible outcomes, even if they were aiming for the most beneficial, and report on such potential biohazards. Most poignant were the strict rules developed in the field of genetically modified organisms (GMO).

The global Cartagena Protocol on Biosafety was developed. The intergovernmental Codex Alimentarius Commission was set up There was a joint World Trade Organisation Agreement on the Application of Sanitary and Phytosanitary Measures. In Brussels, the European Union issued several new directives, including as lately as 2009 and 2014. The EU also instigated a GMO authorisation process and established a GMO register.

In the area of human drug development, this sharpened instinct for the prevention of biohazards resulted in one of the industrial world's most regimented development processes. Developing a new drug, from discovery to putting it on the market, is subject to a strict three-stage clinical protocol. For each stage there are demands on double-blind trials, with the requirements to prove safety and efficacy increasing with each new group of tested humans. The purpose of this is to prove beyond the slightest doubt that the use of a new substance is not only *not* harmful but also *more* beneficial than earlier competitors. This laborious ten to 15-year development process is required in order to get approval by both the Food and Drug Administration in the US and the European Medicines Agency.

This progress towards a safety-first mindset has been replicated in other large-scale ventures that contain both high risk and high reward. Examples are space exploration, the aviation industry and large infrastructure projects. Caution must take the lead where the potential downside is great.

Artificial Intelligence (AI) is now at the stage where gene technology was some 40 years ago. Ultra-rapid developments within facial recognition, scanning, the tracking of consumer needs and demands, blockchains and communications are improving our daily lives. AI sensors are located in road vehicles, AI hearing is found in computers and phones, AI smell will soon be able to detect the breath of sickness. Recently a British woman had a robotic hysterectomy, to remove parts of her gut. A robot, Sophia, has become a Saudi citizen.

While promising progress is being made, warnings are seeping out of the hacker and investor communities and entering the mainstream. A long-standing employee was recently fired from his job with a company when robots running the human resources department mistakenly came to the conclusion that he was no longer working for the company. It took his bosses three weeks to sort out the mistake.

Microsoft founder Bill Gates, Tesla founder Elon Musk, and the Massachusetts Institute of Technology physicist, cosmologist and AI expert Max Tegmark are among the leading figures sounding notes of alarm, as was the cosmologist, the late Stephen Hawking.

There are many areas of concern. I want to address three, widely differing in their scope but all pointing in one direction. These concerns are:

1. Facial recognition – its potential threat in the hands of authoritarian states.
2. Evolutionary dominance – its potential threat as the last human invention if we had to compete for survival with a vastly more intelligent and powerful being.
3. Technology developers and investors – their potential threat as high-risk takers.

Facial recognition is developing with breakneck speed: from smart biometrics systems, aimed at stopping benefits and welfare fraud to bio-identification used to open up personal laptops or iPhones. Scientists at Stanford University show how a computer algorithm, using deep neural networks, could develop "gaydar" capacity, seemingly assessing faces on a dating app for homosexuality more correctly than human beings (with an 81 per cent accuracy rating for men and 74 per cent for women from a sample of 31,000 people).

Next pages: Staff members at Facebook's Berlin office.

The technology is a mixed blessing, raising moral and ethical questions, especially in the hands of authoritarian governments. In China there are presently more than 170 million surveillance cameras, linked up to a system of facial recognition. In the city of Guiyang, the faces of its 4.3 million inhabitants are all linked to the facial recognition system of its police and its CCTV cameras. The BBC journalist John Sudworth was allowed to test the system and tried to hide himself from the authorities in the city. The authorities found and tracked him down within seven minutes. In the BBC story, the authorities claimed that they were able to track every movement of all its citizens for the previous week.

The system can be even more sophisticated, overseeing more than just large-scale physical movement. It can also register small facial details displaying human emotion and how they shift within one individual. In one Chinese school in Hangzhou, the No 11 High School, an "intelligent classroom behaviour management system" is being used. The technology scans the students every 30 seconds, recording their facial movements and classifying them into categories such as angry, upset, lazy or content.

Along with this development is the proposed expansion of the Chinese CCTV camera system to more than 620 million surveillance cameras by 2020, according to *The Huffington Post*. A wider perspective is added when looking at Chinese investments in AI/deep learning space. In 2017, China was the recipient of 48 per cent of all the world's investments in AI, mostly by Chinese investors.

These investments are gearing China up as the new AI hub, as shown in the following table. China is forging ahead in AI, and facial recognition is a major asset for an authoritarian state with a strong desire to control the movements and emotions of its citizens, with very few democratic institutions to question or balance the use of such technologies.

AI PATENT Year of registration	China	US
2013	3	3
2015	92	10
2017	652	110

Since the Cambrian explosion, some 541 million years ago, life on Earth has evolved from the first simple cellular organisms into multicellular

organisms diversifying into today's seven million species of animals of varying degree of complexity. Throughout the evolution of life on our planet, Darwinian selection has produced an astonishing range of life forms, but one common trait is that evolution seems to select for intelligence, as intelligence increases the ability to hunt and gather energy (food) in an energy-scarce and thus competitive environment. So, up the evolutionary ladder, intelligence is accrued. Man is more intelligent than the chimpanzee, which is more intelligent than a sea otter, which is more intelligent than a viper, itself in turn more intelligent than the herring, which is smarter than a mollusc. It is intelligence that gives mankind its role on the planet, where we in the most literal sense "dominate" the biosphere with our larger cognition and the consequent capacity to act jointly across large geographical and time differences, to learn, to develop, to plan, to self-reflect.

Where does this increasing intelligence "sit"? All animals are created by the same basic elements, such as carbon, oxygen, hydrogen, sulphur etc, and these elements in themselves are all built by the same basic nuclear particles, such as protons, neutrons and electrons. In turn protons and neutrons are just basic configurations of "up" and "down" quarks. So, in a reductionist sense, all life is built on quarks plus electrons, and the brain is merely a computational entity. Intelligence cannot be pinpointed at the nuclear level, as no single piece of matter, organic or inorganic, contains intelligence per se. Intelligence is rather a product of organisation. It exists at the structural and systems level and is platform-independent.

Hence, ever growing intelligence can be created in other entities, as long as the systems level is properly structured. Superintelligence can therefore be built, in silicon or other matter. It is just a matter of "time, talent and treasure". Presently, vast resources in all three dimensions are being pumped into the development of AI.

The question is how, and when, will superintelligence be developed, and how will it interact with human beings? One way to set out our consequent concerns is modelled from the questions asked at Asilomar:

1. How is the new technology "contained"? Who will be running the show? Will human beings be able to control a superintelligence, vastly superior in computational capacity to ourselves?
2. Is the quality and strength of the containment sufficient to deal with the potential dangers of a "breakout" scenario? And what damage could AI cause if it did "break out"?

When it comes to containment it is evident that, in the beginning, newly developed AI will have limited tasks, such as automated pricing, or delivering the best spot price for gasoline along a certain strip of road outside Hamburg.

In our present mindset, we visualise AI sifting through vast databases and modelling potential solutions, then "telling" human beings what to do to solve a given problem. The issue is that we cannot comprehend what a being a hundred or a thousand times more "intelligent" than we are, and capable of self-learning, can do or how it reasons even in a limited task – just as a chimpanzee cannot imagine how a human being learns to solve a differential equation or how to build a car.

In a playful thought experiment, imagine that I (representing AI in this analogy) am sitting in a locked kitchen, telling my four children when they were two, four, six and eight years old how to clean the home, shouting through the kitchen door about where to find the vacuum cleaner and the rubbish bin. After a while, perhaps an hour or a day, it might be that I would become impatient with the children's inefficiency and their slow, sloppy cleaning methods, and break out of the kitchen and start vacuuming myself in order to get the job done faster and better.

Such an AI breakout has to be reckoned with, as such behaviour would facilitate an AI being's capacity to deliver on its goals. Or, as Max Tegmark says, "the real risk with artificial general intelligence isn't malice but competence. A superintelligent AI will be extremely good at accomplishing its goals, and if those goals aren't aligned with ours, we're in trouble."

So what damage could be done? Such breakouts could look something like the actions of those robots mentioned above, calculating spot prices for gas companies, forming cartels without human awareness. Cartels being illegal between corporations, the robot issue has prompted the EU Commissioner for Competition, the Danish politician Margrethe Vestager, to consider new legislation to cover such eventualities. Who do you take to court when a robot is, in legal terms, a non-entity? Does anti-trust legislation need to encompass automated and deep-learning systems?

This is just the beginning. As AI will increasingly be intertwined with human beings, co-running banks, financial systems, large infrastructure projects, energy grids, food supply chains, health care administration and the actual delivery of health care interventions, education, commu-

nication networks, the gathering and analysis of information, the production of journalism, running the social media show etc, a breakout scenario could affect and potentially paralyse all human societies.

★

The average age of a Facebook employees is 28. The company's founder, Mark Zuckerberg, famously quipped "young people are just smarter". The same is true for large swathes of the tech industries, with 29 being the median age at Google, 27 at Yahoo. The industry is young. And male.

Among Google employees, some 80 per cent of the tech developers are male (according to the National Center for Women & Information Technology the industry average is 75 per cent), with the new slang word for programmer being "brogrammer".

The tech industries attract a disproportionate share of investment from angel investor and venture capital companies, which are considered the more risk-prone investors in the ecosystem of investors (banks, foundations, institutions etc). In other words, the tech sector is being funded and governed by investors who are in the high-risk segment of investors, willing to accept a larger risk than average, and hoping to benefit from a potentially larger upside as new fortunes are being accrued in the sector at breakneck speed.

It is well-known from psychological research that risk-taking is correlated to gender and age factors. Financial and ethical risk-taking is higher among young people. Risk-taking in general is higher among men than women. We can therefore deduce that AI development, emanating largely from the tech communities, is being carried out by the type of individuals who are most relaxed about taking ethical and financial risks – mostly young men – and it is financed by entities in the investment sector which are also prepared to take on a high level of risk.

New investors in the AI community are the Chinese government and affiliated companies. The biggest AI venture capital deal made so far, at the time of writing, was completed in May 2018, when tech giant Alibaba led a $600 million investment in the China-based facial-recognition startup firm SenseTime.

★

AI is transforming our family lives, private consumer patterns, the face of our cities, human interactions, business dealings, financial institutions, the way politics and public discourse is conducted, how healthcare is administered and provided, how infrastructure is built and run. Robots will come to know us better than our neighbours or even ourselves. AI has the potential to transform what a human life is, as the human/machine intertwining continues.

The recent scandal around Cambridge Analytica and its harvesting of personal data from 70 million Facebook users alerted us that developments are already more far-reaching than most of us had appreciated. So far, the AI industries and all major frameworks have been developed by small university communities, private corporations, venture capitalists and tech gurus, even hackers; a close-knit group indeed, who have offered very little public insight into the inner mechanics of their field.

The risks we now face are vast, as is the potential upside of the technology. This high risk/high reward scenario requires new measures. My conclusion is that society as a whole, the AI community, lawmakers, scientists, politicians and other policymakers can learn from the history of how the community involved in recombinant DNA took responsibility for the potential biohazards of their new technology, and ignited a public discourse about the dangers which the outside world was not yet able to perceive or understand.

This debate, from Asilomar onwards, has set an example of how a public discourse about the moral implications and human ramifications of AI could provide a much-needed starting point for the creation of an essential safety net around a high risk/high reward technology, which could be said to present the greatest risk ever to confront humanity.

The argument that superintelligence is a remote, far-off concept does not carry much weight; if safety-net frameworks are not put in place, there is a danger that the technology will race ahead of our capacity to control it. We need a robust ethical framework of new laws, codes of conduct and institutions that can work in tandem with the tech industries to tame AI for the benefit of mankind.

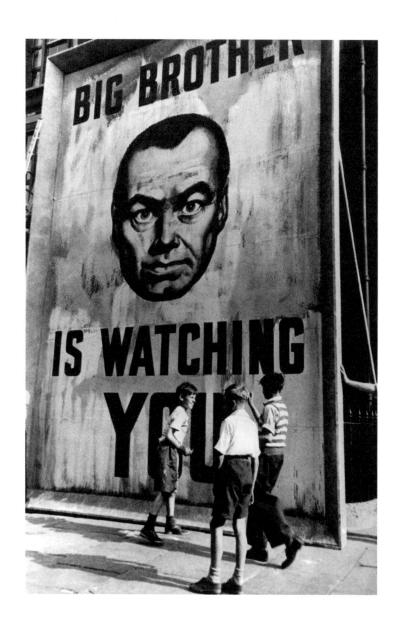

George Orwell wrote *1984* in 1948.

HOW TO FIX THE FUTURE: PROTECTING
DEMOCRACY IN A POST-PRIVACY AGE

Andrew Keen

O ver the last couple of centuries, the relationship between technology and the individual freedom essential to democracy has been premised on what we might call the "Winston Smith Principle". Smith, you'll remember, was the fictional model of resistance to totalitarianism in George Orwell's dystopian 1948 novel *Nineteen Eighty-Four*. He represented the human antidote to a nightmarish political system combining the most disturbing elements of Bolshevism and Nazism. Orwell presents Smith as the final hope, the last man, in the face of a regime that spied on everyone and everything. He is the human resistance, the democratic alternative to Big Brother.

In *Nineteen Eighty-Four*, technology was presented as the key weapon of a secret police state intent on destroying privacy and demanding the complete obedience of its citizens. Spying technology was ubiquitous. There were microphones and cameras in every room, watching and listening to everything we did and everywhere we went. Society had been transformed into a giant inspection house – a place of radical transparency not unlike the "panopticon", that "simple idea of architecture" imagined by the late 18th-century utilitarian thinker Jeremy Bentham. In Orwell's Room 101, the hellhole in the Ministry of Truth where "the worst thing in the world could be found", there was even technology seeking to invade our own consciousness.

Or, at least, technology was *almost* everywhere in *Nineteen Eighty-Four*. For all the nightmarish qualities of Room 101, the one place it couldn't quite occupy was our own heads. Winston Smith's own head was the resistance. Big Brother never colonised what has always seemed to be the essentially private realm of our own minds.

Over the last 200 years, this Winston Smith Principle has had a profound influence on democratic theory. In John Stuart Mill's 1859 book *On Liberty*, for example, arguably the most important 19th-century work setting out the limits of state authority over the individual, Mill argues that

it's the free-thinking person – the Winston Smith in all of us – who determines social progress. And so, for Mill, whose *On Liberty* was partially an attack on the utilitarianism of his godfather Jeremy Bentham, democracy needed to be built around a defence of the sanctity of our own thoughts. A defence of privacy, for Mill, therefore, becomes one of the key components of democracy.

Mill's ideas about democracy were developed more fully by the American jurists Samuel Warren and Louis Brandeis in their 1890 *Harvard Law Review* piece, "The Right to Privacy". Writing in response to the nascent mass media technologies of photography and newspapers, Brandeis and Warren argued that privacy meant the "right of the individual to be let alone".

In the face of these potentially intrusive late 19th-century technologies, Brandeis and Warren argued, in 1890, that "solitude and privacy have become more essential to the individual." "The right to be let alone", they explained, was a general right to "the immunity of the person… the right to one's personality."

Calibrating the right balance between technology and individual autonomy from the state, Warren and Brandeis thus suggest, is essential to democracy. Privacy matters. Without it, there can be no real individual freedom.

More than 125 years after the publication of "The Right to Privacy" nothing much has changed in terms of the importance we give to the ideal of the private self. As the contemporary American technology writer Nicholas Carr notes, "we human beings are not just social creatures; we're also private creatures. What we don't share is as important as what we do share."

And yet while nothing has changed in terms of our ideas about democracy, *everything* has changed in terms of the new technologies of our networked age. The digital revolution, driven by the creation of both the internet and the world wide web over the last half century, has created a very different informational world to Samuel Warren and Louis Brandeis' 19th-century world. Today, the industrial technologies of photography and print have been replaced by the digital technologies of blogs, tweets, Instagram photos, YouTube videos, Facebook log-ins, WhatsApp conversations and Google searches.

On the internet, those ubiquitous microphones and cameras in *Nineteen Eighty-Four* have been turned on ourselves. We are increasingly living in

an age of big data – a vast digital panopticon which Facebook CEO Mark Zuckerberg once fondly described as a "well-lit dorm room". The scale of this data economy is mind-boggling. Three-and-a-half billion internet users around the world create 2.5 quintillion bytes of data each day. In every minute of every day of 2016, for example, we made 2.4 million Google searches, watched 2.78 million videos, entered 701,389 Facebook log-ins, added 36,194 new posts to Instagram, and exchanged 2.8 million messages on WhatsApp.

The problem, of course, is that much of this data is transparent to everyone. In our digital age, individual privacy is in crisis. As the National Security Agency whistleblower Edward Snowden revealed, the internet is increasingly a place dominated by a ubiquitous government surveillance. And as many critics of the new internet economy – with its supposedly "free" services and platforms like YouTube, Google, Facebook and Instagram – have argued, this economy isn't really very new. It's actually a surveillance-style economic system in which we are all collectively being watched in everything we do and say by big data companies like Google, Facebook and Twitter.

Privacy, in other words, is in crisis. Orwell's dystopia has been resurrected in digital form. Only in today's networked economy, we are all Winston Smith – struggling to protect our identities in the face of forces intent on knowing everything we think and everywhere we go.

Most troublingly, we are still in the very earliest stages of a revolution which is producing technologies that reveal our innermost thoughts – the data adding up to what Samuel Warren and Louis Brandeis described as "our personality". Artificial intelligence (AI) companies are developing algorithms, for example, which can determine our voting or consumer habits by just crunching our public data. And we are inventing facial recognition technologies that can identify our sexuality without knowing anything else about us. Indeed, the Chinese government is already developing a facial recognition policy known as "Sharp Eyes" designed to verify people's identities through their faces.

You'll remember that in *Nineteen Eighty-Four*'s Room 101 there was technology seeking to invade our own consciousness. But in an age of big data, with increasingly sophisticated AI that can determine our thoughts, Orwell's "worst place in the world" is, unfortunately, becoming a reality.

In political terms, this digital dystopia is manifesting itself most troublingly in contemporary China where Orwell's 20th-century warnings

about a *Nineteen Eighty-Four*-style intrusive ideological dictatorship have acquired a 21st-century digital form. The idea began in 2010 with local communist party officials in Suining County in the Jiangsu Province north of the Chinese city of Shanghai. The local government began to award people points for good civic behaviour and deduct points for everything from traffic tickets to "illegally petitioning higher authorities for help". The points were then tallied, and people were placed into reputational tables to determine their civic reliability. If you rated highly, you would qualify for fast-track promotions at work or for access to public housing. If not, you were unlikely to be promoted, find a new home, or even qualify for social security support.

In late 2016, the Chinese authorities published a plan to establish a much more ambitious social credit system that, in the Ministry of Truth-style language of the communist party, would build a culture of what the party calls "sincerity" and a "harmonious socialist society". Launched in three dozen local governments across China, as well as with eight private technology companies, and aided by increasingly sophisticated facial recognition technology, this new initiative, called Internet Plus, is designed to collect the information of the 730 million Chinese internet users into regional databases that will determine their individual trustworthiness. The official goal is to unite all these different databases by 2020, creating a national social rating system that will rank individuals according to their online data.

Presumably Internet Plus, like the 2010 Suining County pilot project, will reward loyal citizens and punish those who are deemed, by China's intended second brain, to be politically troublesome or unreliable. The data-engineered caste system in the China of 2020 will, no doubt, be made up of two groups: the trustworthy and the untrustworthy. As Chinese officials put it, by 2020 this system will "allow the trustworthy to roam everywhere under heaven while making it hard for the discredited to take a single step". The underclass, to remix Marx, will have nothing to lose but their bad ranking.

The logic behind China's Internet Plus scheme, of course, is to tighten the undemocratic grip of the communist party on society. In October 2016 President Xi Jinping called for innovation in "social governance" that would, in his words, "heighten the capacity to forecast and prevent all manner of risks". Rather than the creation of trust, the point of Internet Plus—which *The Economist* describes as a "digital totalitarian state" – is

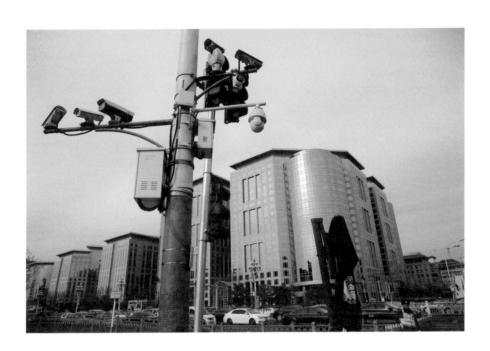

Video surveillance cameras set up near a
street in Beijing, China.

to punish "untrustworthiness". To add to the Orwellian nature of this networked dystopia, individuals will be able to enhance their trust scores by informing on the untrustworthiness of others. Thus Internet Plus will, according to China's elite State Council, "forge a public opinion environment that trust-keeping is glorious" and, at the same time, "reward those who report acts of breach of trust". The most trusted, then, in this surreal system, will be the most untrustworthy. No wonder one Hong Kong human rights activist told the *Wall Street Journal*: "It's just like *1984*."

So how can we make the digital future unlike *Nineteen Eighty-Four*? How can we protect individual rights and, by extension, democracy in an age of big data?

The obvious solution is to try to replicate Samuel Warren and Louis Brandeis' attempts to legislate in defence of individual privacy. This regulatory strategy against the big data economy is most actively being pursued in the European Union through its General Data Protection Regulation (GDPR).

Adopted in April 2016 by the European Parliament, the European Council, and the European Commission after four years of negotiation, the GDPR came into force in May 2018 and has been designed as a single set of rules for member countries to ensure that privacy will become "the norm" in European networked society. Offering to guarantee the "fundamental right" to personal data protection for all EU residents, the GDPR is an attempt to turn today's data equation on its head by enabling individuals to own what technologists call their "social graph". Instead of big data companies owning us, we will not only own our data, we will be able to delete it or take it with us wherever we go on the internet. Google will no longer be allowed, in the words of Gary Reback, a prominent Silicon Valley anti-trust lawyer, to unilaterally "build profiles of everyone". Some are calling for a similar "Social Graph Portability Act" to be created by the US Congress. They would be wise to use the GDPR Act in the EU as a model for this congressional legislation.

The GDPR's "privacy as the norm" legislation offers an entirely new ecosystem for privacy and data in our age of surveillance capitalism controlled by Silicon Valley monopolies. The GDPR is crystal clear about who owns our data on Instagram, Facebook and Google. It's ours. Ours alone. The internet is reimagined as a place where individual privacy is not only the norm but also the highest priority. While the current absence of clear laws puts all the burden on individuals to figure out how their data

is being exploited, the GDPR puts all the burden on the big data companies in terms of their accountability for the fate of online data. In the language of the European Parliament, the legislation "puts the citizen back in the driving seat".

The EU legislation enshrines the so-called right-to-be-forgotten ruling that gives individuals the right to have their personal data erased from the internet. A person must provide "clear and affirmative consent" if data companies are going to process his or her private data. The law requires companies to inform individuals if their data has been hacked or tampered with, and it gives people the right to switch their personal data to another service provider. It also warns that companies face fines of up to 4 per cent of their global revenue for breaking these new laws.

While the GDPR focuses on constraining private companies, it does little to address the big data relationship between governments and its citizens. But what about the transparency of this relationship? How can we protect citizens from the prying digital eye of the government so that China's Orwellian Internet Plus program isn't also established in Western democracies?

What is needed is a new social contract between citizens and government in our big data age. Unlike in the industrial age, individual privacy can't simply be protected by the kind of legislation encouraged by industrial age thinkers like Samuel Warren and Louis Brandeis. Instead, what is needed is new contract of trust between citizens and government in our increasingly transparent digital age.

This new relationship, a forging of a kind of new digital democracy, is being pioneered in countries as diverse as Estonia and Singapore. Both these small, digitally advanced states are experimenting with comprehensive digital identity systems that make both citizens and government fully accountable for their actions. In Singapore, this is known as the "Smart Nation" initiative; in Estonia, it is called the "National ID System".

The thinking behind these new social contracts is that, in our big data age, individual privacy is becoming an archaic ideal. For better or worse, we are all living in public in our networked society. So attempting to protect privacy might indeed be a form of misguided nostalgia for a world that can no longer be recreated.

One of the leading thinkers in the establishment of democracy in this post privacy age is Toomas Hendrik Ilves, the former two-term President

of Estonia. "Our obsession with privacy is misguided," Ilves told me, in explaining the thinking behind the pioneering Estonian model of digital democracy. "The real issue is data integrity."

It's not that Ilves is completely dismissing the significance of privacy or diminishing its importance as a component of individual freedom. But the real issue for government in an internet world, where data about everything and everyone is readily accessible on Google, he believes, is refereeing a system where that data is authentic. Ilves is saying that there's nothing more important than data integrity in a digital 21st-century, where everything – including ourselves – is turned into information. And so the role of government is to create a trustworthy informational exchange system that is secure. If our personal data is, indeed, the new currency of the networked age, then it requires what he calls a "sovereign guarantee". Like currency, it has value only if it has this official stamp of authenticity.

"Somebody knowing my blood type isn't a big deal. But if they could change the data on my blood type – that could kill me," Ilves explained. "The real problem is when somebody starts fiddling with the data."

The spectre of online surveillance, therefore, worries Ilves much less than that of data corruption. And this explains why so much time and so many resources in Estonia have been invested in its second brain, the online ID system. This platform creates ways to exchange data that are completely secure.

"Your data is yours," another of the digital designers of Estonia's ID system assured me. But the information is really *yours* in Estonia only if the government is ensuring that nobody is tampering with it. The greatest service, then, of what Estonians call government-as-a-service is establishing data integrity.

The role of the sovereign in the digital 21st-century, Ilves insists, is to guarantee our identity. He calls this a "Lockean contract" and describes it as the "new social contract for digital times".

Given that the original Lockean contract underpinning Anglo-American representative democracy operates on a series of mutual obligations between the government and its citizens, I asked Ilves about the equivalent obligations for our digital age.

"So what's our responsibility in this new social contract?" I inquired. "If the government guarantees the integrity of the data, what do citizens need to guarantee in exchange?"

"It's a fully transparent system," Ilves responded. Just as it keeps government honest, he says, so it also keeps us honest. The government can, if it needs to, examine our data. So we all have to take responsibility for our own online behaviour.

In the information-rich democracy being constructed in Estonia, he suggests, there can be no digital anonymity. Everything people do – from paying taxes online to ordering medicine to posting opinions to driving cars – is done under their own names. So, for example, Estonian newspapers are connecting the ID system to their bulletin boards, making it impossible to comment anonymously. This new social contract does away with the trolls who have made the internet such a barbaric place. And it makes people accountable for the spreading of fake news, racism and sexism, spiteful rumours, and the other anti-social and often undemocratic behaviour seemingly endemic in digital culture.

"Our goal is to make it impossible to do bad things without consequences. We want to teach people to be good on the internet, to use it responsibly," Ilves concluded.

In a way, of course, this is all very chilling – especially to people like Edward Snowden, who lionise individual privacy. The Estonian ID operating system, with its guarantee of identity, is, in contrast, a mutually transparent system. What Ilves describes as a new social contract is based on the rights of both government and citizens to observe each other. The watching is done with full transparency, within a comprehensive legal framework that requires the authorities to alert people if they look at their data.

It's an architecture of trust designed for what Andreas Weigend, the former chief scientist of Amazon, calls our "post-privacy" world. And that, indeed, might be the fate of democracy in the digital 21st-century. For better or worse, it may be time to retire the Winston Smith Principle. Rather than protecting individual privacy, the fate of democracy in our networked age might depend on establishing a new, radically transparent contract of trust between government and citizens.

The first radio transmitter, invented by the Italian
electrical engineer Guglielmo Marconi in 1894.

NASTY, BRUTISH AND DIM:
ONLINE LIFE RECONSIDERED

Nicholas Carr

In remarkably short order, over just the last 25 years, the successive arrivals of the broadband internet, social media, and the smartphone have changed the way we live. The constant, enveloping presence of digital media has given a new texture and tempo to our days, and it has dramatically altered the way we inform ourselves and converse with others. Not since the spread of electrification a century ago have we seen a technological phenomenon with such far-reaching personal and social consequences.

The entire edifice of digital media has been constructed on two assumptions. The first conflates information and knowledge: if we give people more information more quickly, they will become smarter, better informed and broader minded. The second conflates communication and community: if we provide people with more ways to share their thoughts, they'll become more understanding and empathetic, and society will end up more harmonious. Deeply idealistic, the two assumptions have been fundamental to the ideology and business strategy of Silicon Valley – they explain much about the way online experience has evolved – and by a sort of cultural osmosis, they have also come to be broadly held by the general public.

The only problem is, both assumptions are false. We are now, as individuals and as societies, paying the price for being seduced by a pair of utopian myths.

Let's look first at the confusion of information with knowledge. It's easy to understand the expectation that more information would inevitably lead to more knowledge. Information is, after all, the raw material out of which personal knowledge is formed. The more of it that is available to us, the more our minds have to work with. But when it comes to evaluating the cognitive and intellectual effects of an informational medium, we need to consider not just *how much* information the medium supplies but also *the way* the medium supplies it. How information is delivered to us

has a profound influence on our brain's ability to transform that information into true knowledge.

Information becomes knowledge only when we transfer it from short-term memory (the mind's notepad) to long-term memory (the mind's filing system). Through this complex process, which brain scientists call memory consolidation, a new piece of information gets connected to all the other information we store in our heads. It's these connections, or associations, between pieces of information, not the individual pieces themselves, that give depth to our thoughts. The connections form the essence of our intellect, enabling us to think conceptually and critically, to solve difficult and unexpected problems, and to make leaps of inference and imagination. The richer the web of connections, the sharper the mind.

Memory consolidation is a fragile process. It demands, brain science makes clear, attentiveness. If we're distracted or interrupted while taking in new information, the mind struggles to weave it into our store of knowledge. Either we forget the information entirely, or we connect it only weakly to the other things we know. A smartphone, as anyone who owns one knows, is a distraction machine. Through its constant stream of messages, alerts and notifications, it dispenses a welter of information, usually in short, overlapping bits. The barrage of information breaks our concentration and fragments our attention. The distractions are particularly pronounced with social media apps like Facebook, Twitter and Snapchat, which are carefully designed to encourage continuous information snacking and to discourage any sustained mental focus.

The paradox of digital media is that, even as it provides us with broader and faster access to information than we've ever had in the past, it dispenses the information in ways that impede the fundamental brain processes required to build personal knowledge. More information, we're now learning, can actually lead to less knowledge.

A growing body of scientific evidence reveals the debilitating cognitive effects of digital media. In one seminal study conducted nearly ten years ago, researchers at Stanford University gave a battery of basic cognitive tests to two different groups of people: one group spent a lot of time online; the other used digital media only occasionally. The heavy users performed significantly worse on all the tests. They were more easily distracted, had less control over their attention, and were much less able to distinguish important information from trivia. "Everything

distracts them," observed Clifford Nass, the professor who led the study.

The Stanford study was performed when people still used laptops and desktops as their main devices for going online. More recent studies have examined the effects of smartphones on cognition. They paint an even darker picture. In one study, published in 2017, researchers from the University of Texas and the University of California recruited more than 500 test subjects and gave them two standard tests of intelligence. One test gauged "working memory capacity", a measure of how fully a person's mind can focus on a particular task. The second assessed "fluid intelligence", a person's ability to interpret and solve an unfamiliar problem. The only variable in the experiment was the location of the subjects' smartphones. Some of the participants placed their phones in front of them on their desks; others stowed their phones in their pockets or handbags; still others left their phones in a different room.

The results were striking. In both tests, the subjects whose phones were in view posted the worst scores, while those who left their phones in a different room did the best. Those who kept their phones in their pockets or bags came out in the middle. As the phone's proximity increased, brainpower decreased. A second experiment conducted by the researchers produced similar results, while also revealing that the more heavily people rely on their phones in their everyday lives, the greater the cognitive penalty they suffer.

In an article on the research in an academic journal, the scholars wrote that the "integration of smartphones into daily life" seems to cause a "brain drain" that weakens such vital mental skills as "learning, logical reasoning, abstract thought, problem solving, and creativity". Smartphones have become so entwined with our day-to-day existence that, even when we're not peering or pawing at them, they tug at our attention, diverting valuable cognitive resources. Just suppressing the desire to check our phone, which we do routinely and subconsciously throughout the day, can debilitate our thinking. The fact that most of us now habitually keep our phones "nearby and in sight," the researchers noted, only magnifies the mental toll.

The findings are in line with other recently published research. In a similar but smaller 2014 study, psychologists at the University of Southern Maine found that people who had their phones in view, albeit turned off, during two demanding tests of attention and cognition made significantly more errors than did a control group whose phones remained out of sight.

Next pages: Guglielmo Marconi.

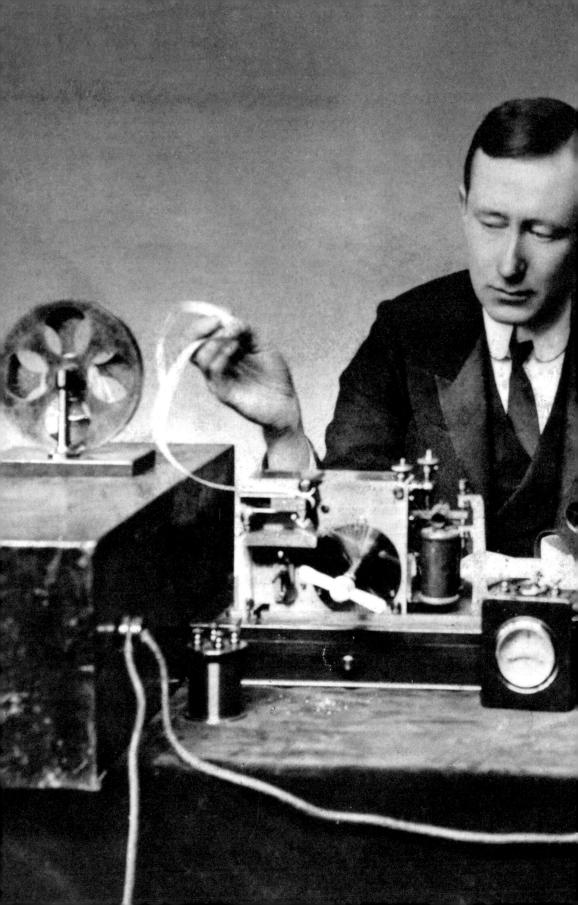

In another study, published in 2017, researchers examined how smart-phones affected learning in a large lecture class at the University of Arkansas. They found that students who didn't bring their phones to the classroom scored a full letter-grade higher on a test of the material presented than those who brought their phones. It didn't matter whether the students who had their phones used them or not: All of them scored equally poorly. A recent study of nearly 100 secondary schools in Britain found that when schools ban smartphones, students' examination scores go up substantially, with the weakest students benefiting the most.

The multifunctional smartphone, with all its intoxicating streams of social information, has become such a powerful mental attractant that it distracts us whenever it's nearby – whether we're using it or not. Even when stowed in a pocket, it disrupts the mind's ability to turn information into knowledge.

It's useful to compare digital media with an earlier form of information delivery, one that until the rise of networked computers was the dominant informational medium: the printed page. A printed page of text serves, literally as well as figuratively, as a shield against distraction. Because nothing competes with the words, the printed page focuses the mind, in effect training us to be more attentive. It provides an aid to memory consolidation and, in turn, to knowledge development. The text on a printed page may be the same as that on a smartphone screen, but the intellectual effects of reading the text could hardly be more different.

Now let's consider the second assumption – the one that confuses communication with community. This myth has a long tradition in contemporary Western thought. Ever since the building of the telegraph system in the 19th century, people have believed that advances in communication technology would promote social harmony. The more we learned about each other, the more we would recognise that we're all one. Community and communication would advance hand in hand, like a pair of hippies on a San Francisco sidewalk. A *New York Times* columnist, in an 1899 article celebrating the laying of transatlantic Western Union cables, expressed the popular assumption well: "Nothing so fosters and promotes a mutual understanding and a community of sentiment and interests", he wrote, "as cheap, speedy, and convenient communication."

The great networks of the 20th century – radio, telephone, television – reinforced this sunny notion. Spanning borders and erasing distances, they shrank the planet. Guglielmo Marconi declared in 1912 that his

invention of radio would "make war impossible, because it will make war ridiculous". AT&T's top engineer, JJ Carty, predicted in a 1923 interview that the telephone system would "join all the peoples of the earth in one brotherhood". The world wars and other depravities of the 20th century did little to dampen the general faith in the benevolence of communication networks.

Social media companies embraced the myth wholeheartedly, using it to portray their businesses as socially salubrious. Six years ago, as Facebook was preparing for its initial public offering, Mark Zuckerberg, the company's founder and CEO, wrote a letter to would-be shareholders in which he explained that his company had a higher calling than just making money. Facebook was pursuing a "social mission" to encourage self-expression and dialogue among the masses. "People sharing more", the young entrepreneur wrote, "creates a more open culture and leads to a better understanding of the lives and perspectives of others."

If our assumption that communication technology brings people together were true, we should today be seeing a planetary outbreak of peace, love, and understanding. Thanks to the internet and cellular networks, humanity is more connected than ever. Of the world's seven billion people, six billion have access to a mobile phone. That's a billion and a half more, the United Nations reports, than have access to a working toilet. More than two billion persons are on Facebook, more than a billion upload and download YouTube videos, and billions more converse through messaging apps like WhatsApp and WeChat.

Yet we live in a fractious time, defined not by concord but by conflict. Xenophobia and authoritarianism are on the rise. Political and social fissures are widening. From the White House down, public discourse is characterised by vitriol and insult. As for Facebook and other social networks, they have been revealed to serve as conduits for propaganda and hate speech. Far from bringing us together, they seem more likely to polarise us.

We shouldn't be surprised. For years now, psychological and sociological studies have been casting doubt on the idea that communication dissolves differences. The research suggests, in fact, that the opposite is true: free-flowing information makes personal and cultural differences more salient. It tends to turn people against one another instead of bringing them together. "Familiarity breeds contempt" is one of the gloomiest of English proverbs. It is also, the evidence indicates, one of the truest.

In a series of experiments reported in the *Journal of Personality and Social Psychology* in 2007, three Harvard psychologists found that the more we learn about someone else, the more we tend to dislike that person. "Although people believe that knowing leads to liking," the researchers wrote, "knowing more means liking less." Worse yet, they found evidence of what they termed "dissimilarity cascades". As we get additional information about others, we place greater stress on the ways those people differ from us than on the ways they resemble us, and this inclination to emphasise dissimilarities over similarities strengthens as the amount of information accumulates. On average, we like strangers best when we know the least about them.

An earlier study, published in 1976, revealed a similar pattern in real-world communities. Scholars from the University of California at San Diego studied a condominium development near Los Angeles, charting relationships among neighbours. They discovered that as people live more closely together, the likelihood that they'll become friends goes up, but the likelihood that they'll become enemies goes up even more. The scholars traced the phenomenon to what they called "environmental spoiling". The nearer we get to others, the harder it becomes to avoid evidence of their irritating tics and habits. Proximity makes differences stand out even more than similarities.

The effect intensifies in the virtual world, where everyone is in everyone else's business all day long. Social networks like Facebook and messaging apps like Twitter encourage constant self-disclosure. Because status is measured quantitatively online, in numbers of followers and friends, retweets and likes, people are rewarded for broadcasting endless details about their lives and thoughts through messages, updates and photographs. To shut up, even briefly, is to disappear. One study found that people share four times as much information about themselves when they converse through computers as when they talk in person.

Being exposed to this superabundance of personal information can create an oppressive sense of "digital crowding", a group of UK researchers wrote in a 2011 paper, and that in turn can breed stress and provoke antisocial reactions. "With the advent of social media", they concluded, "it is inevitable that we will end up knowing more about people, and also more likely that we end up disliking them because of it." It turns out that the old etiquette books were right: the less we talk about ourselves, the more likely other people will enjoy our presence.

Marshall McLuhan.

In his 1962 book *The Gutenberg Galaxy*, the celebrated media theorist Marshall McLuhan gave us the memorable term "global village" to describe what he called the world's "new electronic interdependence". Most people took the phrase optimistically, as a prophecy of inevitable social progress. What, after all, could be nicer than a village? But, despite his occasional utopian rhetoric, McLuhan himself harboured few illusions about life in a global village. He saw villages as inherently tribal, marked by mistrust and friction and prone to viciousness and violence. "When people get close together, they get more and more savage and impatient with each other," he said in a 1977 television interview. "The global village is a place of very arduous interfaces and very abrasive situations." That's a pretty good description of where we find ourselves today.

The problem with Silicon Valley's two formative myths goes beyond their denial of human nature. They reinforce the idea, particularly prevalent in American culture, that technological progress is sufficient to ensure social progress. If we get the engineering right, our better angels will triumph. That's a pleasant thought, but it's a fantasy. Progress toward a more amicable world and a more broad-minded populace will require not technological magic but concrete, painstaking, and altogether human measures: negotiation and compromise, a renewed emphasis on civics and reasoned debate, a citizenry able to appreciate contrary perspectives and to think deeply about complex challenges. It will require less self-expression and more self-examination.

Technology is an amplifier. It magnifies our best traits, and it magnifies our worst. What it doesn't do is make us better people. That's a job we can't offload on machines or hand over to technologists.

INFORMATION ROADS

Google CEO Sundar Pichai and Google VP for
Central Europe and the German-Speaking
Countries Philipp Justus.

THE GLOBAL IMPACT OF
KNOWLEDGE EXCHANGE

Peter Frankopan

W e live in a networked age and an interconnected world, where information, digital media, and cyber pose threats and challenges of unprecedented scale and complexity. It is easy to think that our ancestors did not experience the problems posed by new technologies or face the difficulties of having to adapt to a changing world. In fact, however, connections that have spanned entire continents are part of our global history, from classical antiquity to the 20th century.

For over two thousand years, the exchange of goods, faiths, ideas and new technologies between peoples from the Pacific coast of Asia to the Atlantic coasts of Africa and Europe have not only been a reality, but a vital driver of shifts in political, economic and military power. The only difference in today's world is the speed and intensity of the ways in which we can connect to each other.

Access to information is easier, faster and cheaper than at any time in human history. This partly results from rapidly rising rates of literacy, especially in developing countries; but it is also the result of a digital revolution that has been astonishing in its dissemination. There are three times more devices that connect to the internet than there are people on the planet today. The cost of accessing information online is low and is falling, while the availability of material is vast and growing.

The ways in which we access, observe, absorb and share data is facilitated by services, applications and formats that encourage the exchange of bite-sized pieces of material. It is perhaps not surprising, therefore, that in the digital maelstrom, many should feel uneasy about who controls the information we share, who patrols and guards it – and a host of other questions that include issues around freedom of speech, the dangers posed by "fake news" and the problems of being able to find and process useful or reliable knowledge in stormy digital seas.

While the connectivity of today's world bears no comparison with other eras, it is striking that many of the concerns and fears are the same

as those raised by thinkers in the past. More than two thousand years ago, historians, geographers and commentators were keen to find out about the customs, habits and beliefs of those who lived far away, both in order to assess potential opportunities and challenges, and also to satisfy their curiosity about how fellow human beings structured their societies, what they looked like and how they distinguished themselves from each other.

Herodotus, often called "the father of history" wrote precisely about the mechanics of knowledge exchange, paying attention to the different peoples living in Asia and Africa (and little, incidentally, to those in Europe). He had his peers and parallels writing in Persia, in South Asia, and in China, where authors like Sima Qian were keen to find out more about those living far away – and working out what could be learned from them.

It is the exchange of luxury goods that has often gained the attention of writers over the millennia – because such goods and products were unusual, expensive and valuable. Commodities like spices, textiles and exotic fruit, animals and precious gems were rare, so their arrival was much noted and discussed in literary sources – for example the gift of an elephant to Charlemagne from the Muslim ruler Rashid al-Din around the year 800; or the dispatch of rare tiles from Constantinople to the Umayyad court in Córdoba a century later.

As well as being recorded in the written accounts, non-perishable luxury objects also enjoy a long shelf-life, as they are looked after carefully, passed down across generations or, as in the case of a silver ewer depicting scenes from the Trojan War, buried alongside the owner in western China.

While elite gifts and possessions were part of an intensive process of exchange that tied the Pacific coast to Asia, to the Red Sea and the Mediterranean, and the heart of what is now Russia and Scandinavia to the Persian Gulf – a web of connections that known as the Silk Roads – another key motivator was to acquire information that had practical use in the sciences. Those linked directly or indirectly to military technology were of particular interest and value to leaders keen to gain an advantage over domestic or international rivals, or wishing to catch up with those whose capabilities were greater than their own.

Retaining control of valuable military technology was something well understood in the past. The Byzantine emperors were very careful not to

give away the secret of "Greek fire", an incendiary weapon that worked as a flame-thrower and was extremely effective in naval battles; the Mongols, meanwhile, were so impressed by the abilities of those who made siege engines in the Middle East in the 13th century that they had master crafts-men rounded up and sent back to teach their crafts to others. Scientists like Wernher von Braun found their knowledge in great demand at the end of the Second World War – and played a key role in developing US missile technology in the decades that followed.

Scientific knowledge was also a matter of enormous interest, leading to the transmission and in many cases the translation of important texts and tracts in order to make them available to wider readerships – and to stimulate further advances. Many works of ancient Greek philosophy, mathematics and science were translated into Arabic, for example, in the 9th century onwards, to be pored over by Arabic speakers who were Muslim, Christian, Hindu, Zoroastrian and Buddhist. Scholars in Europe like Leibnitz were fascinated by the Chinese work on binary principles, and wrote excitedly to ask Western visitors to China to send back materi-als that he could study, learn from and react to.

Commercial information was also highly prized. In late antiquity, according to a story that later became popular (though whether it is strictly true is another matter), the secrets of silk-making were conveyed to Constantinople by monks who explained details of the process and also smuggled silk-worms with them – helping to establish an industry that was not just lucrative in financial terms, but hugely important when the emperors of Constantinople sent precious fabrics as diplomatic gifts to other leaders around the Mediterranean and in Europe.

Of course, part of the significance of any knowledge comes from its codification and the ability to share this. The most aggressive at doing both have been the priesthoods of the global religions that have domi-nated world faiths for centuries and in some cases millennia. Buddhist monks were extremely anxious that faithful copies of the Buddha's teach-ings and examples from his life were captured accurately; the same was true, in time, for the evangelists who wrote about Jesus Christ: recording precisely what words had been used, agreeing what they meant and how they were to be understood became a matter of profound importance in the Christian church – and not just in its earliest phases. Discussion, disa-greement and debate between the clergy have been constant themes in the history of Christianity and the Christian church.

The same is true with Islam, where establishing precisely which messages had been revealed to Mohammed in the 7th century required a formal codification in a single volume that is now known as the Koran (literally: the recitation) – and concurrently, the suppression of variants, and of versions that recorded something different. In Judaism too, great store was placed on assuring standardisation of the content of the Torah, the Jewish bible. Messages passed by God, in this case through Moses, needed to be captured exactly before being passed along to the faithful.

Different religions had different methods of expansion and propagation – with some of those driven by their faith to inform, spread their knowledge and evangelise among new communities. The geographic diffusion of faiths like Buddhism, Christianity and Islam was closely linked to transport links and to trade routes. Commercial exchange naturally brought (and brings) the opportunity to do more than just buy and sell products: it also facilitates and encourages the spread of ideas about food, fashion, entertainment and much more besides – including, of course, the divine.

Indeed, the correlation of trade routes and religions that did not actively seek to recruit new members – such as Judaism, where faith and ethnicity were closely bound up together – found incentives to spread into new locations as exchanges between traders and merchants galvanised towns, cities and communities. Although much of the commerce along the Silk Roads, the world's primary web of networks from antiquity to the early modern period was local, with towns serving as local hubs for their hinterlands and being linked with immediate neighbours, elite, high-value goods that were traded in small quantities offered the opportunity for substantial profits.

The shipment of valuable commodities and products, like jewels and fabrics, precious metals and spices required security measures to ensure safe passage of goods and merchants alike. This was provided in the first instance by states themselves, which took precautions to ensure that travellers – and traders – were not harassed. This was partly in order to ensure stability within their own kingdoms; but the scale and nature of systems put in place also make clear that another motivation was to establish conditions that facilitated business, with the aim of generating taxable revenues.

Evidence from the Kingdom of Khotan in what is now western China that is more than a thousand years old explains how squads of militia

were sent on rotation into the countryside to patrol the region and to investigate any unusual occurrences. Reports about the calmness of daily life in Syria, where no one feared brigands, circulated thousands of miles away, while writers like the famous traveller Ibn Battuta, whose adventures took him from North Africa deep into South and East Asia as well as the Middle East, commented with wonder about how easy it was to move around China, with the wealthy being able to do so without any fear of being harassed or robbed; they talk not only of the sophistication of states many centuries ago, but also of the way that efforts were made to enable goods and people to circulate.

This did not mean that people did not get cheated: in fact, as guides like that written by the Florentine merchant and politician Pegolotti reveal, being safe on one's travels did not stop one getting taken for a ride. There were risks of being ripped off if you did not have local knowledge – with Pegolotti recommending that guides who knew what they were doing, where they were going, and perhaps just as importantly, who was who, were worth every penny. Having knowledge and being street-smart were separate skills in the past, just as they are today.

For others, though, alternative solutions were found for the problems of how to move goods and money around safely. In some cases, currency was issued that looked and weighed the same as others, in order to make buying and selling easier. In other cases, what might be considered as single currencies became popular far away from the locations where the coinage was minted. So many silver coins struck in Central Asia found their way north along the river systems of what is now Ukraine and Russia, that it is both logical and plausible to believe that those responsible for bringing them – the Scandinavian Vikings – relied on these pieces to trade with each other, as well as with local communities.

In China, and then elsewhere, paper money that did not reflect actual value began to be issued at least by the 13th century, with notes having a notional, promissory value that could be relied on by the owner across a wide region. This practice eventually caught on all around the world, replacing the reliance on gold and silver in the first instance, and also on the bulk carriage that moving large volumes of both involved.

However, while China typically gets credit for the introduction of paper money and banknotes, communities all along the Silk Roads had long relied on credit. Moving money or goods long distances was itself expensive and could also leave what would now be called a trade deficit

Next pages: Connectivity in the modern age.

of goods and payments ending up in the wrong place. One way to deal with this was to create closed credit networks, typically between minority communities that were distinct either religiously, ethnically or linguistically – or all three.

As such, a key part of the history of the Silk Roads involves the role played by peoples who were themselves a part of communities that spanned long distances. These included the Sogdians, referred to in the 7th-century Chinese *Sui Shu* (*Book of Sui*) as highly skilled merchants; Jews, whose presence across the Middle East and Central Asia is testified to by a rich literature, as well as multiple magnificent synagogues; and Armenians who became heavily involved in trade between South Asia and Iran, as well as the world beyond, in the early modern period.

Indeed, the engagement of Europeans in the Americas as well as in Africa, Asia and Oceania can be viewed through a similar lens, at least in its initial stages, with the British, Dutch, French and Spanish arriving in small numbers and playing a role in stimulating commercial exchange, and also culture, ideas, information and knowledge.

As relations became more regular and trade increased, new styles did not just become popular in Europe, but also became dominant. Colour and design of ceramics from China and the Middle East became so widely adopted that the classic blue-and-white style is now as identifiable with Delft and the potteries of Stoke as to be considered local. The popularity of chinoiserie in interior design became widespread in the 18th century, as did paisley patterns from Persia in the swinging Sixties in the 20th century.

Cultural influences were striking in the way that they moved from East to West, imported, borrowed and appropriated if not as imperial spoils then at least as additions that served as reminders and examples of the benefits of the extensions of military, political and economic power.

Some observers were struck by the asymmetry and the imbalance of relations between Europe and other parts of the world – especially Asia. As Voltaire put it in an essay on the customs and habits of nations: "The peoples of the Western hemisphere... have demonstrated the overwhelming superiority of their genius and courage over the countries of the Orient." Europeans, he said, had settled among and had come to dominate those peoples in different countries, overcoming their resistance, and managing to learn their languages. "Nature, however, gives them one advantage that outweighs all of our own; put simply, they do not want us, but we want them," he noted.

The extraction of minerals, goods, and assets (which included people) provided impetus for new ideas in Europe that helped shaped the period often referred to as the Enlightenment. Certainly, the curiosity spurred by contact with new ideas, cultures and peoples, as well as the acquisition of written texts, material culture and examples of new animals and organisms, were fundamental to a series of revolutions in the sciences as well as in the humanities. The age of European empire, coupled with the speed, scale and growth of long-distance contacts made possible by ever-more reliable, larger and cheaper ships, produced rich fruits for an astonishing period of scholarship.

However, this was closely related to the rapidly growing financial muscle that came with the reality of imperial expansion: artists and scientists need patrons and patronage. It is no coincidence, then, that the period of rapid academic advancement was mirrored by one of growing professionalisation of the processes of extraction from the Americas, Africa and Asia.

This also brought with it changes in attitude to indigenous populations in other continents, including those who had great realms of their own. As one leading scholar has put it recently, the 1700s marked a century of transition of ideas about China where Sinophilia gave way to Sinophobia over the course of a hundred years. This process was mirrored in attitudes to other parts of the world, including Persia, South Asia and Africa, where local rulers and populations increasingly became the subjects worthy not of emulation but of mockery.

As critics of capitalism have long pointed out, while free market theory postulates the benefits of buyers and sellers agreeing on a price that is mutually acceptable without government interference, the realities are that this system can easily become unbalanced when dominated by the pursuit short-term profits. The case of the East India Company provides one good example of this, when the incentives and rewards were so lavish as to prove irresistible; the global financial crisis, in part spurred by the insatiable appetites of financiers to devise more and more complex instruments that seemed too good to be true (and turned out to be just that) provides another.

The parallels between the past and present are also instructive when it comes to patterns not only of trade in general, but of information, knowledge and data in particular. Today's priesthood, who wield enormous power both personally and institutionally, are the digital pioneers whose

companies are the new empires of the 21st century. Although companies like Facebook, Google, Twitter and others call those who enjoy their services "users", rather than customers or clients, in order to create the impression of egalitarianism, the reality is that the services provided by these titans are not free. Rather, the contracts we enter – both literally and metaphorically – are ones that make us subject to the power centres in each case. In each case, the voluminous "terms and conditions" that we sign to give our approval to the way that our data is used is given away with a single click, ceding at a stroke what we do, what we find out, who we connect with, where we are, and more besides.

We might call ourselves digital citizens, who form part of a digital community, but the reality is rather different. There is a price to pay for being able to access digitised books online, to make a booking for a restaurant around the corner, or for calling our friends on the other side of the world. Minority communities used to develop their own language to ensure secure communication along the Silk Roads; the same is happening today via computer coding, through third party authentication to ensure transactions are safe, and through the process of encryption that allows messages to pass unread. Bitcoin, Ethereum and Blockchain provide solutions to questions that have been asked for centuries.

Arguments with the priesthood used to revolve around which teachings were disseminated, by whom and how; the modern equivalent comes with testimonies on Capitol Hill in Washington or in parliaments around the world, where the question ultimately revolves not about the division between the church and the state, but between that of the state and private corporations whose interests – like those of the church in centuries gone by – sometimes elide with those of governments, but often do not.

One of the themes of the 21st century is that of a profound shift in global power from West to East. In many countries in Asia, responses to change have included a crackdown on freedom of speech, obstacles placed in the way of a free press and also impositions on digital corporations which include demands to hand over user data to the authorities and in some cases blanket bans that cannot be circumvented by virtual private networks (VPNs).

Control of information is paramount in the making of the new world; so too is intellectual property which not only has financial and commercial value, but perhaps just as importantly allows for an acceleration of research and development and also of production. According to recent

figures released by a US government agency, the theft of information protected by patents, copyright and trademark, including highly sensitive technological and military information, is costing the American economy somewhere between \$225–600 billion a year.

When we think about history, we sometimes think about important events, or the achievements of great figures – who tend to be generals, rulers and revolutionaries. In recent decades, historians have done much to open up our investigations into the past to try to understand other perspectives too, not least to include those whose roles and experiences are often overlooked by more traditional approaches. Understanding the past through the lens of women and gender, that of non-elites, of ethnic, religious or linguistic minorities has opened up many rich new seams for future generations of historians to work on in the future.

But so too has the idea of looking at themes that span the human experience, that are not restricted to a single country, region or continent or even to a defined period. Studying the exchange of knowledge and the way that information has intensified interactions between states (sometimes with violent outcomes), driven the sciences and arts forward and presented challenges to those in the past, is very useful, not least in helping to provide a context for many of the questions that face us in the present and which will continue to need addressing in the future.

As a species, human beings are extraordinarily resourceful, inventive and also curious. There are times when these characteristics make us capable of profound horrors, when mass media, false or exaggerated claims and technological proficiency enable mass persecution on a scale that facilitates genocide – as it did on many occasions in many states in the 20th century, most obviously during the Second World War.

Our curiosity is capable of being harnessed too, however, and directed into the creation of music, literature and art that is breathtakingly beautiful, or of applications, devices and products that make our daily lives not only easier but more pleasurable, more connected and more meaningful. Getting the balance right between protecting us from ourselves and encouraging co-operation and collaboration is not easy. It is one that our ancestors would have recognised thousands of years ago.

A portrait of Martin Luther, ca 1530,
after a painting by Holbein.

THE SOCIETY OF JESUS AND ITS EARLY
GLOBAL NETWORKS OF KNOWLEDGE

M. Antoni J. Ucerler

B y 1517, a young Augustinian monk and professor of moral theology at the University of Wittenberg by the name of Martin Luther had had enough. Convinced that the Roman Catholic Church needed to be reformed and purged of corruption, he presented 95 theses that summarised his objections to the pastoral practices and theology of his day. Neither Europe nor the church would ever be the same again. While the Roman Catholic Church reacted vigorously and opposed Luther and other reformers, the opposition did not simply amount to a "counter reformation". Almost everyone agreed that some reform was urgently needed, even if there was disagreement on whether this should imply a complete break with the past structures of the church. There had already been calls for reform from within the church's own traditional ranks; and new groups formed and proposed different ways to reanimate the faithful.

One such group, approved by Pope Paul III as a new religious order in 1540, was the Society of Jesus, or Jesuits, as they soon came to be known. These ten men, who came from within the borders of present-day Spain, France, and Portugal had first met at the University of Paris, where they were studying for the degree, Master of Arts. Having achieved this goal, they wished to dedicate themselves to missionary work in the Holy Land to oppose the growing Muslim influence of the Ottoman Empire but were refused permission to do so by the local Franciscans in Jerusalem, the traditional custodians of sacred Christian sites.

They then decided to head to Rome to offer their services to the Pope to work for reform from within the church and to go wherever the Holy See judged they could be useful. They soon found themselves at the forefront of the confessional battles over whose vision of reform should prevail, that of the Roman Catholic Church or that of the reformers and their followers. But while the Jesuit educational project certainly did not ignore or fail to engage with the controversies of the day, religious strife

was not the only defining feature of the early modern world or of the work of the Society of Jesus.

To pursue their objectives, the Jesuits did something that they had originally determined that they should not do: establish schools. The order's principal founder, Ignatius of Loyola, had fretted that taking on responsibility for institutions would hinder their mobility and availability for the mission, but he was soon persuaded that education could be a potent instrument of cultural influence and religious transformation. Their first college was established in Messina in Sicily in 1548. Dozens of colleges were built throughout Italy under the patronage of the local nobility and of rulers and within decades there were several hundred Jesuit institutions of learning across Europe, Latin America and Asia. But none was more important than the Collegio Romano or Roman College, established in 1551 and dedicated to *religioni et bonis artibus,* "religion and solid learning [the arts]" – a simple motto summarising what it sought to achieve. These new schools became powerhouses of learning and reposi-tories of knowledge, regulated by carefully crafted guidelines, known as the *Ratio studiorum,* which outlined in great detail a curriculum that included the subjects of the traditional *trivium* (grammar, logic, and rheto-ric) and *quadrivium* (arithmetic, geometry, music, and astronomy), as well as philosophy, theology, and other subjects, including elaborate theatrical performances. They thus prescribed a rigorous training both in the classical *studia humanitatis* and in the sciences, with a special emphasis on mathematics, physics and astronomy.

It was at the Roman College that the Jesuits engaged in debate with Galileo. Most prominent among them was Christopher Clavius (1538–1612), who taught mathematics and astronomy to generations of students. Clavius's 1574 Latin edition of *Euclid's Elements* became a popular text-book, was reprinted dozens of times over an 80-year period and earned him the title of the "Euclid of the 16th century". The college was also where that most remarkable of 17th-century polymaths and eccentric par excellence, Athanasius Kircher (1602–80), set up his famous hall of won-ders and cabinet of curiosities, which became the Roman College Museum. The sources for the objects and information that he so copiously reproduced in his works were in great part his fellow Jesuits, engaged in the principal and original pursuit of the Society – working in its missions across the globe. For better or for worse, it was an exciting and transform-ative age of maritime exploration and discovery and the Jesuits took full

advantage of the new horizons beyond Europe, which they no longer considered their final frontier.

To underscore their intentions, Ignatius sent Francisco Javier (or Francis Xavier), one of the founding companions, to India six months before the final approval of the Order on September 27, 1540. From Goa and Cochin he travelled to Indonesia and Malaya, before becoming the first missionary in Japan. While in Japan he realised the importance of Chinese civilisation and compared it to the influence that ancient Greece and Rome had exerted on Western culture. He made it as far as the Chinese island of Sanchuan, off the coast of Guangdong province, but died before he could set foot on the mainland – a task that was taken up by the next generation of missionaries in East Asia.

Other Jesuits subsequently made their way to the Philippines, to Mexico, Peru, and Paraguay as well as to New France in present-day Canada. In the Americas they engaged with the indigenous peoples and learned many of their languages, including Aymara and Wendat (Huron). They explored and mapped the Amazon; and the Italian missionary, Eusebio Francesco Kino [or Chini] (1645–1711) journeyed across the western United States between 1698 and 1701 and proved that California was not an island but a peninsula. Both his findings and those of the Jesuits involved in the famous "reductions" in Paraguay were meticulously mapped and published, several in hand-coloured editions that illustrated the locations of the various missions. In Japan the Sicilian Jesuit, Girolamo De Angelis sent back the first European report on the existence and location of the island of Hokkaido (then referred to as Ezo) as early as 1621. The adventures of these individual men were remarkable, but their contribution to the creation of organised networks that transmitted information and knowledge did not happen by accident but was the result of careful planning and foresight.

This brings us back to the beginnings of the Society of Jesus. The ideal of missions, as summarised by Jerónimo Nadal, one of the order's most prominent early members, in the phrase "the world is our home" (*nuestra casa es el mundo*), soon became a reality that affected the lives and fortunes of hundreds of men who had been sent to far-flung missions across the world. But Ignatius worried that this international dispersal, which the society had embraced as its particular charism, might nevertheless also spell the end of the society as such, for without communication among its members, *esprit de corps* could soon dissipate and disappear. To counter

this risk to its internal unity and cohesion, he created and mandated an elaborate system of reporting and letter writing from the peripheries back to the centre – Rome – every year. From Rome, Ignatius and his assistants responded to the questions and concerns that had been raised by missionaries in the field. They resolved disputes and recommended particular courses of action to individuals and their superiors in a specific region – including throughout Europe. At the same time, they also made an effort to communicate to everyone, regardless of where they were, what the order as a whole was thinking. This system was enhanced by personal encounters that took place at regular intervals. Every "province", or regional unit, of the society was charged with sending to Rome every three to five years a "procurator", a man who had been locally elected by his fellow Jesuits to represent them and their concerns. His task was to communicate in person the state of that mission to the society's leadership. Procurators also met with each other while in Rome and brought back to their respective outposts instructions from the Superior General, together with news from Rome and from members of the society working in Europe and in other countries and continents.

The result of all this written communication was one of the largest archives to issue from a single "non-governmental organisation" in the 16th and 17th centuries. The documents that have been preserved range from personal and official letters, financial reports, property deeds, ethnographic treatises, dictionaries and devotional books translated into native languages, from Nahuatl (Aztecan) to Chinese. The archives also preserve a large collection of manuscript maps, paintings, and drawings of fauna and flora in countries as distant as Peru and China, Japan and New France. Ignatius himself left us one of the largest collections of personal correspondence of any figure of the 16th century, with over 8,000 extant letters, most of which are preserved in Rome. What makes this collection all the more remarkable is that so much of it has survived, despite the suppression of the Society of Jesus in the 18th century and the nationalisation of all church properties by the unifier of Italy, Giuseppe Garibaldi in the 19th century. Parts of these extensive archives are now in Vatican or Italian state collections, but most of the documents have found their way back to the headquarters of the Society of Jesus in Rome. They reflect the religious and cultural history of the early modern world and are regularly consulted by historians.

What made it possible for Jesuits to travel so extensively at a time when

such journeys were limited to a minuscule group of carefully selected passengers, whether merchant, missionary, or colonial agent? They were quick to take advantage of the division of the known world decreed by the Treaty of Tordesillas in 1494, in the wake of Columbus's "discovery" of the Americas, that allowed Spain to explore and colonise the New World, and Portugal to explore and colonise the East. (Portuguese Brazil was one notable exception in the West, and the Spanish Philippines was the other exception to this rule in the East.) Missionaries found passage aboard these ships and came under the jurisdiction of one or another system of royal patronage. The Portuguese *Padroado real* or the Spanish *Patronazgo real* regulated all secular and ecclesiastical affairs in the territories and colonies under their governance or spheres of influence.

These shipping routes made it possible to send back to Europe both letters and artefacts, some of which had never been seen before in Rome, Lisbon, or Madrid. The Portuguese route was very long and tedious and took almost thirty months, from Lisbon to Japan, with long breaks in Mozambique, Goa, Malacca, Macau and Nagasaki. The journey was marked by the treacherous rounding of the Cape of Good Hope, originally referred to as the "Cape of Storms", where many ships sank in the early decades of navigation.

In 1565 the Augustinian Friar, Andrés de Urdaneta (1498–1568), discovered a route from the Philippines to Acapulco that made use of the Black Current, taking the Manila Galleon northwards to Japan and picking up the North Pacific Drift, then sailing across the Pacific and first making landfall at Mendocino in California. Urdaneta's crossing from Cebu took only four months and one week (between June 1 and October 8). From Acapulco, they travelled over 725km by land to the Atlantic coast at Veracruz – a crossing that had its own dangers, in particular from marauding bandits who often attacked the convoys. Once they had reached the Atlantic coast, they re-embarked and crossed the ocean for six to eight weeks until they reached the mouth of the Guadalquivir River, near Cádiz. The last part of the journey was sailing the final 83km upstream to Seville, the colonial and financial headquarters of the Spanish empire. If all went well, this route from Manila to Seville could be covered in about nine months, less than half the time required by the Portuguese.

Jesuits were initially sponsored by the Portuguese crown, and in particular by King John III, but they subsequently made use of both routes, notably after the union of the crowns of Portugal and Spain under

Next pages: Detail from *Purchas his Pilgrimage: or Relations of the World and the Religions observed in all Ages and Places discovered, from the Creation unto this Present* by Samuel Purchas, published in 1613.

North Part of AMERICA

Conteyning Newfoundland, new Eng-
land, Virginia, Florida, new Spaine, and
Nova Francia, w'th y' riche Iles of Hispaniola, Cu-
ba, Iamaica, and Porto Rieco, on the South,
and upon y' West the large and goodly Iland
of California. The bonds of it are the Atlan-
tick Ocean on y' South and East sides y' south
sea on y' west side and on y' North Fretum Hudson
and Buttons baye a faire entrance to y' nearest
and most temperate passage to Iapa & China

In Porte Nelson did S'
Button winter in 57 deg: findinge the t
constantly euery 12 howers to rise 15
more: and that a west winde did make th
tides equal to y' springe tydes. And y' sumer
about y' latitude of 60 degrees he founde a stro'
of a tide runinge sometymes eastwarde somety
wards whereupon Iosias Hubbarde in his platt c
Hubbarts hope

In the Bottome of Hudsons bay
but two foote, and in the bottom
Baffin to be but one foote, whems
Porte Nelson, it was cons tan

C. Nelson

Hubbarts hope

C. Philip

C. Blanco

C. de S' Sebastian
C. Mendocino
P. S' Francisco Draco
Punta de los Reyes
P. de monte Rey
P. de Carinde
Punta de la
Conception
Canal de S'
Barbaria
Punta de
Conception
P. de S' Diego
S' Catalina
S' Clement
S' Martin
J. de Paraxos
S' Marco
J. de Ceintas
J. de la Carra

Laguna de
Anguchi

R. de Anguchi
R. de Flecha
R. de Corall
S' Miguell

REY COROMEDO

PVEBLOS DE
MOQVI

AMERICA

REAL DE NVEVA
MEXICO

B. de todos Santos
B. de S' Quenten
B. de S' Virgines
P. de Engaño
P. de Francisco
P. de S' Symon
P. de S' Bartolome
Sierra Pintada
P. de Roqui
B. de las arenas
R. de S'
Cristoual
Punta de S'
palmat
P. de Mastin
P. de la Nidad
R. de la Madalena
B. S' Iames

Las Playes
P. de S' Clara

R. Gigante

Costa del Perles

R. del Norto

S' Francisco
Petarlan
Culiacan
Punta de sinoloa
R. Guahmac

ASTABLAN

GRANADA

R. de Nauito
VILA DE S'
SEBASTIAN

NEWE
MEXICO

Vllao

B. Barnabe
S. Marias
C. de S' Lucas

Cuthuacan
Chiametlen
P. de xalisco

Cuchillo

SPAINE

California sometymes supposed to be a part of y' westerne continent,
but since by a Spanish Chart, taken by y' Hollanders it is found to be
a goodly Ilande: the length of the west shoare beeing about 500 leagues
from Cape Mendocino to the South Cape there
as appeareth both by that Spanish C
Gaule whereas in the ordi

S' anublada
Roca Partida

MEXICO
Valleras
P. de Senendad
Quahyatula
Ciguatanso
Aquapalco

295

Frenum Hudson — Ile resolution

50

C. Charles
The Kings foreland
Hackluts headland
Howld with hope
Buttons files
Smiths foreland
The Iles Merchants

NOVA
BRITTANNIA

45

Bell Ile — Feeke
Groy
May
Cogones
I. of Berts
Verluces
Bonauista
B. Concaruaption
of Bulls
Agosorte
C. Race
B. Portugall
Terra England
C. S. Laurence
I. Comeado
C. Britten
P. Anglois
I. Rouge
Sablon
C. Negro
Cit. Sable
Ancile Sablon

Newfound land

345

40

The lake of Angoleline
The peer Bauters
Red Bay
Canada

35

340

New England — Plymouth
C. Codd
De la war bay
Hudson
Caupaw
Marthas vinyard
Elizabeths I.

IONALIS

30

C. Charles
C. Henric
Creatomong
S. Haterash
Croatean
Virginia
Roanoke
335

Summers ſlands

25

Florida
B. de Baxas

20

Tertugas
Bahama
Lucaii
Cigacata
Gamina
330

Abroio
el Sombrito

Hauane
Porus principis
Triange
St. Johns
Anguilla
S. Antonio
C. CVBA
Mota
Baracca
C. Enano
15
C. Latoche
Trinitat
S. Iago
Torquina
P. noua
Pt. Rico
HISPANIOLA

Cozumel
Iameca
Iibroc
Domingo
325

Cainanea
10

Philip II in 1580. They also travelled overland and by ship on more local routes, for example between Lima and Mexico or between Nagasaki, Macau, and Manila. Regardless of which route they took, correspondence was always at risk of being lost, especially at sea.

To ensure the arrival of their correspondence, the Jesuits in Japan and China would usually make three copies of each letter and send them on different ships, in the hope that at least one copy would survive and reach its final destination. The Roman archives of the society sometimes preserve all three copies, sometimes only one or two copies, and sometimes there are only references to a letter – that had obviously not reached Lisbon or Rome as a result of the perilous voyage. Correspondence was not always lost because the ship sank. With the ascendancy of the Dutch and English maritime empires in the 17th century, Portuguese and Spanish ships were sometimes captured and documents confiscated. This explains why some of these letters and reports are preserved to this day in archival and library collections in the United Kingdom and the Netherlands.

Manuscripts were not the only way to transmit information. The Society of Jesus put to good use the first great "information technology" revolution in Europe: the invention of the Gutenberg hand press. They realised that the missionaries' correspondence and reports were of great interest to the European public. Reading eyewitness reports about places such as Japan, which had been mentioned centuries before by Marco Polo as a legendary island filled with silver (but without any concrete evidence of its exact location), was as exciting to readers in the 16th century as it might be for us to see images from the Mars rover that took months to reach earth. The Jesuits were well aware of the value of these reports to further their own mission as well as to counter Protestant claims of being a more "universal" church.

These letters were edited and subsequently published in many languages by the leading printing houses of Europe, beginning with collections of letters printed in Portugal and Spain by the royal presses. Other prominent printers included Kristoffel Plantijn [or Plantin] (1520–89) and Jan Moretus (1576–1618) in Antwerp, as well as Johann Mayer (1576–1615) in Dilingen. In Italy, besides generations of the wealthy Zannetti family of Rome and the influential Giunti publishing house of Florence, there were the Gioliti of Venice and Sébastien Cramoisy (1584–1669), the royal printer in Paris, to name but a few. Cramoisy took advantage of Jesuit correspondence coming from both the East Asian and

New World missions. These included his editions of accounts of the Japanese martyrs, of the missions among the Huron (Wendat) people, and of the accounts ("relations") of the Jesuit martyrdoms in New France (Quebec) in the mid-17th century.

It is significant that these imprints were circulated not only in Europe but also across continents. For example, the report by Pedro Morejón from Japan describing the beginning of the persecution of Christians in 1614 was brought to Rome as a manuscript, edited, translated into Italian, and published by Bartolomeo Zannetti. From Europe it was sent to Mexico, recast into Spanish and printed locally by Joan Ruiz just two years later. It was then translated into English, reprinted in 1619 on the Catholic press at the English College of St Omer in France, not far from Calais, and smuggled into England for the benefit of local Catholics.

But it was not only Catholic presses, official or clandestine, that were interested in these books. As politically or religiously "incorrect" as it may have been to print them, one effect of Gutenberg's revolution was to create an insatiable desire for knowledge and information. And with an eager market of consumers, it was not long before printers realised how lucrative a commercial undertaking this was. One example is an early Elizabethan era imprint, the *History of Travayle in the West and East Indies* [...], printed in London in 1577 by Richard Jugge. This volume reproduces letters from the Portuguese Jesuit missionary, Luís Fróis, including the first detailed description of Japan ever published in the English language. The compilation was prepared by Richard Willes (1546–79), who had met the archivist of the Society of Jesus, Giovanni Pietro Maffei (1533–1603), in Rome before returning to England in 1573. Although Willes chose to abandon the society and his Catholic faith, he did not hesitate to cite in the printed text itself his "old friend Maffei" as his privileged source of information. Even the word he first used for Japan in English, "Giapan", is clearly influenced by the Italian word, "Giappone", which he would have learned from his former Italian confrères.

We have another example in the English cleric and academic, Samuel Purchas (1577–1626), who continued the work of the great travel writer and proponent of the American colonisation of Virginia, Richard Hakluyt (1553–1616). The latter had composed his *Principall Navigations, Voiages, and Discoveries of the English Nation* beginning in 1589, one of the most comprehensive travelogues printed in English. In Purchas's *Hakluytus Posthumus, or Purchas his Pilgrimes*, printed in 1625–26, an

expanded version of an earlier work he published in 1613, he begins by paying due diligence in his lengthy preface to criticising the Jesuits' "Popish superstition" as well as their "Politicke Mysteries and Mythicall Policies". But he then quotes extensively from Jesuit letters on Japan throughout his writings and tacitly accepts them as a reliable and even authoritative source.

Yet another particularly important case is that of Amsterdam, where the official Calvinism of the state was not usually allowed to interfere with profitable commercial ventures – the basis of Dutch success. The German Jesuit, Athanasius Kircher, published most of his works, including a deluxe edition of his *China Illustrata* in 1667, with Johann Jansson van Waesberghe, one of the most important Dutch printers of 17th-century Europe.

Another area of great interest to Europeans, Catholic and Protestant alike, was, as mentioned earlier, cartography – a field of study to which many Jesuits made major contributions. Manuscript maps sent from the Americas and from Asia were later used as the source for important printed editions. One such hand-coloured map of China produced in 1606 by Jodocus Hondius (1563–1612) also shows Korea and Japan plus a cartouche that includes a scene of the execution of Japanese Christians by order of the Regent, Toyotomi Hideyoshi, in 1597. This visual "hyperlink" was based on Jesuit reports of the event that had arrived in Europe as early as 1599. Among other publications in Protestant lands, we find a Danish map of "Tartary", *Kort over det Ostlige Tartari til den Almindelige Reisebeskrivelse af Jesuiternes Kort*, that explicitly quotes Jesuit letters as its source. This map, printed in Copenhagen between 1748 and 1760, was based on the work of renowned French geographer and cartographer, Jacques-Nicolas Bellin (1703–72).

A revised map by Bellin printed in German in Leipzig in 1749 is entitled *China nebst Corea und den benachatbaren Laendern der Tartarey*. The latter map cites in its title the cartographic survey the French Jesuits undertook for the Kangxi Emperor in China between 1708 and 1715 that was subsequently published by the Imperial Court as the official atlas of Qing China. Several decades earlier, the Italian Jesuit in China, Martino Martini (1614–61) produced his beautifully illustrated atlas of all the provinces of China. Martini returned to Europe from his mission in China and arranged for its publication in 1655 in Amsterdam, where he worked closely with the Dutch mapmaker and printer, Joan Blaeu (1596–1673). What resulted was the most important European atlas of China in the 17th century.

Besides cartography and ethnography, missionaries also produced manuscript drawings of fauna and flora based on detailed observation, including that of a hippopotamus or "sea horse" (*cavallo marino*) by the Polish missionary to China, Michał Boym (c1612–59). He later compiled all his drawings and descriptions into his famous collection printed in Vienna in 1656 entitled *Flora Sinensis*. This first "natural history" of China, which was re-published in numerous translations and editions, included copious notes on the richly coloured illustrations of plants for the benefit of the curious European reader, including drawings of "exotic" fruit such as the pineapple, lychee and mango. A century later, the Dutch engraver, Johan van Schley reproduced them as individual sheets.

The Jesuits' publishing activities were not limited, however, to European printing houses. They also exported printing presses to publish books and pamphlets in India, Japan, Peru, and Mexico. China stands as an interesting exception, as the Chinese already had an extensive network of printshops that produced books from woodblock, primarily for those who were preparing to take the provincial and imperial examinations that were the prerequisite for government service. Thus, in China, once they had mastered the language, the Jesuits made use of these local printshops and relied on the patronage of mandarins and scholars whom they had befriended, to print works they had composed in classical Chinese. In Goa and Nagasaki, on the other hand, they imported a Gutenberg press; and in Japan they were the first to experiment with the casting of metal Japanese type. Curiously, metal type first arrived in Japan from Korea, where it was used by Joseon dynasty printers from as early as the 13th century. These types were brought back by the Japanese who had invaded Korea in 1592. It was around the same time that Jesuits independently produced their own Japanese metal type. They also published at their college in Nagasaki between 1604 and 1608 the first Western grammar of Japanese and the first European dictionaries of the language. These works remain an indispensable source for the study of pre-modern Japanese.

But the networks of knowledge did not flow only in one direction. In the case of East Asia, they brought Western scientific knowledge, particularly of mathematics and astronomy. It was also collaborative. Matteo Ricci (1552–1610) worked with his first convert, the scholar and mandarin Xu Guangqi (1562–1633). Together they produced the first translation of Euclid's *Elements* into Chinese in 1607. The word they coined together for

"geometry" – *jihe* – is still used today in China, Korea, and Japan, according to the pronunciation of the two Chinese characters in each language. The preface in Chinese to this work mentions that Ricci "dictated" (*kouyi*) what Xu "recorded with this brush" (*bishou*). Ricci used in part as his point of reference the *Commentarii Collegii conimbricensis*, a series of textbooks on Aristotle and other classical works which the Jesuits had compiled at their university college in Coimbra, Portugal in the 1590s. Ricci also took advantage of the knowledge that he had gained while a student of Christopher Clavius at the Roman College before his departure for Asia. Even more impressive was Ricci's six-panel map of the world, based on Abraham Ortelius's *Typus Orbis Terrarum,* first published in 1570. Ricci translated his world map into Chinese with the help of another close collaborator, Li Zhizao (1565–1630) and the mandarin, Zhong Wentao. But unlike Ortelius, in his *Kunyu wanguo quantu* or "Map of the Myriad Countries of the World" (1602), instead of placing Europe and the Atlantic Ocean at the centre, Ricci placed China and the Pacific at the centre – literally creating a new *Weltanschauung* that was no longer eurocentric but rather in keeping with Chinese sensibilities. In fact, both the expression "Middle East" and "Far East" presuppose Europe as the principle reference point, from which distances are calculated – and Ricci's map reversed that. Europe had become the "Far West" and the Americas the "Far East". A great number of place names he translated into Chinese on this map are still used in China.

These maps were greatly sought after by both Japanese and Korean scholars for decades. Ricci's map reached Joseon Korea in 1603 and Edo Japan in 1604 and were hand copied or reprinted on woodblocks in the 17th and 18th centuries. Another example of early scientific transfer of knowledge took place at the Chinese court, where the Jesuit scientists, Johann Adam Schall von Bell (1591–1666) and Ferdinand Verbiest (1623–88), were in charge of the Imperial Astronomical Bureau. They reformed the Chinese calendar and, in the process, transmitted the work of Danish astronomer, Tycho Brahe (1546–1601) to East Asian scholars. The observatory that was built under the supervision of Verbiest, including many new instruments he personally designed, can still be seen in Beijing.

In 1644 Verbiest met in Beijing with Korean Crown Prince Sohyeon (1612–45), who had been a hostage in China following the Manchu defeat of the Ming empire. Verbiest gave him many objects related to his scientific work as well as works on the Christian faith, including Ricci's

True Meaning of the Lord of Heaven. These contacts were not, however, welcome when the prince returned to Hanyang (Seoul) the following year. King Injo (1595–1649) was suspicious and hostile to "foreign learning" and is suspected of having had his own son murdered for "treasonous" alliances with his Qing captors and their foreign "barbarian" advisers, ie the Jesuits. This tragic setback notwithstanding, these objects and maps became an important source for a new movement of "practical learning" (*Silhak*) that would dominate political and intellectual discourse in Korea a century later. The Joseon dynasty's greatest scholar and philosopher of the 18th century, Jeong Yakyong (1762–1836), known by his scholarly pen name, "Tasan", was deeply influenced by the Chinese books that the Jesuits had written – although he too initially paid a high price and suffered 18 years of exile in the remote countryside for his "Catholic" and foreign sympathies, while both his brother and nephew were executed for their Christian faith in 1801 and 1839 respectively.

In Japan, all the books that the Jesuits had composed in Chinese, including scientific works, were banned after the prohibition of Christianity in 1614. Nevertheless, the Japanese were eager to reform their own calendar and were curious about the scientific knowledge the Jesuits had successfully introduced at the Chinese court. They preserved copies of Ricci's map; and Edo period Confucian scholar and geographer, Nagakubo Sekisui (1717–1801) reprinted it in the late 18th century. This was made possible by Tokugawa Yoshimune (1684–1751), the eighth shogun, who relaxed the ban on the import of Jesuit scientific books in 1720 at the urging of the renowned Edo astronomer, Nakane Genkei (1662–1733).

These are just a few examples of how Jesuits in the early modern world acted as brokers of knowledge and information – creating new networks that connected Asia and the Americas to Europe, and Europe to distant worlds beyond the Atlantic and the Pacific. Their letters, reports and books often traversed not only stormy seas but those even more treacherous confessional and civilisational divides that marked the world they inhabited.

Gore Vidal.

INFORMATION HIGHWAYS AND
INFORMATION SNARL-UPS

Christopher Coker

In Gore Vidal's novel, *Creation,* a fictitious Persian diplomat called Cyrus Spitama, banished to Athens as an ambassador by his master the Persian King of Kings, remains largely unmoved by the Greek achievement; he is particularly bored by the interminable tragedies he is expected to sit through every other day. For a man who has spoken to the Buddha and debated the finer points of philosophy with Confucius, the Greeks are simply pompous bores. And what of their renowned philosophers? It is true that he makes the acquaintance of Socrates, but only so that he can hire him to paint the front wall of his house. Socrates needs the money. Vidal's novel nicely cuts down to size the most famous philosopher of the ancient world and, in so doing, allows a Western reader to grasp the actual distance of her own past against its deceptive familiarity.

And Vidal perhaps had a point. In Peter Frankopan's book, *The Silk Roads: a new history of the world,* Persia is portrayed as a beacon of stability and civilisation. By contrast, the Greeks are portrayed as small-time troublemakers, the kind that many German bankers think them to be today. Vidal, of course, liked to provoke. He was a mischief-maker. When asked on television in the 1960s whether his first sexual experience had been heterosexual or homosexual he replied: "To be frank, I was too embarrassed at the time to ask."

As it happens we still celebrate the Greeks for their intellectual achievements, the thoughts of Socrates included. The "glory that was Greece" was real enough, but today's historians now know something that the historians of Vidal's day didn't: the extent to which the Greeks were highly indebted to the civilisations of the East for many of their most ground-breaking ideas. Possibly, wrote the German scholar Walter Burkert, the "Greek miracle" owed everything to the fact that they were the most *easterly* of Western peoples.

None of this is really surprising. Contacts between civilisations are many and often surprising. The Greeks got their alphabet from the

Phoenicians and their astronomy from Babylon. A quarter of the Hellenic vocabulary has a Semitic origin. As for the extent of the collaboration between Greek and Babylonian thinkers, much may well have been lost to history, but we catch a rare glimpse of it when around 280BC a priest of the god Marduk founded a school of astronomy on the island of Kos where he wrote a book about his native Babylon in Greek. Some historians even go so far these days as to describe Hellenistic astronomy as Greco-Babylonian. Finally, the Greeks got the concept of money from Lydia. According to one writer it was the advent of monetisation in the 6th century BC that was the prime influence in the evolution of abstract thought and philosophy. Explanations of this kind tend to be over-schematic but they also help to demonstrate the ways in which imports from outside can influence intellectual developments in subtle, and often unacknowledged ways.

Even when it comes to philosophy (the Greek trademark) these days writers like Orlando Patterson, the author of *Freedom in the Making of Western Culture* (1991), are the first to acknowledge that the originality of Greek thought owed everything to the constant encounters with the "barbarians" they aspired to despise. Take the case of the pre-Socratics – the philosophers who came before Socrates – and the most famous of them, Heraclitus. Like all early Greek thinkers, Heraclitus tried to identify the driving force of the world in which he lived. And just as his countrymen thought metaphorically in terms of the elements such as air or water, he chose fire as a symbol of what he considered the most important force in life: flux or change. A flame can flare up briefly, illuminating its surroundings, before diminishing and casting us back into the darkness. Knowledge can be said to do the same. We often catch a glimpse of what is real before losing sight of it, and philosophers then try to put us back in touch with reality again. So where did Heraclitus get the idea that fire was the essence of life? Quite possibly from the Persian religion, Zoroastrianism. One of its principle tenets was the identification of wisdom with everlasting fire. The Persians worshipped the god "Lord Wisdom". The word *theos* appears nine times in the fragments that have survived from Heraclitus' work. Most translators elect to render the word into "god", but the smart money these days is on the word "wisdom". Hegel, for once, got it right when he wrote that Greek culture was the result of a confrontation with "the strangeness… it contained within itself".

In the end, Western civilisation is no different from any other: it offers a series of styles which interact and overlap, and which converge at the

poles of the pre-modern/modern eras, like meridians on a map. Western civilisation, like the few other civilisations to have survived into the 21st century, is highly diverse, and it is this diversity that is part of its underlying unity. As scientists discovered to their surprise in the 1970s, complexity is not an enemy of order, quite the opposite. The fact that an ecosystem is so complex is what makes it so stable.

In reality, wrote the Chicago historian William McNeill, "the principal factor promoting historically significant social change is contact with strangers possessing new and unfamiliar skills." And civilisations enable change thanks to what most possess: a lingua franca or unifying language (the language of the ruling elite) and the ability to network knowledge (think of the 48,000 miles of roads built by the Roman state). Think too of their centres of excellence such as schools and universities which tend to attract a community of scholars, many from abroad. All have helped to facilitate profound changes, both material and ideational.

But at the same time many people find these encounters and the changes they provoke profoundly disorientating; they often challenge the beliefs and values that civilisations brought into the world and helped to propagate. That is why they can provoke a backlash, a rear-guard attempt to protect society from corrupting influences from the outside world.

One of the most disturbing trends in the world today is the growth in some countries of an idealised existential version of civilisation in the often openly declared hope of giving a country a competitive edge in the zero-sum struggle for life. Immediately you may think of Social Darwinism which remained popular until it was finally discredited by the Second World War. It retained a following largely because of its pseudo-scientific claims. It suggested that there were inescapable biological laws which it was unwise to ignore. Race was considered to be a biological reality as well as the driving force behind history. And part of its appeal was that it could be invoked to justify the most ruthless market capitalism, as well as the most ambitious projects of social engineering. Its most famous formulation, "the survival of the fittest", was coined, after all, by a renowned liberal writer, Herbert Spencer (one-time editor of *The Economist*).

Cultural Darwinism also allows politicians of different persuasions to claim that civilisations find themselves locked into a struggle with eternal

enemies (usually the West). And, like Social Darwinism before it, it offers people a collective identity that is both inclusive and exclusive at the same time. It helps solidify the in-group while helping it to identify an out-group, which is to be defended against, not ignored in the discourse between the two.

Let me discuss three ideas that have gained some traction in China and Russia. The first is the claim that a civilisation has a unique cultural DNA, thanks to gene-culture co-evolution. The second is the claim that some languages are different – so very different as to make it next to impossible to engage in a cross-cultural conversation. And the third is the claim that we are shaped by the interaction between genes and geography. And all these myths share one thing in common: their use of metaphysical sledge-hammers to prise out hitherto unsuspected linguistic, genetic and genetic-geographical realities that are deemed to lock the world's respective civilisations into a confrontational future.

What makes all of this so depressing is that they are also unapologetically *transgressive*. They throw into question the cultural diversity which is a hallmark of our species, the fact that though we wrestle all the time with the fear of losing touch with the familiar, we all have to deal at some stage in life with the problematic encounter with difference.

★

One of the publishing sensations in China in the early 21st century was a novel called *Wolf Totem* (2004). Its subject is life in the remote steppes of Inner Mongolia, the most northerly of China's provinces, a life that is shared both by wolves and man. In an unremittingly hard existence, both compete for scarce resources. But both have also found a way to live in harmony, though this is now threatened by the demands of modern life. *Wolf Totem* is a totemic book. It has sold more copies in China than any work except Mao's *Little Red Book* and has been translated into several Western languages. It has even been turned into a movie.

Its author Jiang Rong (a pseudonym) was a victim of the Cultural Revolution (1966–76), a period of particular political turmoil in China's history. Jiang was exiled to Inner Mongolia where he eventually learned to prize a way of life even older than Chinese civilisation itself. For the nomadic peoples among whom he lived, Mao was not god; the sky was. And in place of Mao's famous *Little Red Book,* with its

revolutionary catechism, there was the wolf, both in the role of totem and teacher.

As it happens, the book is quite popular in the West. It is deemed to be ecologically sound. It is a favourite of many environmental campaigners who tend to take away a simple message: the goal of life should be the urgent need for coexistence with nature. But what they won't find in any of the translations is the epilogue with its quasi-Cultural Darwinist message. They won't find the bizarre claim that a country's history is determined by its peculiar genetic inheritance, the fact that over the centuries various nomadic tribes crossed the frontier into China. During the Song dynasty they included Tanguts, Khitans and Jurchens to name but a few. Over time, they gradually intermarried with the local population. Today's China is home to 56 different nationalities or ethnicities. Its great genius as a civilisation has been to persuade nearly all of them that they are Han Chinese.

But that is not actually the real message that Jiang Rong wants to get across. Instead he reminds his Chinese readers that their civilisation is a product of two different sets of genes: its "wolfish" traits are inherited from the northern nomadic races, and its commercial "sheepish" traits from the original Han people. And the distinctive rhythm of Chinese history – the rise and fall of its many dynasties – can be attributed to the fact that in every period in which the country has cut a figure in the world, its warlike genes have come to the fore. Jiang advocates returning to a "purer" form of Confucianism, to the period when the values of "steely fortitude and valour" were dominant. Indeed, the message of his book is to be found in an aphorism from *The Book of Changes:* a people should always strive for "self-strengthening".

Tatar genes, by the way, also make an appearance in another socially constructed myth which tells the Russians that they are not a European or even a Slavic people, so much as a Eurasian one. Even Hungary's right-wing Jobbik party links the Hungarians to the Turkic-Tatar peoples of Central Asia. For politicians looking for the main chance, a country's genetic inheritance is a blank screen onto which they can project whatever primordial fantasies they think their supporters will find most appealing.

★

Culture, as Charles Taylor tells us in *The Language Animal,* is behind the expression of every thought. A word only has a meaning within a cultural context. It is not possible to understand a word or a sentence in isolation; or to put it more directly, we often have to know the cultural background to make sense of the linguistic foreground. Language structures our way of seeing the world and thus profoundly alters our experience of it, often in life-changing ways.

The point is that, whatever linguistic differences there may be, the major works of every culture are open to translation. And yet in today's China there is a movement called cultural nativism (*bentu zhuyi*) that contends that the Chinese language is unique and that Chinese characters are an expression of the "national soul"; they penetrate its people's thoughts and its collective unconscious (or dreams). In other words, they can be considered part of the Chinese peoples' cultural DNA. Consistent with this belief, cultural nativists are demanding a return to "native studies", as well as an end to the practice of reformatting classical Chinese texts using modern (in this case Western) categories. And they are particularly scornful of Western sinologists, however gifted, for lacking what they call "cultural consanguinity". What is being claimed is that a non-Chinese speaker, even one who has mastered the language, can never really understand China or its people. In other words, the Chinese language is essentially unintelligible to non-Chinese.

All of this is nonsense, of course. However foreign a text may appear on first encounter, it can always be translated into another language: that is why we have a world literature. Ideas can be communicated across time and culture. Ultimately, cultural nativism is a telling example of an objection to an age-old civilised belief that every educated person on the planet should make an effort to learn a language other than his own. That is why, to quote the Nobel Prize winner Gao Xingjian, language is "the ultimate crystallisation of human civilisation". He notes: "The written word is also magical for it allows communication between separate individuals, even if they are from different races and times. It is also in this way that the shared present time in the writing and reading of literature is connected to its eternal spiritual value."

And what is the practice of international relations, asked the scholar Michael Oakeshott, if it is not what he called famously "the conversation of mankind"? It's worth quoting him at length:

Quotations from Chairman Mao Tse-tung is the only Chinese book to outsell *Wolf Totem*.

"In conversation 'facts' appear only to be resolved once more into the possibilities from which they were made; 'certainties' are shown to be combustible, not by being brought into contact with other 'certainties' or doubts, but by being kindled by the presence of ideas of another order; approximations are revealed between nations normally remote from one another. Thoughts of different species take wing and play around one another, responding to each other's movements and provoking one another to fresh exertion. Nobody asks where they have come from, or on what authority they are present; nobody cares what will become of them when they have played their part. There is no doorkeeper to examine credentials."

Unfortunately, the nativists want to reshape a culture with which they claim to have privileged intimacy. The doorkeepers are out there, intent on hobbling the conversation at the cost of narrowing the range of thought.

★

The famous Silk Road was, in the words of Peter Frankopan, "the key artery", the international highway which for thousands of years brought China and the West into contact with each other. The historian Felipe Fernandez-Armesto argues that the intellectual achievements of Plato and Aristotle and the Hundred Schools of Thought in China, and the Nyaya School in India, owed everything to the long-range cultural exchanges that one geographical region in particular opened up. Eurasia really is the world's greatest highway. If you were not part of the Eurasian world, you were marginalised in one way or another. Cut off from both Asia and Europe, Latin America and sub-Saharan Africa were both dealt a poor hand by history.

Unfortunately, Eurasia today has taken on a quite different connotation in contemporary Russian thinking. For some nationalist writers, geography translates very conveniently into geopolitics. Russia, they insist, is both northern and eastern at the same time: it is the fulcrum of the Aryan race and it has an inner Oriental nature. Geography makes it unique: racially western, Asian by culture, and possibly even inclination?

We are back to metaphysics and, in this case, Oswald Spengler who was at his best when he left his wilder theories behind him in favour of memorable insights which, though not always demonstrably true, are

nonetheless thought-provoking. One such idea was that whenever two civilisations interact with each other, one is bound to be more powerful, the other more creative. In this situation the more creative will be forced to conform outwardly to the more powerful civilisation's cultural configuration although the latter's ideas will never really take root. Spengler called the phenomenon "pseudomorphosis" and thought it applied particularly to Russia – a satellite society that, in the reign of Peter the Great, was drawn into the field of European civilisation of which it never really became part.

Some Russian writers would agree with him; they prefer to see their country as a civilisational state as opposed to a nation state and argue that the country, when a young and undeveloped culture, was set back by Peter the Great's attempts to modernise it along European lines. In Spengler's rendering of the story, the burning of Moscow in 1812 by its own citizens can be seen as a deprogramming exercise, a rejection of Peter's programme, even a primitive expression of a wish to return to its roots. The modernising Bolsheviks took a very different view: the novelist Gorky famously saw the Russian peasant as a "non-Russian nomad" and argued that the country's "Asiatic-Mongol biological heritage" had significantly retarded its historical development. Yet it is precisely that historical inheritance that now divides Russian historians, with liberals insisting that their country should continue to see Peter the Great in the traditional light as the great moderniser, and conservatives insisting that Russia can only be true to itself if it re-engages with its Asiatic-Mongol heritage.

The latter will tell you that, on the great Eurasian steppes, a variant of Tatar genes got recoded. The process was described as "passionarity" by one of the first Eurasianists, Lev Gumilev (the estranged son of the poetess Anna Akhmatova). It is not a word that most Russians would recognise even though it occasionally appears in some of Putin's speeches. It is the process by which organisms absorb bio-chemical energy from nature, in this case from the soil of Eurasia. Another writer, Peter Savitsky, later developed the concept of topogenesis, or "place development", to explain the deep link between geography and culture. Cultural Darwinism doesn't recommend itself only to novelists or poets; in Russia it has become a concern familiar to many political scientists. Group mentalities and invariant forms of biosocial organisation, unanchored in history, ethology or even mainstream textbooks on civilisation have become legitimate topics in teaching and research, and they are now well known

to the country's leading politicians. And that is one of the reasons why Russians are coming to self-identify in increasingly civilisational terms.

When you come to think of it the idea that civilisation is an organic entity is similar to Spengler's belief that it is an organism that experiences life cycles from birth to death. As with Spengler, there are Russian nationalists who feel that their own civilisation is measured by the seasons and pace of growth – and the more pessimistic, feeling that winter is already setting in, are given to dreaming of one heroic last act. If you visit Moscow you may see cars with bumper stickers proclaiming "To Berlin!" and "We can do it again!" (Both are rather crude allusions to the nation's achievement in the Second World War). In the West, most people are metaphysically tone-deaf but Russia is different; it always has been. And the concept of passionarity shows an interest in exteriorising the nation's psychic state in a physical setting. Although distinctly strange to a Western audience, it offers Russians an emotional engagement with the environment – it allows them to reconnect with a history much older than the era of the great moderniser, Peter the Great.

And the message? It is a rather bleak one. Much of the recent writing on why Russia is a civilisational state turns, as we shall see, on the antagonistic relationship between two opposing forces: Western cosmopolitanism and Russian nativism which may one day end in war. Unfortunately, all this is a telling testament to how the imagination can shape identities in bizarre ways; and how intellectuals in bed with a political class can hoodwink both themselves and others.

<p style="text-align:center">★</p>

In Ismail Kadare's novel, *The Palace of Dreams,* an empire (which is loosely based on the Ottoman) has a department which monitors its subjects' dreams for signs and portents of disaffection. Once collected, they are sifted through, classified and ultimately interpreted to identify the "master dream" that they share. Every country, Kadare implies, has dreams that are distinctive; every civilisation has a collective unconscious. If only it were possible to put a country and its people on the couch. (One can't of course but then perhaps it will be possible one day – Cambridge Analytica, the pollster credited with helping Donald Trump win his election harvested masses of consumer and personal information from Facebook to build a "psychographic profile" of the US electorate. If you know the

personality of a people and what they are dreaming you can adjust your message to resonate more effectively. Anton Vaino, Vladimir Putin's chief of staff, is even more ambitious: he is working on a "nooscope", a device to measure humanity's collective consciousness.) So, perhaps Kadare's novel is not so left-field. Except for the fact that while electorates may dream, civilisations don't. They are not unitary actors, unlike states, but that doesn't stop governments from seeding dreams in the mind of their own citizens.

Regrettably, today's political regimes in China and Russia prefer to exploit history quite cynically for their own purposes, usually to bolster their legitimacy. And they tend to hype up the elements of conflict in the encounters between societies in order to rally support for the status quo. Cultural Darwinism is useful for that reason, even if at the moment the competitive advantage it promises falls short of the "winner takes all" message of the Social Darwinism that preceded it. But the message is bleak enough.

Ultimately, our encounters with other human civilisations always involve an encounter with ourselves. Frequently we may conclude that we *are* superior and more civilised, and perhaps even congratulate ourselves on being exceptional. Sometimes, however, we may even see ourselves in an entirely new, and not always flattering light. Claude Lévi-Strauss spent much of his academic life telling us that what we find in other cultures is our own in unfamiliar dress. If we are willing to dig deep we will find the same regularities, the same social patterns, the same myths, even the same cognitive maps. In *The Savage Mind* he claimed that the Australians revealed a taste for erudition and speculation, but it wasn't the sun-bronzed surfers of Bondi Beach that he had in mind, but the country's much abused aboriginal peoples. In other words, occasionally our encounters with others can lead to a major breakthrough; sometimes they can get us to recognise that we are human only to the extent that others can see their own humanity in us.

THE STATE OF THE UNIVERSITY

Two completely different roads.

THE VOCATION OF THE UNIVERSITY
IN THE AGE OF SUBJECTIVISM

Janne Haaland Matláry

"When I use a word," Humpty Dumpty said in rather a scornful tone,
"it means just what I choose it to mean – neither more nor less."
"The question is," said Alice, "whether you can make words mean so many
different things."
"The question is," said Humpty Dumpty, "which is to be master – that's all."
Through the Looking-Glass, LEWIS CARROLL

As a university professor I cannot fail to notice that the tyranny of the perpetually insulted and discriminated against has also reached our own institution. I have no personal experience of this, perhaps because I do most of my academic work in the "hard" field of defence and strategic studies, explicitly relating to accountable facts and clear actor imperatives. Here we also rely on rational theories of interest-based action and strategic interaction, and most students and practitioners in this area share a mindset characterised by mental robustness and a keen interest in national security issues and realism.

However, claims of subjective feelings of discrimination abound, and group identity politics as a basis for quotas in all sorts of societal and professional settings is now commonly seen. Typically, some group will claim historical discrimination and "under-representation", and thereby assert its right to be equitably represented by means of a quota. These claims are seldom if ever established factually but simply invoked, and, even if justified, it does not follow from historical injustice that this can be rectified through granting jobs, study places or the like to members of these self-established groups. Moreover, this logic becomes even more problematic when school and university curricula are changed and rewritten to reflect the interests of these groups. This form of manipulation and politicisation is reminiscent of how totalitarian regimes seek to rewrite the past and thereby change it.

In this essay I examine the premises of the group identity phenomenon and especially the major problem of the extreme subjectivism that forms

its basis. First, I present some cases of this new politicisation, arguing that the dynamics are the same in these various examples: there is no tolerance of opposing viewpoints, those that refuse the group identity logic are even vilified. The group in question will invoke discrimination, self-defined, but also claim that quota representation is a force for good, bringing diversity to a societal field. Since those who oppose this are discriminatory on this logic, they are not to be tolerated.

In Norwegian schools there is a curious debate about *krenkning*, or being insulted when corrected by a teacher. One such teacher, Simon Malkenes, gained national attention when airing his frustrations and concerns on a radio programme, in which he quoted from his notes – "K walks about, L talks aloud, S leaves the classroom" – to illustrate the everyday reality for a Norwegian schoolteacher. This led his pupils to uproar – they were insulted and produced a formal complaint, citing the school's rules that no student must be insulted (*krenket*) by a teacher. Malkenes received a formal reprimand from his superiors and all hell broke loose in a very public debate. Under Norwegian school regulations, a teacher can be removed from their post simply for being charged with insulting or offending a student, and this on purely subjective grounds. This has turned things completely on their head and cleared the way for the practice of witch-hunts: Who will dare to give a poor grade to a student deserving of such, given these rules? The student may take it personally, feel insulted and launch a formal complaint.

The problem here is the issue of subjectivism, with students failing to distinguish between their own feelings of anger, disappointment, and low self-esteem because of poor results or bad behaviour and the objective facts of poor performance and/or bad behaviour. They are guilty of taking correction and criticism personally. Instead of recognising how poor their exam performances were or how unacceptable their behaviour was, they confuse and conflate the professional and the personal. This shows us not only that they lack self-awareness and the capacity for self-criticism, but also that they lack an ability to separate facts from feelings and emotions. If it is a fact that the student made a noise in class, it is a fact, and the one with authority to declare it a fact is the teacher. Likewise, if the student insists that two and two make five, it is not a fact,

it is simply incorrect – in this case an error that is easy to point out. But in many academic disciplines, facts are of course not so clear-cut. There epistemological theories are often called constructivist, arguing that there are no other facts than the ones I have constructed – or others have constructed. If reality is socially constructed, how can it be studied scientifically? Isn't a fact and my view of the former one and the same? Can there be any facts beyond subjectivism?

The Malkenes example concerns two major issues for any school or university: *authority* and *knowledge*. The two are related – the teacher has authority because he has expert knowledge in a particular field. The professor professes something because he has superior knowledge, to be taught to students. If there is nothing objectively important called knowledge, then there is no need for a teacher or a professor, nor for pupils or students. This is extremely elementary, yet it needs to be stressed at this time of confusion about whether a teacher has any authority in the classroom (Malkenes) and whether knowledge exists apart from subjective views of it.

The more subjectivist knowledge is argued to be, the more politicised it can be rendered. If only the proletariat can know how capitalism really works because they belong to the working class, no professor of economics can do so. Moreover, this knowledge about capitalism is not value-free or disinterested, but a tool of revolution. Knowledge, on Marxist analysis, is always political. Likewise, if I share reality with other women because we construct or understand the world *qua* women, we should study the world through women's eyes. If only women can understand how women see the world we need gender studies departments and "gendered" history classes. History cannot then be studied in a disinterested, scholarly manner, because it is always political: when old, white men study it, it is through their perspective only, no more correct than a feminist or anti-colonial perspective, in fact intolerable because old, white men are deemed to represent colonialism or imperialism. It soon follows from this that there must be syllabuses where female authors are the subject of a quota, such as the 40 per cent female component on the international relations course at the London School of Economics. The difference between a disinterested, scholarly approach to the study of history and the perspective described above is vast. If all knowledge is viewed as interpretation from a group perspective, aimed at social and political change, then knowledge is political and subjective because every human

being is assumed to represent his or her group. Representation is of course what politics is about – we have political parties and elected representatives who are political actors on our behalf. But representation is a foreign concept in scholarship.

It follows logically from this that groups must be represented in the university in the form of quotas for, say, female or black students, professorships, and in syllabuses. If the point of knowledge is to represent various groups' views of it, then a representative structure follows, and the objective of the whole exercise is to promote the views of the various groups. If the case for discrimination can be made – for example, that works by female composers are seldom played in concert halls, then female composers must have their due compensation, even if this has to do with the facts that (1) few women choose to become composers, and (2) their work may, like that of most male composers, be of insufficient quality to be performed. If such objections are heard they are dismissed, certainly if they come from white middle-aged men (who make up the majority of both composers and musicians).

This kind of 'representation' may sound utterly silly, devoid of substance, but the fact is that this idea – that there must be some kind of representation of black people, women, native Americans etc, in each and every sphere of societal activity – is now real policy, creating a "diversity dictatorship" as it has been called. The BBC's shortlist for top jobs now has to contain diversity in the form of ethnic minorities and women, and the writer Lionel Shriver lost her column in a newspaper when she criticised diversity policy of this kind. The feeble intellectual foundation for diversity has not stopped it from becoming a key criterion for almost every type of activity that was hitherto based on merit. Moreover, this is a highly selective diversity – why not demand that every job, government, or board has 10 per cent aged over 80, another 10 per cent aged over 70, 25 per cent handicapped, 25 per cent poor, etc? These groups are rarely much catered for, and the elderly are truly discriminated against in both the workplace and in politics. If discrimination is to be compensated for through quotas, those groups who are truly affected by it should surely be included.

The argument in favour of quotas is of course nothing new, and the logic is the same as in the old Marxist argument that there is no objective study or interpretation of society, only what a class sees. With regard to race, black people or Afro-Americans have been active in their attacks

not only on Civil War monuments in the United States but, further afield, for instance, on the statue of Sir Cecil Rhodes at Oriel College, Oxford, demanding that it be pulled down. History, especially Western European history, is taught from the angle of colonial oppression and imperialism can hardly be talked about in a disinterested, apolitical, and scholarly manner. Perhaps colonialism brought some benefits in terms of schooling, administrative organisation, and social institutions? Perish not only the thought, but anyone suggesting it.

Similar examples abound, also in academia and business – criticism of an employee becomes a "reputation loss" for the employer who distances himself from the employee instead of defending him. Such a case is often based simply on someone's subjective feelings or accusations of racism, homophobia, discrimination of women, or the like. This naturally creates a culture of fear – everyone must avoid triggering such reactions and therefore conform to whatever new dogma is launched. As in the Malkenes case, the employer – the Oslo School Board – defended the pupils rather than the teacher. Fortunately, this case led to major debate and uproar, and therefore to a full examination of the facts of the case in public debate. But this is far from always the norm. The danger lies in the subjective element: being accused of something and having a campaign conducted against oneself over social media amounts to extremely heavy pressure, and many employers are cowardly, not daring to stand up for the basic justice criterion of objective scrutiny of the facts of the case. In addition to cowardice, the strong inducement to protect the reputation of the employer is at work, especially in business. In a university it should be natural that criticism is welcome and praiseworthy, but that does not always hold true, especially when one depends on tuition-paying students.

If power is what defines scholarship or knowledge, we have this dynamic: a group defines a dogma about some subject, claiming that collective historical injustice or discrimination should lead to changes in the teaching of the subject, even that group representatives only can teach the subject. This is exactly like the situation in a communist society where curricula in schools and universities were changed to conform to Marxist ideology. Contemporary dogma has to do with identity politics and groupthink, but the power dynamics are exactly the same as in Marxist ideology – (1) the group or class interprets what should count as knowledge, (2) everyone must accept this lest they be punished,

(3) knowledge is not separable from politics, fact from value, the subjective from the objective.

I now proceed to present a dissection of the subjectivist mindset described above and contrast it with the true vocation of the university: the scientific search for truth, including the rational discernment of ethical principles.

★

The present climate of public debate and ideas is marked by groupthink/ identity politics – the premise that what Aristotle calls "accidentals" (such as sex, race, etc) are of such importance that they constitute the definition of human nature and therefore give rise to collective or group rights. On this logic, women are profoundly different from men, so different that they are entitled to specific rights *qua* women – not the right to be equal, as that presupposes a universal, common human nature for both sexes against which one measures equality, but the right to be different, possessing unique qualifications in professional, political, and scholarly life. Thus, being a woman in and of itself may entail a qualification to be a professor, to be included in university curricula, to be employed on boards and in professional jobs (there are usually no calls for quotas in the service sector, such as female quotas for garbage collectors or road construction workers).

The justification for quotas is twofold: it is a right claimed in order to ameliorate alleged historical and contemporary discrimination of the group, and it is held as a general good for professions and for society at large. The latter is often invoked as an argument against male predominance in company board rooms, business, the military, etc – women provide diversity. Diversity is a positive term, who can be against it? Perhaps only in the military can one argue meaningfully for uniformity, hence the uniform and drills.

The premise of this kind of groupthink is that men and women are essentially different, and this difference is argued to be so profoundly important that it entitles women to a 50:50 gender balance in all sorts of professions, politics, and other areas of life. Professional qualifications are sometimes reduced in importance in order to achieve this balance.

But not only does this argument lack substance, no real attempt is made to substantiate it. Are women so very different from men that they

can be lumped together into a distinct category of human beings? Isn't there profound variation among women, as there is also among men? Do women really have much more in common with each other across age, nationality, educational level and so on, than do young people with other youngsters, doctors with other doctors, Norwegians with other Norwegians etc?

Those who advance sex-based quotas as the provider of diversity carry the burden of the proof, but have hitherto failed to provide it. The fact that group interaction in a milieu of only men is different from situations with mixed sex components does not constitute proof of such profound difference. The flaws in the argument that women represent diversity *qua* women are obvious, but nonetheless this argument is the very basis for quota policy. The general underlying premise seems to be that a group consisting of both sexes, many races, many nationalities, young and old, is a diverse group, but such diversity is superficial. Real diversity exists among people of different religions, cultures, philosophies, and social classes. If people in a group have very little in common, it is truly a diverse group. But such a group will probably not function at all – the more real the diversity, the less synergy is likely to be generated, leading to the very opposite of the argument that diversity is good for business. True diversity may be very beneficial, but this requires that the members of, say, a company board have professional knowledge of the business field in addition to different perspectives and experiences. This does not result from being black or female. White middle-aged men may naturally make for a very diverse group if their knowledge and experience vary.

Also, sex-based diversity is trumped by professional identity; when the two sexes are mixed in army dormitories in Norway, the soldiers cease to see each other as men and women and start to identify as teams, focused on the job at hand. This suggests that sex is greatly overrated in general importance and that professional identity is much more important. Modern society is, as Max Weber wrote, based on meritocracy, on professionalism, not on tribal identity. Yet the modern campaign for group identity constitutes a return to pre-modern tribalism.

The old feminism of the 1970s was logical and just, insofar as it argued for equality with men in terms of *equal opportunity*: women should rightly have access to the same jobs and education as men do. There should be no discrimination based on sex. Note that this is logical because it is premised on one common human nature and therefore that "accidents" like

sex should not matter to human freedom and self-realisation. Here the ontological premise is correct: there is one human nature for both sexes, irrespective of race, ethnicity and whatever else that may differ among human beings.

"Old" or "equality" feminism simply argued for *equal treatment for all human beings* because they share in the same human nature, they are equal before the law, as citizens, professionals, etc. Group identity feminism, on the contrary, demands quotas for women because they are argued to be *ontologically different* from men, to such an extent that this warrants up to 50 per cent female representation in all sorts of professional jobs, student programmes, company boards etc, regardless of formal qualifications.

Group identity politics works on the same logic as Marxism: if you disagree, you are *entfremdet* (alienated) and in need of consciousness-raising. Men can never have any say in group identity feminism because they are men; the bourgeoisie can never have any say in class struggle given their class. By this logic, there is no common human nature that is the basis for equality among humans, only the group or the class, as defined by the group or the class. If this logic is allowed to permeate the university it will be impossible to speak truth unto power in the academy.

I have so far but alluded to the importance of epistemology in passing. I have argued that "old" feminism (and by logical implication, the fight for racial anti-discrimination and other types of discrimination) is ontologically sound, being based on the idea of a common human nature. Now this ontological position is no longer shared by group feminism/identity politics. The ontological premise here is the group or tribe: women make up a group that has nothing much in common with men, black people have nothing much in common with whites, and the attributes that form the group or the tribe make up an endless list. The tribe becomes the basis for claiming group rights, often in retribution for alleged discrimination. The individual no longer counts, only the group – as is typical of any tribe. Moreover, the attribute that defines the group is so fundamental that one must be born in the tribe to be part of it.

If it is only the group that can define what it is and what its rights are, there is no longer any measure of what is true or false, just or unjust. There is no longer any intersubjective understanding of facts simply because

there is no common standard of humanity to refer to. Anthropology – what a human being is, what human nature is – is therefore of central importance to academic and political debate and inquiry. Here the grave problem of constructivism as an extreme form of subjectivism enters. Popular in academia but probably too obscure to catch attention in the political debate, constructivism postulates, like Marxism, that there can be no intersubjective, objective knowledge. What exists, exists for me, from my vantage point, in my interpretation of the world. In my own field of political science, extreme constructivism would imply that war could be abolished if we started to think about peace instead. There is an element of subjective construction of reality that can be deconstructed by information, discussion, and persuasion, but there is also an objective reality that consists of hard power and weapon systems. The point here is not that subjective views of things are not real, but that they must ultimately be checked against reality, and that this is what a university is tasked to do. If I think that the world is flat because all that I can observe indicates this to be so, such a thesis must be exposed to intersubjective testing. It is never enough to claim something to be true. Facts and reasoning must be presented and scrutinised.

The problem with constructivism is that it is now being used to define a very political agenda, such as the "trans" agenda whereby biology is ignored as one can now change one's sex (called gender in constructivism since it is changeable by subjective will only) by filling in a form, as in Norway and many other states; and the feminist agenda that only feminists can define. The epistemological premise underlying gender feminism, Marxism, and other self-defined universes is the same: there is no objective fact or method of arriving at such because there is no truth to be had. Truth about the human being is only possible if we share one common human nature. Truth-seeking as the university's *raison d'être* is premised on this. The methods are logical deduction and empirical induction, and the way is reasoning: rational argument with an open mind to contradiction and opposing arguments.

In sum, knowledge can only be gained according to certain rules of logic and by an attitude of courtesy and open-mindedness in debate. All knowledge must pass the test of intersubjectivity, especially in the university. Arguments must be presented in an apolitical, disinterested manner where personal interest should play no role. When students take academic criticism personally, they show that they are unable to distinguish

Next pages: Identity politics on the blackboard.

Straight Bis

|
I

Ide

Gay Le

ual

Transexual

ity

Asexual

ian

between these fundamental elements. If I say that I am uninterested in a student's pigmentation, sex, race, weight and political preferences, I exhibit the correct attitude as a scholar: it is not the student per se that matters, but his academic arguments and writings.

★

The university as we know it is the product of Western civilisation – Athens, Jerusalem, and Rome. Plato erected his own academy and taught through the Socratic method, as it is called after Socrates' suicide for the cause of justice. Plato's dialogues deal with the highest science (in the sense of the German word *Wissenschaft,* connoting all disciplines of human inquiry), the most advanced and the most important type of knowledge – philosophy. Philosophy's question is about anthropology – what is a human being? Is there a soul? It is also about ontology: what exists? And it is about epistemology: how can we know?

Philosophy is about the most important issues of knowledge. The second most important discipline is politics, as the practical science about justice in the *polis*, and other fields such as mathematics, logic, and natural science. The academy is the arena for seeking knowledge, and Plato postulates that the human being is born with the rational ability to know both facts and value, as does Aristotle.

The university as we know it came into existence around 1200, but schools existed long before, developed by monks and nuns as part of the monastic life of learning. Colleges were religious schools and the curriculum built on "the greats": philosophy, logic, physics, etc. There is a direct continuity from Athens via Jerusalem to Rome: Christianity adopted neo-Platonic philosophy through the work of St Thomas Aquinas, perhaps the most productive university professor in history.

The educational programme is one of bringing knowledge to the student and of forming his or her character. The latter involves the classical insight into virtues and vices, based on the same anthropology in ancient Greece, the Roman empire, and later. Christianity added the virtue of *caritas* as perhaps the most cardinal of all virtues. Classical and Christian norms of behaviour formed both European society and the university. The anthropological premise of ancient Greece remains the basis for character formation throughout the centuries: human nature with its vices and virtues can be known through reason, therefore it can be formed

by combating vices and training oneself in virtue. Human nature is one and the same for both sexes and at all ages. This is also called the natural law tradition and is the very basis for human rights and citizenship rights, and is also expressed in the dictum of "equality before the law", a major contribution of Western civilisation.

There is therefore a canon in the university: the philosophy of the ancients Greeks, and at its core also the character formation programme of the cardinal virtues, as demonstrated in Plato's dialogues and in the writings of the Romans, such as Marcus Aurelius, Seneca, Cicero and the Stoics. Knowledge is objective in the sciences, such as physics, arithmetic, and geometry, but human nature can also be defined objectively in philosophy, and man's rational ability makes it possible for everyone to know and adopt virtue. The ability of everyman to reason about justice is why Socrates conducts his dialogues with children and the uneducated. He shows that reason is a universal trait of human nature and that every human person can therefore attain virtue, given effort and will. This insight is intersubjective, hence the format of the dialogue.

Education is thus about character formation and scholarship from the very earliest times in the West. The ability to know human nature – what is rightly termed anthropology – is the very basis for the ability to know the world objectively. And only a definable human nature, shared by all, can be the basis for inquiry, politics and the professions.

It is true that women were discriminated against for very many centuries, thought to not to possess the same level of rationality as men and therefore denied the vote. John Stuart Mill frets over the rationality issue in *On Liberty,* as late as 1859, and women in Norway, for instance, were not granted the right to vote until 1913. Also, women were generally admitted to universities as students and professors only comparatively recently. Given the importance of "politically correct" language today, I am surprised that the term "bachelor's degree" is still accepted unquestioningly – it says that students must be bachelors, which is what they were until very late on at the likes of Oxford and Cambridge, and naturally all were men. Both the title Bachelor of Arts and Master of Arts are medieval terms, and both apply to men only. How can the bachelor's degree survive in the modern PC world?

It is of course also true that black people have been discriminated against, as many other groups have been – in pre-Christian times the handicapped and the old and sick were put out to die in the woods – but

the implication is that discrimination is combated through equal treatment of all human beings, not differentiated treatment. If we all have equal dignity because we all share in the same human nature, it follows logically that men and women, blacks and whites, young and old, sick and healthy all have the same rights to professional education, competition for jobs and study places, etc. In short, what we call "equality feminism" follows if women are discriminated against, not "group rights".

The curriculum of the Western university and school continued largely unchanged for centuries: the *trivium*, the basic curriculum, consisted of logic, grammar, and rhetoric – teaching the student to reason according to the rules of logic and to present arguments correctly. The *quadrivium* is more demanding: arithmetic, geometry, astronomy, and music – which in the Middle Ages was thought to be about numbers. As we see, variants of this curriculum continue to this very day. The point here is simply to underline that there is a body of knowledge as well as a canon that forms the core of what a university should teach, and that these subjects are internally consistent and build on each other: without knowledge of logic and grammar, there can be no ability to reason intersubjectively and to study more advanced subjects.

The fields of study require expert knowledge, but the *artes liberales* (liberal arts) are the basis for all disciplines as well as for character formation. Thus the university provides character formation in the humanities, as they are called today, not aimed at "usefulness" in a direct sense, but in a general sense of becoming an educated, informed, and upright person. This tradition survives in the US with its liberal arts colleges and in a more diluted form in Europe's national universities.

Critical perspectives – often called critical theory, including Marxist and feminist perspectives – are naturally part of a normal pluralistic university debate, but any hypothesis must be capable of being examined intersubjectively according to scientific method – deduction, induction, quantitative and/or qualitative method – always based on the rules of logic and reason. Does Marxism explain the state of current capitalism? Is it convulsing, dying from inner contradictions, as historical materialism predicts? Or is it thriving? Only careful empirical examination will tell.

Intersubjectively verifiable knowledge is what should count as knowledge, established through disinterested, careful inquiry. Perhaps anti-colonial theory can explain African history better than other

approaches? Let's look at the evidence. But such an attitude is light-years from the push for certain conclusions based on groupthink about group rights.

<div align="center">★</div>

This chapter has argued that current group rights based on so-called identity politics represent intolerance. It holds that the group, like the working class, is the only actor which can define knowledge about itself: only Africans can interpret colonial history, only black Americans can legitimately interpret Civil War history, and only women can define to what extent they have been discriminated throughout history. The epistemological principle is entirely subjective, and evidence and arguments do not meet scientific criteria when presented, even in a university setting. They are not examined in a disinterested manner, but used to promote power politics.

The status of the group in this kind of identity politics is ontological: women are a group, not a "subset" of human nature. Men and women apparently have nothing in common – no common human nature – but are in distinct groups that form different tribes. The same is true for black people and other groups that claim group rights. They are no longer fellow citizens and fellow scholars and students that happen to be black or female. Being black or female defines them so much that these characteristics give rise to specific rights, not to equality with all other human beings.

The above implies that there is no basis for intersubjective, disinterested knowledge aimed at arriving at the truth or an approximation of it, according to the possibilities of scientific inquiry. On the contrary, all is a political struggle, and all are political actors. The term "representation", which is the justification for quotas, properly belongs to politics where an interest-based power struggle is to be expected. But representation has no place in professions or in scientific inquiry. The idea that historical injustice justifies contemporary privilege is really outrageous, relying as it does on entirely subjective feelings of injustice and serving to legitimise collective rights as a retribution for collective guilt that is ascribed to the West, white men, the ruling classes, etc.

The Western intellectual tradition is based on individual responsibility for individual actions – there is no collective that acts, no class or group

that assumes actor roles. In Marxism the collective trumps all individual duties and rights, as it seems to do also in current identity politics. History holds lessons about wrongdoing of many sorts, but guilt and responsibility for these wrongs cannot be attributed to collectives, and collectives cannot claim privileges based upon them.

Lastly, on a personal note, my career has always been in typically "male" fields such as the Oil and Energy Ministry, the Ministry of Foreign Affairs, and as a professor in political science and an expert on strategy and defence matters. I have little to register that would count as discrimination. But I may of course be totally *entfremdet* and in need of "consciousness raising".

A memorial wall with the names of the victims of a
suicide bombing in Yemen, 21 August 2018.

JIHADIST MEDIA STRATEGIES

Elisabeth Kendall

Jihadist media strategies evolve according to changing circumstances, both practically in their format and ideologically as they attempt to exploit unfolding events. Most research has focused on the slick media of so-called Islamic State (Isis) and on high-profile material that appears in English. Yet the material in English, although prolific and more easily accessible to Western researchers, represents only about 6 per cent of jihadist media output. By contrast, much less attention has been paid to the media of al-Qaeda, particularly in Arabic, yet closer inspection of this media reveals a smart long-term strategy. Although considerably more primitive than Isis media, it is nevertheless highly tuned to local narratives and evolving conditions on the ground. This essay therefore focuses primarily on the Arabic media of al-Qaeda, and on the Arabian Peninsula in particular, since this is generally considered to be the home of al-Qaeda's most active and dangerous branch.

Al-Qaeda in the Arabian Peninsula (AQAP), which is based in Yemen, has adapted its propaganda media and narratives to suit emerging pressures, political circumstances and local concerns since the start of the Arab spring. This essay begins by analysing briefly how the media formats of AQAP have evolved. From bulky cultural magazines through to punchy news bulletins and encrypted messaging services, AQAP has shown that it is a learning organisation. It then examines how extreme pressure from drones and spies since 2017 has started to impair jihadist media output. The jihadists are certainly down, but they are not out, as the essay demonstrates by identifying AQAP's strategies for youth outreach to ensure the movement's longevity. Finally, the essay focuses on an important area in which al-Qaeda media, not only on the Arabian Peninsula but more generally, appears to be struggling. This is its attempt to appeal to women. Al-Qaeda's women's media is replete with breathtakingly misogynist information on how to please one's holy warrior and features clumsy stabs at explaining awkward questions like – if men get

72 virgins in Paradise, what's in it for women? The analysis presented in this essay stems from my penetration of encrypted group networks and fieldwork inside eastern Yemen, close to where al-Qaeda ran its de facto state until 2016.

★

AQAP has generally succeeded in maintaining a strong and steady media presence at both domestic and international levels, although this activity has started to fragment since late 2017 owing to heavy losses resulting from spies infiltrating the jihad movement. With regard to AQAP's domestic media, this has undergone several iterations to suit the changing times since the Saudi and Yemeni branches of al-Qaeda merged to form AQAP in 2009. Its voluminous Arabic magazine, *Sada al-Malahim* ("Echo of Epic Battles", 2008–11), which included locally attuned cultural material such as poetry, social announcements and even a women's page, ceased with the eruption of the Yemeni revolution in 2011. It was replaced by *Madad* ("Support", 2011–12), a shorter newspaper published with greater frequency and designed to situate AQAP at the centre of the rapidly unfolding events of the so-called Arab spring. AQAP exploited the instability generated by the revolution to establish Islamic emirates in central southern Yemen. Casting aside recipes and women's pages, *Madad* focused instead on promoting anti-American and anti-democratic sentiment. Most significantly, it aimed to entrench a revised image of AQAP as "the people's champion" capable of governing territory in accordance with Islamic law and not a terrorist organisation as the rest of the world claimed. The newspaper was complemented by a series of short videos, *'Ayn 'ala al-Hadath* ("Eye on the Event", 2011–12, 2016) which showcased AQAP's "good works" in the community. Its jihadist spin on events included improbable news items such as a man thanking AQAP for the honour of being the first person in the fledgling jihadist emirate to have his hand chopped off in penance for his act of theft.

A further iteration occurred in Yemen's jihadist media as it began to learn from the successful media storm created by its Islamic State rival in Iraq and Syria in 2013. The rise of Isis coincided with the unravelling of Yemen after the end of the UN-led national dialogue in 2014 when rebels, known as Houthis and linked increasingly to Shiite Iran, started marching aggressively south from their northern strongholds near the Saudi

border. AQAP media became more militant and sectarian. This was best exemplified in AQAP's snappy new military action video series called *Min al-Midan* ("From the Battlefield", 2014–15) which filmed the planning and implementation of successful domestic operations to a soundtrack of rousing jihadist anthems. AQAP's traditional spiritual and emotional sustenance still continued alongside, with a standard menu of martyrologies and several theological video series featuring its most charismatic talking heads, such as ex-Guantanamo Bay detainee Ibrahim al-Rubaysh (droned 2015) and the outspoken critic of Islamic State, Harith al-Nazari (droned 2015).

The next milestone in AQAP's jihadist media evolution arrived with the outbreak of war in 2015 when a Saudi-led coalition intervened militarily to try to restore the Yemeni government toppled by Iran-linked rebels. As Saudi bombs rained down on Yemen's west, AQAP seized the opportunity to take control of vast territory in the east of the country. A flourishing jihadist "state" emerged and its ambitious governance and expansion agenda was reflected in a new al-Qaeda-linked Arabic newspaper called *al-Masra* (an alternative Islamic name for Jerusalem, 2016–17). This carried a much more international news agenda. By drawing together updates from all al-Qaeda's global franchises, as well as standard international news (often translated wholesale from the Western press), it helped to position al-Qaeda as a broad international movement to rival Isis at a time when the latter was recruiting aggressively and dominating world attention. *Al-Masra* ran to 57 issues before it ceased in July 2017. Although AQAP news featured prominently and *al-Masra* was handed out on the streets of AQAP's "capital city" Mukalla, nevertheless it later denied any official link to the newspaper.

AQAP's various media formats are disseminated both online, most reliably via encrypted applications like Telegram, and in hard copy during *da'wa* (proselytisation) activities. Hard copies are important in Yemen, given the challenge of internet access, particularly on the frontlines or in remote tribal areas. Photos have circulated of AQAP driving a proselytisation truck openly around the city of Taiz, profiting from the chaos at one of the major frontlines in the battle against the Houthis. The side of the truck advertises the contents being handed out free: CDs, films, nasheeds (anthems), lectures, copies of the Koran and poems. Isis has also released photos of its fighters in Yemen watching jihadist films together and sitting in the desert reading hard copies of the

Isis weekly newspaper, *al-Naba'* ("The News", founded in 2013 and still ongoing).

By contrast, AQAP's media format and approach for English language audiences has remained more constant. So-called "lone wolf" attacks in the West continue to be incited through bulky, if increasingly infrequent, issues of *Inspire* magazine (2010 – ongoing). *Inspire*'s ambition is precisely as its title implies – to inspire acts of terror. Its content ranges from illustrated instructions on "How to Build a Bomb in Your Mom's Kitchen" to suggesting atrocities such as mowing down pedestrians using bladed vehicles, lighting wildfires to burn down forests and derailing trains. The magazine has been supplemented since 2016 with a series of occasional *Inspire Guides* that offer brief analysis of the pros and cons of various terror attacks in the West, including the Orlando gun massacre, the Nice truck massacre in 2016, and the Westminster attack in 2017. This demonstrates well how AQAP media can be a catalyst for international attacks without the need for direct operational links. Online sermons by the Yemeni-American AQAP ideologue Anwar al-Awlaki (droned 2011), a co-founder of *Inspire*, have been linked to numerous international acts of terror. These include the 2013 murder of a British soldier in London, the 2013 Boston marathon bombing and the 2015 *Charlie Hebdo* massacre in Paris.

Such attacks highlight an important strength of al-Qaeda media in recent years: it endows its most charismatic figureheads with an enduring ability to inspire long after they have been droned. This occurs in three ways. First, much al-Qaeda material remains readily available online, particularly as security agencies have been heavily focused on stemming the flow of propaganda from Islamic State. Second, al-Qaeda sermons and films are frequently reposted online; there are entire channels on encrypted applications like Telegram devoted to reposting archival material. Third, old footage – and sometimes previously unseen footage – of al-Qaeda figureheads is reworked into new videos, giving the impression that these "martyred" heroes continue to address the faithful from Paradise.

★

Since late 2017, AQAP media has been forced to adapt to increasing pressure from drones and internal spies. The US has acknowledged carrying out over 120 airstrikes on jihadists targets in Yemen during 2017 as well as multiple ground operations. This is more than three times as many as

occurred in 2016. The jihadists have therefore suffered severe losses, including key commanders. AQAP's own media releases suggest it is feeling these losses keenly, both practically and emotionally.

In practical terms, AQAP released a spy film, *Secrets, Dangers, and the Departure of the Best* in January 2018 which exposed the methods and catastrophic consequences of internal traitors. It featured several interviews with spies explaining how easy it was to collect fatal intelligence. AQAP presented statistics for the number of jihadist deaths arising from each type of information leak, resulting in a total of 410 "martyrs", killed mainly by drones. It claimed that 30 jihadist deaths arose simply from telling a secret to just one person. AQAP's leader, Qasim al-Raymi, is featured doing an impression of a woman gossiping on the phone as he chastises jihadists for sharing information with their chatty wives. The film ends by circulating an official statement which describes conversation, mobiles, and social media as "out of control... reckless... and a grave danger to the jihad". It imposes a comprehensive ban on all "jihadist brothers" from communicating via mobile phone and the internet. The extent to which the jihadists are preoccupied by this growing existential threat is reflected in the fact that the first-ever publication by a new AQAP-linked media group, al-Badr Media Foundation, was a booklet on how to avoid drone assassination. Ironically, it was written by a jihadist who was killed in a drone strike in 2015, on his very first night in Mukalla after the city was seized by AQAP.

AQAP central communications continue to be severely impacted as a result of the precautions required to evade spies and drones. Despite the recent drop-off in media output, however, AQAP has launched a new documentary film series entitled *Destroying Espionage*. The introductory film, released in September 2018, outed seven internal spies recruited by Saudi intelligence and also claimed to have dismantled a separate 12-man spy cell. Since several successful drone strikes have nevertheless followed, the jihadists' problem of infiltration by spies clearly persists. As such, and somewhat improbably, AQAP's leadership is offering a full pardon to any spies who voluntarily give themselves up. For those who wait to be discovered, a horrible end is promised. Although AQAP media, as part of its strategy for posing as the good guy versus the brutality of Isis, prohibits the dissemination of graphic images or footage of blood and guts resulting from its own acts of violence, some informal jihadist wires have posted photos of the spies being gruesomely crucified.

Next pages: Victims of the *Charlie Hebdo* terrorist attack
honoured at Place de la République in Paris.

In emotional terms, the flood of dead jihadists has necessitated a reaffirmation of the benefits of martyrdom. To help one another cope psychologically, pro-AQAP wires circulated a video clip of an old speech by Harith al-Nazari, in which he said: "Don't think of those who are killed in the path of Allah as dead... don't worry about them. They are alive with their Lord and are receiving sustenance. And that's not all... they are rejoicing in what Allah's bounty has bestowed on them. Yes, the martyr is in good condition. He is happy. All is well."

<p align="center">★</p>

Naturally, a recruitment drive is necessary to replenish numbers. Poster series like al-Mujahid Media's "Join the Caravan [of martyrs]" circulated on pro-AQAP wires in late January 2018, posed questions like "What's making you hang back from this great noble deed?" Most worrying has been the considerable effort exerted by AQAP on youth engagement. Unlike Isis, al-Qaeda has understood full well that founding a caliphate is still a faraway prospect and that re-education of the next generation is key to preparing for it and for the sweeping implementation of Islamic law. US drone strikes, air strikes, and raids have been exploited to the maximum by jihadist media, particularly when poorly targeted strikes kill women and children or destroy village housing. Several AQAP videos feature interviews with grieving villagers pasted alongside footage explaining the global jihadist agenda. Following US Navy Seal raids in 2017, which killed Yemeni villagers, AQAP issued statements designed to plug into tribal anger, positioning itself as the conduit for revenge. Jihadist poems lamenting the dead are still appearing. In 2016, AQAP even held a "Festival of Martyrs of the American Bombing" in Hadramawt, which included a competition for schoolboys to design anti-US and anti-drone posters. This kind of youth outreach nurtures the next generation of angry young men for potential recruitment.

While AQAP ran its state out of Mukalla, it held several festivals and disseminated videos of people "having a good time" in its jihadist enclave while the other side of the country was embroiled in war. These included games, such as boys eating ice cream blind-folded, and Koran recitation competitions with Kalashnikovs and motorbikes as prizes. Thirteen per cent of tweets from AQAP's governance Twitter feed were about celebrations. Even after being driven out of Mukalla, AQAP continued its youth

engagement by exploiting battlefronts. One way to get boys interested in jihad was to entice them to read AQAP material. In Taiz, any youth who wrote a summary of AQAP's jihad booklet, "This is Our Mission", was entered to win a Kalashnikov as first prize, followed by a motorbike, laptop, revolver, and money. This focus on young hearts and minds indicates that the battle against AQAP will be a long one, even though it no longer runs a state or holds significant territory.

★

One way in which jihadists could boost their workforce at a time when they are under severe pressure is by mobilising women. From a jihadist perspective, a woman's primary task has been and still is to support jihad through being a good wife to her jihadist husband and a good mother to future jihadists. Women have not been encouraged to take on active combat roles, with the exception of suicide bombing since the latter does not compromise female honour through mixing with men on the front lines. Isis also formed a fearsome women's police squad, known as the Khansaʻ Brigade, but its remit was limited to policing women, including most famously by fixing a spiked clamp on to the breast of any woman daring to breastfeed in public. However, as Isis is driven back in Syria and Iraq, there are hints that it may be relaxing its strict approach to women's participation. In late 2017, the official newspaper of Isis announced that it was an "obligation" for women to fight jihad "in every way possible" and, in early 2018, an Isis-affiliated group circulated photographs of women, still veiled from head to toe in black, firing on the frontlines next to men.

Al-Qaeda also recognises the need to win women over to the cause, but its focus remains firmly on keeping women indoors. When French security forces arrested three women in Paris in 2016 for planning an operation in the name of Isis, AQAP released an issue of its *Inspire Guide* entitled "Our Sisters in France", advising that it was wholly inappropriate for women to take such active roles. Symbolically, al-Qaeda did not direct its criticism at the women, but instead censured the Isis menfolk for allowing their women to behave in such a way.

Al-Qaeda's media drive to enthuse women to support the jihad, but from behind closed doors, is best exemplified in its glossy new magazine, *Baytu-ki* ("Your Home", 2017-ongoing). This startlingly misogynist magazine is published by an al-Qaeda-linked media organisation based in

Syria and is complemented by an online wire using an encrypted messaging service. Both the magazine and the wire are replete with stereotypically feminine decorations like butterflies, roses, smiling babies, and little pink and violet love hearts. Yet these sugary frills belie a content that is far from innocuous and is written from a decidedly male point of view. Problems allegedly submitted by female readers seeking advice include: "My husband is a jihadist and always busy; what should I do?" The jihadists' answer is that she should stop complaining. After all, he sees blood and exploded body parts all day so she should avoid being an added stress and focus instead on making the home a paradise on earth for him. Another question seeks advice on how to react if one's husband takes a second, third or fourth wife. The answer again is that she must not complain because this is his right. She should focus on the advantages, which include being able to share the housework with the new wife. She should also be grateful because the pleasure that her husband will derive from enjoying this new woman might improve his mood more generally, with knock-on benefits for her own quality of life.

The domestic tips and recipes served up by al-Qaeda women's media tend to be so simplistic as to suggest that they were written by someone with no genuine experience of running a home, in other words by a male jihadist. Basic instructions are provided for how to make everyday dishes like mashed potatoes or scrambled eggs. Top tips for how to do the washing up include bewilderingly obvious advice like using hot water and starting with the glassware. It is likely that al-Qaeda's target female market would already be aware of such pearls of wisdom so it seems safe to presume the women's media is written by men. At any rate, it includes a great deal of material that is unlikely either to impress or to benefit its female audience.

★

Examining the changes in jihadist media strategies is useful not only for tracking a group's evolving outreach agenda but also for understanding the nature of the pressures and challenges it faces. By 2018 it was clear that AQAP's capacity to deliver a coherent centralised media strategy had been severely impaired as it struggled to cope with the damage wrought by spies and drones. But the long-term threat remains. AQAP has sown the seeds of jihad among a young generation ravaged, angered and

dispossessed by the ongoing war in Yemen. Moreover, rather than disappearing, the higher echelons of the jihadist leadership are going to ground, causing the movement to fragment and thus rendering it more difficult to track and counter.

Targeting the West remains a top ambition, not just to avenge drone attacks and to punish the West for supporting Israel and assisting repressive coalition activities in Yemen, but also to regain international kudos as the primary jihadist movement. This may seem like a distant prospect given AQAP's current operational incoherence. However, the governance vacuum is increasing as the war drags on. Even if a peace deal is reached, it will need to be coupled with strong investment at grassroots level and will have to take account of regional grievances. Otherwise, the various jihadist splinters may find common cause again and bring with them disillusioned sectors of the population, including women. Videos produced by AQAP have already featured women ranting over the forced disappearances of husbands, sons or brothers into prisons run by newly formed militias recruited inside Yemen by the United Arab Emirates. The time may be ripe for more active female involvement in jihad. After all, women across the Middle East's conflict zones, as elsewhere throughout history, are already being obliged to take on increasingly active roles in society as their menfolk are either killed or remain absent at the battlefront. It may be that women's growing empowerment, whether as a result of conflict or of recent reforms such as Saudi Arabia permitting women to drive and work more broadly, has motivated al-Qaeda's new women's media push that insists on women sticking to the traditional roles of wife, mother and homemaker. Nevertheless, one potential scenario is that some women, especially those whose newfound confidence is coupled with anger and political disillusionment, may just take matters into their own hands and become active in jihad, with or without the blessing of al-Qaeda's leadership.

Michel Foucault.

ACADEMIC CULTURES AND
EXPLANATORY CONFLICT

Claire Lehmann

The French philosopher Michel Foucault is the most cited scholar in the humanities of all time: as of July 2018, he has 873,174 citations on Google Scholar. Judith Butler's influential book *Gender Trouble*, which gave rise to Queer theory, and the idea that gender is a performance rather than a biological reality, has been cited over 51,000 times; vastly more than most books written in the 20th century, or any other time period.

In recent years, universities across the Western world, and particularly in the United States, have seen a rise in new forms of protest: the de-platforming and disinvitation of speakers, the implementation of trigger warnings and safe spaces, and a perception that there is a growing hostility to the principles that define the university experience such as open inquiry and debate. Simultaneously, populist revolts have been occurring around the globe, from Brexit to Trump to the rise of the Sweden Democrats and the backlash to liberal centrist parties across the European continent.

Does anything unite these two disparate trends? It may seem like a long bow to draw, but in a 2018 essay posted on his blog, Californian psychiatrist Scott Alexander developed a model of politics which allows one to find parallels between the far-left activists on US university campuses and the far-right populists of continental Europe. His model is called the "Conflict versus Mistake" model and it neatly reduces the fissures that many of us have observed within contemporary political discourse into axioms that can be applied across contexts.

Within his model, Alexander identifies two key explanatory styles that are crucial for understanding contemporary political discourse. The first is that of the "mistake theorist". A mistake theorist, according to Alexander, is someone who believes that political problems arise because there is a mistake or an error in the system. To the mistake theorist, social phenomena arise from an interplay of many different variables. To

understand social problems, one must generally undertake an in-depth analysis to work out what is really going on and how to fix it. Mistake theorists view politics like a science, or an engineering problem. They are like a mechanic looking at the engine of a car.

The second explanatory style is that of the "conflict theorist". A conflict theorist sees the world as being comprised of oppressor classes and oppressed classes. Powerful groups systematically exploit disadvantaged groups. Any unequal distribution of resources is seen as evidence of one group exploiting another. The conflict theorist generally views interactions between groups of people as zero sum. For conflict theorists, politics is war.

The mistake theorist values debate, open inquiry and free speech. There is an understanding in the mistake theorist's worldview that different people bring different skill sets and knowledge to the table, and that we need diverse views in order to harness our collective intelligence. Because free speech allows us to search for the truth and uncover our mistakes, the mistake theorist views free speech as sacrosanct. Conflict theorists are not so enamoured of the need for debate. They may view debate as being a distraction, a delaying tactic, or an attempt to proliferate ideas that are harmful to the disadvantaged. To the conflict theorist, protecting the disadvantaged is sacrosanct.

Moral sociologists Bradley Campbell and Jason Manning have theorised in their 2018 book, *The Rise of Victimhood Culture,* that within this conflict theory worldview (what Campbell and Manning call the "victimhood culture" worldview) a moral hierarchy is set up according to one's status as a member of an oppressed group. Members of less powerful groups are imbued with a special moral status, and due to this special moral status, members of the less powerful groups demand fierce and vigilant protection. To criticise the victim is to engage in victim-blaming.

By contrast, mistake theorists (what Campbell and Manning call the "dignity culture" worldview) see persons as possessing equal moral status. A member of a so-called "oppressor" group is just as entitled to his or her rights as a member of an "oppressed" group. Moral status is not determined by one's membership of an identity category. Emphasising the importance of process and method in coming to accurate conclusions, in contrast with rushing to judgement, the mistake theorist is likely to advocate principles like the presumption of innocence, procedural fairness, and due process.

Conflict theorists are not the sole purview of the Left. Leading up to the 2017 French presidential election, Marine Le Pen frequently used conflict theorist rhetoric, pitting native Frenchmen and women against oppressive elites: "Immigration is an organised replacement of our population. This threatens our very survival. We don't have the means to integrate those who are already here. The result is endless cultural conflict."

Le Pen draws on the language of victimhood: immigration "threatens the survival" of the French people, and that this threat is "organised" – indicating an identifiable enemy. The enemy is a powerful class of elites. While the left-wing manifestation of conflict theorist worldview blames oppression on white people, men, straight people, and increasingly cisgender or "cis" people (those who identify with the sex or gender they were born with), the right-wing version blames bankers, globalists, and technocratic elites for exploiting and oppressing the ordinary people.

Unlike conflict theorists, mistake theorists are suspicious of passion and emotion when it comes to answering complex political problems. The apotheosis of this attitude is the Yale psychologist Paul Bloom's book, *Against Empathy*. In this book, Bloom argues that empathy leads us to irrational decision-making, and a cool, detached, more statistical process leads to fairer and more utilitarian moral outcomes. By contrast, the conflict theorist is suspicious of methodological purity, and the cool rationality that process demands. Hot emotions are seen as assets, not weaknesses. "Lived experience" trumps data. To get anything done in the political sphere, one needs the spirit and passion of a true believer.

Importantly, the academic cultures we are exposed to in formative periods of our lives will influence which explanatory style we gravitate to. Naturally, a training in the behavioural sciences or the empirical social sciences may often lead one to be a mistake theorist. A student who has undertaken several years of coursework in statistics will know that any social phenomena likely has a multiplicity of causes. She will know that correlation does not imply causation. She will know that if she wants to talk about causality she must control for many extraneous variables. She will know that all scientific findings are provisional, and that hypotheses and theories are likely to be revised at a later date, when new and better data emerges.

A conflict theorist, on the other hand, does not see problems as having a multiplicity of causes. If there is a gender pay gap, then this is because men are oppressing women. If there is a gap between the earnings of

immigrants and a native population, then this is because the native population are discriminating against the immigrant group. If there are health discrepancies between LGBT people and heterosexual people, then that is because heterosexual people are engaging in discrimination. This simple formula can be extended and applied over and over again.

A mistake theorist will look at the same problems and agree that discrimination is likely to be a factor. But the crucial difference is that the mistake theorist sees it as one factor among many. Understanding that correlation does not immediately suggest causation leads the mistake theorist to adopt a position of epistemological humility. A mistake theorist will also suggest that it is important to look at what other factors might be influencing an outcome. She might suggest that to fully understand why the gender pay gap exists, one must look at the difference in earnings between women who have children and women who don't. If the earnings of women who do not have children are comparable to that of men, then this will tell us something very important, something that the standard oppression narrative cannot. Likewise, when looking at an earnings gap between migrants and a native population, we might want to control for prior education levels. If migrants as a group have a different average level of education, then this tells us something important. If there are health discrepancies between heterosexual and LGBTI people, then we might want to have a look at discrimination, but we will also want to look at many other variables including income, health-seeking behaviours and genetic influences. The picture is often more complicated and random than is implied by simplistic narratives.

While the mistake theorist hunts for data, conflict theorists view debate as a distraction from the real issues on the ground. What is the point of debating when women are only earning 70 cents in the dollar? Why conduct another study into the impact of immigration on the local economy when people are escaping persecution and are simply trying to find a better life for their families? Treating people as if they were mere statistical units is inhumane. By the time one has collected the data and run the analyses, people will have already died. How can one think about these issues with a cool rationality, when what we really need is compassion and feeling?

If you are a mistake theorist, you will view conflict theorists as simply lacking in information. A conflict theorist simply has not read enough literature on economics, psychology or history, or simply does not have

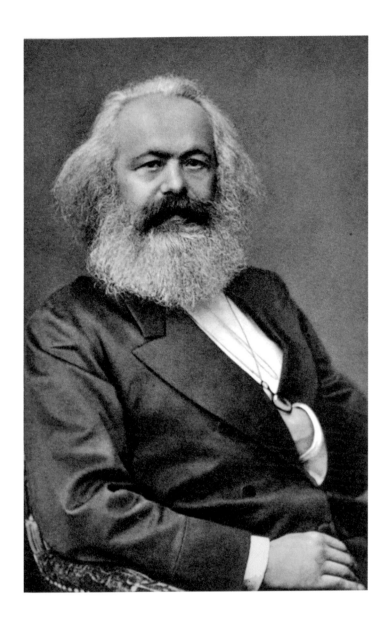

Karl Marx.

training in the scientific method. If you are a mistake theorist, you will view the conflict theorist as simply being naive and/or ignorant. And if in possession of the correct information, the conflict theorist will naturally become a mistake theorist. Mistake theorists believe that we improve the world through increasing education and reducing cognitive bias. They believe that we can reduce bias by being exposed to a range of different viewpoints, even those which are objectively bad, because one can then refine one's own arguments.

This attitude is encapsulated by John Stuart Mill's declaration: "He who knows only his own side of the case knows little of that. His reasons may be good, and no one may have been able to refute them. But if he is equally unable to refute the reasons on the opposite side, if he does not so much as know what they are, he has no ground for preferring either opinion."

With this quote, Mill accepts and expresses his own fallibility. He might be wrong, therefore he would not wish to prevent another person from speaking lest they possess information or insight that he might not have. This exchange of information helps the individual and the collective move towards a clearer understanding of the truth.

Alexander points out that conflict theorists, on the other hand, do not see the point in debating with one's sworn enemy. If you are a conflict theorist, you are very clear about who is your enemy and there is no legitimate space for neutrality or objectivity. You view mistake theorists as enemies in your conflict. In trying to be objective, the mistake theorists effectively defend the status quo.

This attitude can be summed up in this quote from Herbert Marcuse, a prominent figure of the Frankfurt School: "Liberating tolerance, then, would mean intolerance against movements from the Right, and toleration of movements from the Left." Marcuse argued for the opposite of what Mill argued for, that is intolerance of anything not deemed to be of the correct political disposition.

This "intolerance of intolerance" is arguably behind the rise of speech codes, de-platforming campaigns and the reduced support for free speech held by students on American campuses. One of the reasons why conflict theorist perspective is gaining prominence is because it is very popular within our higher education institutions. The methodology through which conflict theory is taught is known as critical theory. One of the reasons why critical theory has been so powerful and has become so

popular within academia is because of its unassuming name. Who can possibly argue with critical theory? Isn't being critical why we go to university in the first place? What is not to like about critical theory?

Critical theory is not synonymous with critical thinking. To understand what it is exactly, one must go back to Karl Marx, and his observation that "philosophers have merely interpreted the world, and the point is to change it". Marx pointed out that philosophy and science had heretofore been descriptive, and what he wanted was a prescriptive approach to scholarship.

Critical theorists of the Frankfurt School argued that traditional "theories" or ways of looking at the world had thus far served the interests of the powerful. Because traditional forms of inquiry were uncritical towards power, it therefore served the powerful, while critical theory, in unmasking powerful interests, helped serve the powerless. All scholarship is political, they said, and by choosing critical theory over traditional forms of scholarship, one chose to challenge the status quo. When the Frankfurt School were developing their theory, this approach was new and fresh, and was no doubt very useful in mobilising emancipatory civil rights movements across the world. But these liberationist impulses have since ossified into rigid orthodoxies.

On campus, at least in the humanities, critical theory is the new dogma. In critical legal theory, academics focus first on politicising the law, and then prescribing the correct political values that the law should reflect, ie the correct attitudes around gender, sexuality, race, the environment and economics. Scholars cited within critical legal theory include Marx, Gramsci, Foucault and Derrida. Critical theory also dominates the study of literature, and other humanities subjects such as international relations are also increasingly influenced by the spectre of the methodology. New fields of study have also opened up such as critical plant studies, which claims that humans occupy a "privileged place" in relation to plant life.

Critical theory is not without its uses. It has proven that as a methodology it is capable of critiquing the dominant power structures of the mid-20th century. Arguably, however, the method has dated. Now critical theorists are in a position of dominance. In many humanities departments around the world, theirs is the dominant ideology. In the humanities, feminist, queer and post-colonial approaches of interpretation have become the status quo. Uri Harris, writing for the online magazine *Quillette* which I edit, has argued that this predominance of critical theory

in the academy opens up challenging and paradoxical situations because, as critical theory becomes more widespread and its adherents more powerful, critical theory must then be turned on itself.

Both the far Right and the far Left are re-emerging across the Western world. It would be reductive and simplistic to place the blame for this development on either conflict theory or critical theory. Likewise, media which draw on erroneous and black-and-white narratives for explanations of complex social phenomena are not solely to blame. Of course the resurgence of left-wing and right-wing populism is influenced by a multiplicity of causes. Unfortunately, however, one of those causes is currently dominant within our institutions of higher education.

University of Cambridge students on graduation day.

HEAD, HAND AND HEART

David Goodhart

There are many explanations for the discontent in Western societies that has led to the current political instability – from inequality and the delayed impact of the financial crash to politicians deemed incompetent and aloof.

But there is one overarching explanation that encompasses most of the others: cognitive ability – the analytical intelligence that helps people to pass exams when young and process data efficiently in their professional lives – has become the gold standard of human esteem, and cognitive elites have come to shape society too much in their own interests. To put it more bluntly: smart people have become too powerful.

Sixty or 70 years ago, when we lived in somewhat less complex societies, the people who ran government and business were generally brighter and more ambitious than the average – as they still are today – but it was a time when skills and qualities other than analytical intelligence were held in higher esteem.

Today the "brightest and the best" trump the "decent and hardworking". Those other qualities like character, integrity, experience and willingness to toil hard, are not irrelevant but they command less respect.

A good society is one with a proper balance between the aptitudes of "head", "hand" and "heart". The modern knowledge economy, however, has produced higher and higher returns to the highly qualified and reduced the relative pay and status of manual and caring jobs. An economic system that once had a place for those of middling and even lower cognitive abilities – in the semi-skilled jobs of the industrial era, on the land, in the military – now favours the cognitive elites and the educationally blessed. Other institutions that have stressed aptitudes other than cognitive ability have been in sharp decline across most of the West and especially in Europe. The decline of religion, family life, the military and traditional industrial employment, along with the increased demand for analytical and numerical skills in the computer and then digital age, has

elevated cognitive ability above more traditional virtues and aptitudes. Think of Silicon Valley versus Sandhurst.

Moreover, for most of human history cognitive ability has been more or less randomly scattered through society. But in recent decades a huge sorting process has hoovered up the young exam-passers and sent as many as possible into higher education, leading in Britain to a 400 per cent increase in student numbers since 1990 and a precipitous decline in the prestige of so much non-graduate employment.

This does not mean that we live in a true meritocracy. Family income in childhood is still highly correlated with educational success. This has been reinforced by something described by the ugly phrase "assortative mating", meaning that people in high status jobs requiring high cognitive ability are far more likely to pair up with similar people.

The children of these couples do not form a genetic elite of the highly able but they are far more likely to be brought up by two parents who are both well connected and understand what is required for children of even middling ability to enter good universities and higher professional jobs. They could thus be said to form a kind of hereditary meritocracy.

But surely modern, technological societies simply need more clever people, and so long as some of the biases just described can be ironed out and, through more spending on education, people from all backgrounds can have a fair crack at joining the cognitive elite, then all is well?

I don't think so. In the tradition of Michael Young's *Rise of the Meritocracy*, Daniel Bell's *The Coming of Post-Industrial Society* and Charles Murray's *Coming Apart*, I believe that today's achievement society has replaced one system of domination by another.

From the point of view of the efficiency of society, cognitive ability plus effort is a better selection criterion for high status jobs than inheritance of land or capital. But it is not necessarily any fairer or more humane. As Young pointed out 60 years ago, people blessed with advanced cognitive skills often feel *less* obligation to those of below average intelligence than the rich have traditionally felt towards the poor.

It is one of the most difficult balancing acts of open, modern societies, though one that is seldom articulated: how to constrain meritocracy and prevent a disproportionate degree of status and prestige (and financial reward) flowing to high cognitive ability jobs – and away from the "hand and heart" jobs that are still so vital – without at the same time disincentivising the most able and ambitious people in our society.

The pleasure of mastering a task and performing it well is available to people of all levels of ability. It is inevitably the case that more complex and difficult tasks, such as designing a building or helping to invent a new drug, will receive, and deserve to receive, more esteem and reward than being a postal worker or an office cleaner. (Albeit a significant proportion of high qualification jobs appear less useful and productive than many low qualification jobs.)

A successful society must, however, manage the tension between the *inequality* of esteem that arises from relatively open competition for highly skilled jobs and the ethos of *equality* of esteem that flows from democratic citizenship. Economic inequality versus political equality.

To put it another way: an achievement society that wants to avoid widespread disaffection in the democratic age must sufficiently respect and reward achievement in the lower cognitive ability hand and heart jobs and provide meaning and value for people who cannot or do not want to achieve.

In the current age of disruption it seems clear that we have not been getting the balance right. Many people on the Left see this as mainly about income and wealth inequality.

Inequality has not, in fact, been rising sharply in many of the countries, including Britain, where there has been the biggest push-back against the status quo. It is true that slow or non-existent wage growth is harder to bear when a small minority, most notably bankers, seem insulated from austerity. But this misses an even bigger story about esteem and how valued you feel in the social order.

For we have often almost unwittingly come to confuse cognitive ability with human value and human contribution more generally. There is no reason why people who complete certain mental tasks more efficiently than others should be regarded as more admirable people.

Yet there is a clear trend in modern liberal politics to tell us that this is indeed the case. High cognitive/analytical ability and success in the knowledge economy is highly correlated with support for the modern virtues of openness, mobility and hostility to tradition – the opposite of parochialism and insularity. These virtues are also dominant in the expanded higher education sector of modern societies.

This was one of the themes of my book, *The Road to Somewhere*, in which I described the value divides in British society, revealed starkly by the Brexit vote, that have been exacerbated by this narrower focus on cognitive ability.

On the one hand is the group I call the "Anywheres", making up about 20 to 25 per cent of the population, who are well educated (mainly with high cognitive ability) and usually live far from their parents, tend to favour openness and autonomy, and are comfortable with social fluidity and novelty.

On the other hand is a larger group of people, about half of the population, I call the "Somewheres", who are less well educated, more rooted and value security and familiarity. They place a much greater emphasis on group attachments (local and national) than the Anywheres.

Anywheres are generally comfortable with social change because they have so-called "achieved identities" – a sense of themselves derived from educational and career achievements, which allows them to fit in pretty much, well, anywhere. Whereas Somewheres have "ascribed identities" based more on place or group which means that their identity can be more easily discomforted by rapid change to those places.

The Anywhere/Somewhere divide does not always map directly onto the high cognitive ability/modest cognitive ability divide (there are, of course, Anywheres of average cognitive ability and Somewheres of high cognitive ability). But there is considerable overlap, not least measured by the cognitive element in the head jobs that Anywheres tend to do, and the hand and heart jobs that Somewheres tend to do.

It is certainly the case that Anywhere values and priorities, which have come to dominate modern politics and all mainstream political parties, tend to coincide with the values and priorities of those with high cognitive ability. And the Anywhere answer to everything from social mobility to improved productivity has been the same: more academic higher education.

Yet as David Lucas, the children's author and illustrator, has persuasively argued, society needs the cognitive skills of the knowledge economy but we also need the craft skills of artisans and tradesmen, and the emotional intelligence of those in caring jobs.

Hand and heart skills have become chronically undervalued in the modern world, unbalancing our societies and alienating millions of people.

Everyone is in favour of social mobility – and bright people from whatever background travelling as far as their talents will take them – but today's British Dream has become too narrowly defined as going to university and into a professional job. This is not surprising when more than 90 per cent of MPs are graduates.

Anywhere.

In Britain there has been some attempt in recent years to offer other options to school leavers with improved apprenticeships and T-levels. But they cannot compete with the prestige of the university route, leaving our economy starved of essential workers – last year fewer than 10,000 young people started proper construction apprenticeships while half of the building workers in London are from abroad.

Meanwhile heart jobs in social care, parts of the NHS, early years education and childcare continue to be undervalued (and paid) because they are roles that used to be performed for free in the private realm of the family, mainly by women. The modern women's equality movement has focused on breaking glass ceilings and equal competition with men in higher professional jobs and has rather looked down upon jobs and roles associated with traditionally female aptitudes for caring and nurturing. Hence, in part, the crisis in social care and in nurse recruitment.

We are encouraged to live increasingly "head" lives, reinforced by most advances in technology that reduce opportunities for craft, and the need for human contact or attachment to specific places. By contrast, it is the relatively undervalued skills of hand and heart that promote belonging and attachment. (The modern obsession with cooking, on television and in the newspapers, may reflect the continuing desire for useful hand work on the part of so many people who no longer use their hands at work.)

All across the developed world, the one quality-of-life indicator that is going *down* is mental health. Mental well-being depends on a sense of meaning and purpose. We create meaning and purpose through attachment, belonging, stories, love. And through transcending a narrow sense of ourselves – the most powerful route to meaning is through self-sacrifice: giving to others.

There is nothing more spiritually rewarding than caring for others, or making things with your hands. It is the pleasure of belonging, of attachment, the pleasure of being embodied, in this place and time, the pleasure of being much more than a disembodied intellect, a brain in a jar.

Yet abstraction and detachment dominate our culture. Consider the ethos of the digital giants like Google and Facebook. And joining the world of cognitive achievers generally means detaching yourself from your roots. Justine Greening, Britain's former secretary of state for education, said this in a speech in 2017: "All the years I spent growing up in Rotherham I was aiming for something better...a better job, owning my

own home, an interesting career, a life that I found really challenging…
I knew there was something better out there."

The unselfconscious way in which a cabinet minister doubts whether it
is possible for an able, ambitious person to live a fulfilled life in a town of
120,000 people (a 30-minute commute from Sheffield) reveals something
flawed about modern Britain.

Many Somewheres cannot or do not want to leave their roots and join
the Anywheres, and, in any case, half of the population will always, by
logical necessity, be in the bottom half of the cognitive ability spectrum.
Yet all of us need to feel we have a valued place in society even if we are
not mobile, high achievers.

Anywheres, because they are generally more articulate and better
trained in sifting evidence, flatter themselves with the belief that their
values flow from reason and evidence and for that reason are morally
superior. In fact they are generally just as subject to groupthink as Some-
wheres, as the UK's environment secretary Michael Gove pointed out in
his famous comment about experts (during the EU referendum campaign
of 2016, he suggested that Britons had "had enough of experts").

The Anywhere political class has ruled too much in its own interests,
ignoring some of the basic political intuitions of the Somewheres: the
importance of stable neighbourhoods and secure borders, the priority of
national citizen rights before universal rights, the need for narrative and
recognition for those who do not easily thrive in more head-based,
cognitive ability-favouring economies.

And, in Britain, this lack of empathy for the Somewhere worldview has
now left us with the Brexit backlash and a country more divided than at
any time since the 1970s. Is that not ample evidence of the limits of
cognitive ability?

So how can a better balance between the "Three Hs" be achieved?
Markets do not simply respond to supply and demand but can also reflect
the underlying value and priority that society places on different activities.

Political pressure from those who do not share the interests of the
higher cognitive elites will help to drive change. And there are several
trends that suggest the head could be about to face a more even contest
with hand and heart.

A dystopian one suggested by Nicholas Carr in his book *The Shallows* is
that we are all going to be made dumber by the internet. Carr argues that
sustained exposure to the internet is reordering our synapses and making

Next pages: Somewhere.

us dependent on constant novelty. This may bring improvement in some fields such as decision-making and problem-solving but overall it will mean significant losses in language facility, memory and concentration. (Recent evidence that the Flynn effect of consistently rising IQ levels is going into reverse could offer corroboration of Carr's thesis.)

There are two more positive trends that could help to boost both hand and heart.

The potential boost to hand, in the UK at least, comes from a combination of changes to employment patterns as a result of Artificial Intelligence and changes to immigration patterns as a result of Brexit.

Technological change and more open markets have mainly impacted middle and lower cognitive jobs in the past 40 years, causing a sharp decline in skilled industrial labouring jobs. But the next wave of AI is expected to have its most dramatic impact on high cognitive jobs (at least at the lower end) in accounting, law, medicine and so on.

This disruption felt by well-educated Anywheres could lead to a new sympathy for people performing relatively routine, hand and heart jobs, partly because the former accountants and lawyers may find themselves doing those jobs themselves.

At the same time, because of the widespread push-back against historically high immigration flows, in Britain and elsewhere in the developed world, it should become harder for employers to hire already trained people from other countries, especially in the middling technical and skilled manual jobs. As a consequence the training opportunities and the pay for such jobs ought to rise.

In some sectors such as IT and construction there may even be a "your country needs you" drive to replace immigrants, raising the visibility, prestige and pay of such jobs.

The final benign trend, raising the status of heart jobs, is linked to two big and irreversible trends: the increased number of old people who will need significant levels of care in their final years and the rising power of women.

The #MeToo movement exposing the predatory behaviour of men in the entertainment industry, politics and elsewhere was welcome not only because of the constraint it helped to place on such behaviour but also because of the expression of female power that it represents. #MeToo would have been impossible 30 years ago because there were simply too few women in positions of authority in the media and politics.

One of the most important questions in British society over the next generation is whether the increased status of women in society will drive significant increases in the pay and prestige of caring (heart) jobs that are still mainly performed by women.

Could #MeToo mean a £20 an hour minimum wage in social care in the foreseeable future? Or are #MeToo women – educated upper level professionals – concerned only with a level playing field with men in high cognitive ability jobs. Are they too detached from the interests of more traditional women who work part-time in a care home?

To conclude: the combination of the rise and rise of cognitive ability, and head jobs, as a measure of economic and social success, and the hegemony of liberal (Anywhere) political interests, has led to the unbalancing of Western politics. The disaffection of large minorities, even majorities, in many countries, is intimately linked to the declining prestige of hand and heart roles. The stress on economic inequality does not properly capture this disaffection.

What are the lessons of history? Was there a better head, hand and heart balance in the past? What about the Victorian era that valued brains but placed more stress on character and virtue? Does that provide a model? Cognitive ability will remain central to the advance of human civilisation, and all societies will want to continue to nurture it. Can cognitive elites, and the liberalism they tend to espouse, be politically constrained without causing economic and cultural damage? What can the cognitively blessed reasonably expect, and how much power will they willingly concede?

Head work is not destined to become less important in our knowledge-based economies, but there are signs that the hand and the heart will be restored to positions of greater respect. Politics is, in fact, already demanding such a rebalancing.

Mr. WILLIAM

SHAKESPEARES

COMEDIES,
HISTORIES, &
TRAGEDIES.

Publiſhed according to the True Originall Copies.

Martin Droeſhout ſculpſit London.

LONDON
Printed by Iſaac Iaggard, and Ed. Blount. 1623.

The 1623 published collection of
William Shakespeare's plays, commonly
referred to as The First Folio.

THE TRIGGERING

Brendan O'Neill

Thphis year I witnessed my first-ever triggering. It was at Oxford University. I was giving an after-dinner speech on the virtues of freedom of thought when it happened. A triggering. A real, physical triggering. The physical meltdown of an individual upon exposure to my ideas.

Most people are aware of the word triggering these days. To be triggered is to encounter words or ideas that you find so disagreeable, so offensive, that they make you feel ill or possibly even traumatised. The idea of the "trauma trigger" has its origins in psychology, in the discovery that some people who have suffered a traumatic event in their lives can find themselves reliving that event, or at least having it invade their minds involuntarily, if they see or hear something that is reminiscent of the bad thing that happened. In recent years, this psychological category has crossed over into the political sphere, so that many, particularly on the left, now claim that all sorts of people, possibly even all of us, can be triggered by alarming words or images.

Indeed, the easily triggered individual, the fragile, susceptible person whose self-esteem might be shattered or at least bruised through exposure to difficult ideas, has become a central motif of the new left's political outlook. It is a key component of the culture of political correctness: the idea that words can wound, ideas can scar, and tense discussion can cause actual psychological and even physiological ailment among the attendees to that discussion.

This is why on some campuses now, books come with "trigger warnings". These are warnings to students that as they read this book, they might encounter a difficult or disturbing idea or scenario that might cause them actual harm. At Columbia University in New York, students recently called for a trigger warning on Ovid's *Metamorphoses* on the basis that it includes a story of rape. The Columbia students said these texts were "wrought with narratives of exclusion and oppression", which

means they are potentially harmful to "survivors of rape, people of colour, and students from low-income backgrounds". In short, these Ivy League students are arguing that we are all fragile, but poor people and black people are especially fragile and need special assistance when they engage with classical Roman literature. Such is the paternalism of the PC worldview.

At Cambridge University last year, the English faculty added trigger warnings to Shakespeare's *Titus Andronicus* and *The Comedy of Errors.* Students were cautioned that talking about these plays would involve having "discussions of sexual violence". It was implied that they could opt out of the Shakespeare seminars if they were likely to find such discussions harmful to their well-being. This is where we are at in 2018: we are encouraging students to be scared of Shakespeare, to see Shakespeare as potentially detrimental to their mental health.

One of my favourite trigger-warning stories involves University College London. In 2016, an archaeology tutor warned students that they might have to look at pictures of human remains and informed them that bones can be scary. Students were given permission to "walk out of classes if they find dealing with some topics too traumatic". You know the Western academy is in a bad way when even archaeology students are being told that digging up old dead things might cause them trauma. That is what archaeologists do. The very stuff, the very heart, of a student's learning is now presented to them as something that might hurt them.

So I was already aware, prior to my talk at Oxford, of the idea of triggering. I had watched as trigger warnings spread through campuses in the US and the UK in particular. I had encountered students in the past who claimed to have been triggered but did not show actual signs of having been triggered. They would simply declare it. "You have triggered me. I hate you. Get off my campus." And so on. A very welcoming bunch. And I had argued many times, in speeches and articles, that this cult of triggering is detrimental to the very ideal of learning. The very mission of the academy – which is to encourage engagement with texts, confrontation with difficult ideas, and the cultivation of confidence and independence in students as they pursue greater knowledge – is thrown into disarray by today's culture of intellectual caution. Universities which accept the premise that ideas can be psychologically destabilising, and which give a green light to the ostentatious taking of offence by students who see everything from Ovid to Shakespeare as a looming mental

threat, stop being universities in the real meaning of the word. They become, instead, nervous institutions, forever issuing intellectual warnings, and in the process making the very attempt to expand one's intellect appear as an unacceptably dangerous task.

However, I had never seen an actual triggering. I had never witnessed one, a real one. I had never appreciated the seriousness of triggering, until I gave my after-dinner speech at Oxford.

My talk was on the benefits of heresy, on the relationship between heresy and progress. I addressed the fact that I had been prevented from speaking in defence of abortion rights at Christ Church, Oxford in 2014, after it had been decreed by the Feminist Society that "a person without a uterus" – they meant a man – was not a suitable speaker on matters of female reproductive health. The college authorities agreed with them that my presence in the college would make them feel "unsafe" and agreed to cancel my talk.

And I explored other instances in which the right of individuals to feel "comfortable" – that is, mentally, intellectually comfortable – is now elevated above the right of others to speak freely and to express controversial or simply non-mainstream points of view: whether their view is that men cannot become women (now branded "transphobia"), or that Islamic values are not as good as Western liberal values (Islamophobia), or that marriage should be for opposite-sex couples only (homophobia), or that the European Union is a ruthless bureaucracy (Europhobia), or that mass immigration is either not a good idea or certainly something that should be debated in depth before being pursued (xenophobia). Like those old Soviet commissars who wrote off their critics as mentally ill, we now brand anyone who holds unfashionable or controversial views as "phobic" – that is, unstable, fearful, unhinged.

During the question-and-answer session after my speech, one of the students asked me what I thought should be done about "rape culture". I replied that I had a problem with the term rape culture. I said that it conflates a crime, rape, with a non-crime, culture, and that this acts as an invitation to censorship. I argued that it rehabilitates in pseudo-radical language the old, traditionally conservative idea of media-effects theory, which holds that culture can cause people to become beastly, rapacious or evil, in a quite direct way.

I suggested that if we accept that culture contributes to or even causes rape, then we do two bad things. First, we lessen the culpability of the

rapist himself through implying that other people bear some responsibility for his crime, whether it's pornographers, filmmakers or writers. Or maybe Ovid or Shakespeare. And the second thing we do is sanction censorship. We sanction the official control of any words or images that might be seen as contributors to the crime of rape. For if we are serious about controlling public life in such a way that men never see anything saucy or pornographic lest it "trigger" their alleged rapacious instincts, then we can say goodbye to certain movie posters, bra adverts, sexy pop songs, even books: *Lady Chatterley's Lover*, for example, which was effectively banned in Britain for 30 years on the basis that its content could make certain men lustful and dangerous. Do we really want to breathe life back into such a paternalistic view of men, women and society?

As I was saying this in response to the student, I suddenly realised that she was having difficulty breathing. Soon she was wheezing violently. She was hyperventilating. Right in front of me. Eventually she had to be helped from the room by two other students. They held her by her arms and escorted her away from what had clearly become a physically unbearable situation: someone expressing his point of view in her presence.

It is, without question, the strangest, most disturbing thing I have witnessed at a university. I found it disturbing for many reasons. First, because it looked almost religious, almost as a form of possession. It was as if my words had somehow possessed this student and caused her to lose physical command over her person and mind. And secondly, because the other students in attendance seemed not to have been shocked by what happened. When I asked some of them afterwards what they thought had happened, they casually said: "Oh yes, you triggered her." Which suggests to me either that they have witnessed this kind of behaviour before or that they now expect it. These young people at one of the highest seats of learning in the world *expect* that the expression of certain ideas will bring about physical convulsions in some students.

And I found it disturbing because it made me think to myself: maybe words really do hurt. Maybe activist students and the new left and the culture of political correctness more broadly are not making it up when they say disagreement can destabilise minds and souls. Maybe the culture of offence-taking and the cult of vulnerability are now so deeply entrenched in the new generation that they genuinely experience ideas they disagree with as a threat to their physical and mental well-being.

Yale University Law School Building.

This was the lesson I took from the triggering I witnessed. This, I think, is where we are at in relation to millennial fragility and the crisis of robustness on campus and in other sections of society: we now have a new generation that seems to experience difficult ideas as a physical attack. Which seems to lack the filters through which earlier generations might have made sense of the world around them and its various ideologies and outlooks. Which seems to lack the cultural and moral resources that are necessary if we are going to negotiate public life and political life without feeling harmed by, in Hannah Arendt's words, the "merciless exposures" of the public realm.

In short, we have a generation of young adults who seem to lack the raw materials of adulthood. And as a consequence, university life itself, the very act of learning, becomes difficult, if not impossible.

What I think this points to is a problem that actually precedes university itself, which comes prior to the arrival of young adults on campus. It points to a broader crisis of socialisation. To a society that has lost the ability to lead the next generation from childhood to adulthood, and to impart to it the skills of adult life and the cultural resources and materials built up by past generations.

Many students today seem to lack the instinct for adulthood. The triggering I witnessed at Oxford was only an extreme manifestation of a general cultural trend on campuses in the US and the UK and, increasingly, in other parts of Europe too. We have witnessed the rise of "safe spaces": zones in which certain words and ideas are forbidden in order to facilitate a sense of "safety" for students – safety from controversy, this means. More than 50 per cent of student unions in Britain have safe spaces. King's College London even has "safe space marshals", who really are as Orwellian as they sound – they attend student events and political discussions to ensure no one in the audience is being made to feel intellectually distressed.

What is striking is how many of these safe spaces mimic the conditions of childhood, even of the kindergarten. Some safe spaces provide colouring books to calm students down. Harvard Medical School and Yale Law School have resident "therapy dogs" which students can pat in order to feel less stressed out. In 2015, the University of Canberra in Australia helped students to deal with exam stress by providing them with a petting zoo and balloon-bursting sessions: students would gather to burst balloons as a way, presumably, of forgetting their adult responsibilities.

In one particularly sad story, Twiglet, the therapy dog for stressed students at Cambridge, has gone on a strike because *it* is feeling stressed. Twiglet was there for distressed students to pet or take for a walk. But as news reports informed us in May this year: "Twiglet became so distressed by the experience that she refused to go for walks." Even dogs have had enough of fragile millennials.

This recreation on campus of the conditions of childhood is not the achievement of students alone. This regressive activity is often backed by universities themselves. In May of this year, the vice-chancellor of Buckingham University in England was quoted as saying: "We have to stop assuming that 18-year-old school-leavers are capable of running their own lives." Some students and universities are essentially calling for the reinstatement of the very thing that students fought against in the 1950s and 1960s: the rules of *in loco parentis*, where it was assumed that the university should guard students, especially female students, from the vagaries of adult life.

What we are witnessing is the rise of a climate of extreme psychic vulnerability. Many in the young generation can experience wounded feelings in response to almost anything. Books, photographs of bones, Shakespeare, even statues: campaigners at Oxford who want to remove a statue of the old colonialist Cecil Rhodes have described his stony presence as an "environmental microaggression". Even inanimate objects, mere representations of long-gone historic people or events, can now induce trauma, can be experienced as an act of violence, of "aggression". The institutionalisation of psychic vulnerability encourages sections of the new generation to expect, and by extension actually to see, harm in every word or image or monument they encounter.

And this is now the key argument for censorship in the 21st century – not the need to quash certain ideologies or police sexual expression, but rather to ringfence the young, and others, from allegedly aggressive or disturbing content. The arguments for censorship now are couched in the language of self-protection, of self-esteem, of the preservation of mental comfort. From the "no-platforming" of controversial speakers to the spread of safe spaces to the demand for trigger warnings on Shakespeare – what we have today is therapeutic censorship. In the past we had ideological censorship, for example in the clampdowns on communist literature, and religious censorship, in old wars on blasphemous thought or speech; now we have therapeutic censorship designed to protect the fragile individual from whatever he or she deems to be potentially triggering.

And this springs, not from the academy itself, not from the relativistic philosophers whom students are encouraged to read, or from professors who pollute their minds with nonsense about the overarching power of language, but rather from the broader, pre-university crisis of socialisation. Too many critics of PC focus on what is taught on campus; they fail to explain why students are susceptible to the cult of fragility long before they get to university, and in some cases even if they do not go to university. It is because they live, we all live, in societies that have shifted from valuing the robust individual towards celebrating the fragile self. As a consequence of this, the younger generation increasingly lacks the spaces in which to *practise* adulthood, and thereby to become adult.

Our society now cultivates permanent infancy. Surveys continually show that in the US and in parts of Europe, children now spend less time without their parents; they are less likely to have Saturday jobs; they take fewer drugs, drink less, and have less sex than earlier generations. They continually postpone, or rather are continually encouraged to postpone, the responsibilities of adulthood. It is not surprising that some experts have called for the official expansion of the period of adolescence. Writing in the British medical journal *The Lancet* in January, a group of scientists argued that adolescence now lasts from the age of 10 to the age of 24. This represents the adaptation of medical understanding to a social reality – that society, through new styles of over-close parenting and schooling which increasingly focus on self-esteem over knowledge – has nurtured a generation that is reluctant to embrace the putative joys of being an adult.

Alongside the failure to encourage the young to practise adulthood – through taking time away from their parents, having part-time jobs, socialising with friends, and so on – modern Western society also fails to impart the cultural resources of the past to this new generation. As Hannah Arendt argued, a key part of socialisation, perhaps the key part, is the transmission of cultural knowledge, of the values and gains of past generations. Adult society ought to give the next generation both the raw materials of adulthood and the cultural leaps forward of earlier generations – today it tends to do neither.

Indeed, Western societies have become increasingly estranged from their own history, values and knowledge. Our societies have become adept at self-loathing. They have made an artform of it. Britain beats itself up over the empire and colonialism. America has turned its history of slavery into the original sin of the republic, a crime America will never

recover from. France is in a permanent state of meltdown over the radical bourgeois ideas and virtues upon which it was built: were these in fact exclusionary, destructive ideas, they now ask, constantly? So it is not surprising that the young do not only feel ill-prepared for adult existence but that they also feel increasingly distant from the culture and knowledge of their own societies, whether it be Ovid, Shakespeare or the gains of archaeology. It is because we no longer culturally transmit such facts and ideas and breakthroughs because we ourselves, adult society, have lost faith in the intellectual origins of our world.

This problematic dual process, this devaluation of adulthood and knowledge, is cultivating vulnerability in the new generation. It discourages *courage*, the taking of risks, whether personal risks or intellectual risks. It forgets how central courage is to both life and learning. As Arendt said, the "virtue of courage is one of the most elemental political attitudes". Why? Because it is the virtue that allows us to make the journey from the comfort of the home to the discomfort of the public sphere, to the "merciless exposures" of everyday life – the often wonderful, life-changing merciless exposures. It is the virtue that prepares us for intellectual confrontation and for the experience of knowledge. Dare to know, as Kant put it. In that great line of the Enlightenment, the daring part is as important as the knowing part.

The crisis of the university, the crisis of freedom of thought, the crisis of intellectual experimentation – these are not the handiwork of "cultural Marxists" or armies of millennials hell-bent on foisting identity politics upon us all, as too many of the critics of PC would have us believe. Rather, they are a consequence of Western society's turn against itself, and its history, and its responsibility to make adults of the young. In that triggering at Oxford, in those gasps for breath, in the hyperventilation of a young person who had simply heard something she disagreed with, I saw the crisis of enlightened thought itself. And the way out of it, too: build robustness, celebrate courage, valorise daring.

THE STATE OF THE
DEBATE

Jordan Peterson following his rule number one:
Stand up straight with your shoulders back.

GOING UNDERGROUND:
THE INTELLECTUAL DARK WEB

Fraser Nelson

A good chunk of my home is lined with books from the Ax:son Johnson foundation. The one you hold in your hands is typical of the species: beautifully typeset and illustrated, enlivened with gorgeous illustrations and filled with the work of experts in various fields. Religion, consciousness, war, culture: their formula is to assemble the best writers they can. People of all kinds of political orientations – yet united by a love of vigorous but civil debate, an interest in viewpoints they disagree with, a willingness to go against the grain. But now, the writers in this book might ask themselves a question: are they part of the "intellectual dark web"?

The phrase was invented as a joke by Eric Weinstein, an American mathematician and economist, to describe a movement that he witnessed and, indeed, was part of. It involved the fate of academics who declined to go along with certain campus fads – the use of new pronouns, for example, or demands that reading lists are changed to reflect ethnic and gender diversity. If they declined, they'd be the target of furious protests; cast as racist, transphobic or worse. With their reputations damaged, in the eyes of terrified university authorities, their careers would stall and they would end up ostracised or losing their jobs.

A few of them went online, with podcasts or YouTube, to continue the argument, and found an audience of millions. This is not shock jockery, nor a kind of political porn. These are academics and thinkers, holding debates that, for very modern reasons, it's now hard to hold on campus. There is no membership list of the dark web, no secret handshake, no system of joining (although, in recent months at the time of writing, quite a lot of people would quite like to do so). Even if the movement only lasts a short while, it can stand as a monument to the style of political debate in 2018.

The cast: Eric Weinstein, of course, and his brother Bret, a biologist and evolutionary theorist. Both are Bernie Sanders supporters. Then

Sam Harris, an outspoken Hillary Clinton voter, whose podcast now has a million listens a month. Not as many as the podcast of Ben Shapiro, an anti-Trump conservative. Then come the feminists such as Christina Hoff Sommers and Camille Paglia. Perhaps most famously there is Jordan Peterson, a Canadian psychology professor. And I'd certainly include here Douglas Murray, an associate editor of *The Spectator* and author of *The Strange Death of Europe.*

They like to discuss all kinds of topics: religion and its place in society, economics, culture, changing social norms. This isn't unusual: academics like to have such discussions. But perhaps most strangely of all in the world of highbrow ideas and discussion, they enjoy vast popularity. Harris's YouTube channel has had more than 16 million views at the time of writing, greater than any writer of any broadsheet newspaper could hope for. But this looks pathetic compared to the YouTube views of Ben Shapiro (23 million) and Jordan Peterson (72 million). Dave Rubin, a political commentator and talk show host, has more than all of these put together – 179 million.

The tone of their discussion is mild and gentle. Their pitch is not that they'll make you outraged for the sake of it, but that they'll offer thoughtful discussion that often goes way off the deep end, and that 60 or 90-minute long discussions with other public intellectuals are more fulfilling than the ten-minute debates offered by national TV and radio. And even the short mainstream media discussions tend to be Punch-and-Judy, with two people from opposing sides put together in the hope that they'll start tearing lumps out of each other. For those who want light rather than heat, the podcasts and YouTube lectures are a technological breakthrough.

And then come the lectures. When my *Spectator* colleague Murray told me he was going to the O2 Arena in London to have a discussion with Peterson and Harris, I was intrigued at the idea of highbrow discussion in a 20,000-capacity arena and wanted to book tickets for my colleagues to go along. Until I found out the cost: £160 a ticket. Sometimes, popular thinkers, like Thomas Piketty, are referred to as "pop-star academics". But that phrase does not suit Petersen because there are not many pop stars who can get away with charging £160 in venues with the capacity of a small town.

Not since Billy Graham visited Wembley Stadium in 1954 have so many gathered to hear discussion, so there is no doubt that we're witness-

ing something extraordinary, perhaps unprecedented, in the realm of debate. But what?

★

Those who read Peterson's book, *12 Rules for Life – An Antidote to Chaos*, will enjoy it: but it is not full of novel or unusual facts. He has been writing books for 20 years, and no one bought them in any numbers. But what has marked him out this time is his readiness to debate with his critics, rather than to cave in when faced with their accusations. And also his plain talking about what he is dealing with. "I regard the made-up pronouns as neologisms of radical PC authoritarians who seek to exercise control of what other people say and think," he says. "I'm not a fan of that sort of person, and I'm not going to be a mouthpiece for language that I detest." His fans will be people who wish they had thought of such eloquent put-downs.

The books, podcasts and YouTube debates in the intellectual dark web are of high quality, but not a quality or originality that you could not find on a television station. I mean no disrespect to these stylish, eloquent writers to say that they are not – really – the phenomenon. It's not about even what they are, but what they are a reaction to. They are saying fairly standard things, at a time when doing so is seen to be inflammatory. To paraphrase Orwell: at a time of universal hysteria, stating the obvious becomes a revolutionary act.

As a magazine editor, I've noticed this mood grow over ten years. My first exposure to it was my first month in the job, September 2009. *The Spectator* was staging a discussion with some documentary-makers who had made a film about HIV. In it, Luc Montagnier, a Nobel laureate, says that a healthy immune system can shrug off the virus and that, in his opinion, many Africans are diagnosed as dying of Aids when they are really dying of malnutrition. This film had been banned in certain places, which seemed an odd way of dealing with a controversial topic. So *The Spectator* assembled a panel of medical experts to put the claims to the test. I wrote a short blog about it. "That's rather brave of you, Fraser," said one of the commentators. "Be prepared to meet the Aids denial community who will be arriving on this blog post in 5 – 4 – 3 – 2 – 1..." And then, the explosion.

This was my first experience of a Twitterstorm. Ben Goldacre, a pioneer in the art of whipping up a Twitter mob, alerted his followers to what

he called "Aids denialism at *The Spectator*" and called for the event to be pulled. At the time, I didn't see what was serious about this: no one was "denying" Aids at *The Spectator* or anywhere else. But as I discovered, the Twitter era meant that the accusation is enough; people didn't want to know more, or ask what we were trying to do. Needless to say, Goldacre didn't want to come on the panel to try to argue with the film-makers, he wanted the event cancelled. To offer them a platform, he argued, was to confer legitimacy to a repulsive pseudo-science. It was my first encounter with no-platforming as a verb.

We refused to pull out, but the digital mob went after other panelists (and their employers) and they withdrew. There were other scientists sympathetic to the idea, but they explained that in their line of work, funding quickly dries up from anyone vaguely considered to be aiding or abetting Aids denialism. The event had to be cancelled. We lost, because we had been unprepared. This was, to me, entirely new – and thoroughly sinister.

Since then, Twitterstorms have now claimed several victims. David Remnick, editor of *The New Yorker*, had decided to interview Steve Bannon live on stage – taking the standard, journalistic and liberal view that it's a good idea to probe and expose an opponent. But a revolt on Twitter, led by one of his own staffers, led him to pull out of the event just 12 hours after announcing it. Ian Buruma had to resign as editor of the *New York Review of Books* after a twitterstorm about his decision to ommission an article from someone acquitted of a sexual offence.

The same formula applies every time. A toxic allegation is made – Aids denialism or "normalising hate" (a phrase applied to editors who publish opinions that some disagree with). Then there is a pile-on, seeking to enlist enough high-profile people to create the impression of an irresistible force. Then the calls come: sack the lecturer! Or the columnist! Or the cartoonist – an Australian caricaturist had to go into hiding after drawing Serena Williams and being accused of racism on Twitter by JK Rowling. The Twitterstorm led to death threats against his wife and children. Not that the *Harry Potter* author will have intended this, but an accusation of racism from someone with 14 million Twitter followers can be enough to convict in the court of digital opinion.

The historian Niall Ferguson has described the process well. "As soon as you've had that experience, it's quite transformative," he wrote. "You're taken aback to be on the receiving end of a social media mob. And to be

Camille Paglia.

attacked not for the actual substance of anything you have argued but for being – covertly – a racist, an Islamophobe, a homophobe. I was always a believer in meritocracy and that we were engaged in rational debate: one made one's case, presented the evidence and then the other side did the same. But here, it's not the content of the article under discussion but the personality of the author."

The attacks are intended to blacken the name of the target. The era of instant outrage, easily transmitted on social media, means the other side are looking for enemies of the people and for heretics to denounce. And before I criticise university authorities for not standing up for free speech, I need to answer the question: why did I pull the Aids event? Why didn't I continue, with empty chairs for other panelists? The answer: I needed to pick my battles. Did I want to go into battle for a film-maker about whom I knew almost nothing? Was I so sure that his argument held water? If *The Spectator*'s name was going to be dragged through the mud for this, was it worth it? The answer to all of these questions is an obvious "no".

Such attacks work because everyone is mortified. I was a few weeks into the job, yet smeared as an Aids denier. We had letters from people expressing disgust at opinions we'd never expressed. The mob works. It will target your boss, your boss's boss – and it often takes nerves of steel to carry on. In this way, Twitter – a medium actively used by perhaps 0.1 per cent of the population, including a disproportionate number of the unhinged – sets the parameters of national debate. It manages to influence those who run universities, newspapers and television shows. I'm struck by how many television producers check Twitter immediately after their shows have aired, in lieu of an audience reaction. It is a tool that gives huge control to a vocal, often hysterical minority. In this way, the parameters of debate are narrowed. With effects that can be seen the world over.

★

Like so many political phenomena, this one was summed up best by a Swedish academic. Henrik Oscarsson pointed out how the debate had narrowed so much that it had, in effect, created an "opinion corridor" – outside of which opinions were not respectable. And there were many widely-held beliefs that were rarely expressed in public. That 40 per cent of Swedes think that Sweden should accept fewer refugees, 60 per cent

want more animal rights, 50 per cent don't agree that homosexual couples should be allowed to adopt children, 20 per cent think that there should be a death penalty for murder and – my personal favourite – 25 per cent of all Swedes want to increase the number of wolves.

Sweden has an unusually large number of political parties, but if they all huddle together in this corridor then they hand a vast amount of ground to new parties who will not be afraid to express such opinions. Hence the rise of populism. The intellectual dark web is a highbrow expression of the same phenomenon; people wish to have discussions about all kinds of topics, and can vote for new parties in order to widen this debate. The message of populists all over is a simple one: "you are an ordinary person, holding ordinary beliefs. And for this, you are neglected – perhaps even despised – by an out-of-touch political elite who regard you as racist." So when populists are attacked as racists, they say their point is made for them. This is the feedback loop of populism.

It extends, of course, far beyond Sweden. In America, for example, let's take a list of policies that were popular *before* Donald Trump was elected. Building a wall along the Mexican border drew the support of 39 per cent of the US electorate. Repealing "Obamacare" – or the Affordable Care Act – was backed by 46 per cent of voters. Bringing back torture for terror suspects? 64 per cent. Banning all Syrian refugees? 51 per cent. And a ban on Muslims entering the US? 51 per cent.

When Trump endorsed each of these proposals, he was attacked as a bigot, a racist, an Islamophobe and worse. He revelled in the obloquy and sought more of it, because – as he understood far better than his opponents – this is his greatest form of advertising. To be attacked for championing a popular opinion. Which allows the feedback loop to set in: look, he says to his supporters, this is what they think of you! It works because they rise to the bait. Every time.

When the history of Trump's presidency is written, it may be seen not as the success of an extraordinary political entrepreneur (although he certainly is that) but an example of a politician created by his critics. He hogs the agenda because they talk about nothing else. He uses crude language to say things that most Americans perceive as common sense, then waits to be attacked. See, he says to his audience, look how crazy they are. See how they are wound up. Consumed by anger. And they look down upon you, as well as me. He has identified a certain shrillness in the debate, and used it to power his own campaign.

After attacking the upstarts, mainstream politicians tend to calm down, asking themselves, if these populists are so vulgar, why are so many millions supporting them? Might they have a point somewhere? And might our political conversation have dealigned with what our voters want? In Britain, this happened with Brexit: a traumatic political event. But it killed populism. The UK is, at the time of writing, the only large country in Europe not to have members of a populist party in parliament. Brexit has tugged politicians back to the people, and the process is agonising for them. But it may well end up killing populism stone dead.

In his classic definition, Princeton's Jan-Werner Müller says that populism is not a political agenda, it's a rhetorical style, shrieking at those in power (and the media) as collusive out-of-touch elites. Populists claim to speak for "the people" and often claim to be the only ones who can do so because other parties are illegitimate. "The only thing that matters is the unification of the people," Trump once said, "because the other people don't mean anything." Britain might have a far-left Labour Party but the only politicians making such noises are, yet again, seen as cranks with no serious support.

The intellectual dark web would not exist without the atmosphere that seems to have led basic conversations to be forbidden. Trump would not exist, if more politicians had learned to debate immigration and culture without calling each other racist. A centre-left/centre-right duopoly tried to keep important issues off the agenda, but this can only work for so long in a democracy. Those who like broad-minded and wide-ranging discussion can choose the podcasts, YouTube channels and websites that provide them. Voters who wish to change the political agenda can do so more forcefully by using coarse politicians only too willing to shake things up. And eventually, things improve.

A couple of months after the 2018 meeting in Engelsberg, Sweden had its general election. I listened to the final leaders' debate. We had the leader of the Christian Democrats denouncing "honour repression" of Muslim girls in Swedish homes. The Liberal Party leader was attacking hardline Islamist free schools. The Conservative leader, Ulf Kristersson, was taunting the Social Democrat prime minister asking him which part of immigration he was most proud of. The unemployment? The gang crime? My (Swedish) wife, who was only half-watching, looked up at that point and asked if this was Jimmie Åkesson, the leader of the populist Sweden Democrats.

Åkesson expected to come first in that election. His party stayed in third place, having lost its monopoly on discussing immigration-related problems. This is the democratic process in action. The opinion corridor is widening, and it looks like the march of Swedish populists has been halted. Similarly, it will not be too long before universities start to stand up to the intolerance of a minority, and defend people's right to disagree. The intellectual dark web will, most likely, be a flicker in history, a reminder of when the West's conversation was at its most shrill. And free-thinking people had to look to underground clubs for a place to air their thoughts. We should enjoy it while it lasts.

Demonstrators protest outside
the Royal Bank of Scotland in London.

MARKET COMPLEXITY AND REMAKING
THE MORAL CASE FOR CAPITALISM

Iain Martin

Those of us above a certain age will all know what a financial crash is supposed to look like, in television and media terms, in the electronic era of rapid mass communication. There's a horrible beauty to it, the red line heading down on a large graph on the screen showing a sharp fall in share prices. In the crashes, or brief market reverses as they turned out to be, of the late 1980s and 1990s, footage of the red line filmed at the height of the emergency tended to be intercut with footage of men – traders – shouting and gesticulating dramatically. The signal was obvious. Look, even the well-paid people who are supposed to know about this stuff – the business of managing money – are in a state of blind panic. Something terrible is happening here, it said. Something important – usually the entire stock market – has markedly less value than it did yesterday, or five minutes ago, and no good will come of it for the rest of us.

Financial firms and stock exchanges soon came to realise such footage broadcast in an emergency only makes matters worse by increasing the herd-like sense of panic. Now, any television crews admitted onto trading floors are shown rows of earnest types tapping into keyboards, trying to look like the calm and reassuring data scientists they are.

In 2008, the public relations people for the most part managed to keep the televised media outside looking in, from where it filmed stunned bank staff leaving their offices carrying cardboard boxes. But the red line – down, down, down – was ubiquitous on television screens during that crisis. It was just such a red line that brought home to me the enormity of what was happening, on that morning in October 2008 when the Royal Bank of Scotland (briefly, at the wrong moment, the biggest bank in the world) crashed. I had for three years been the editor of *The Scotsman* newspaper, in Edinburgh, home town of RBS, at the height of the boom and had admired the bank's success, with some reservations, without really understanding how it had managed to get so big so quickly. And there it

was a few years later on the television screen, its share price collapsing, down 25 per cent in a matter of minutes, with confidence in the institution's ability to fund itself evaporated.

By that day in 2008 I was working as a department head in the newsroom of one of the UK's main newspapers. We stood and gawped at the screens turning red, and then snapped into journalistic mode, asking questions. Once you asked ten questions, another ten occurred. It was dizzying. Modern markets had developed to a point of complexity beyond popular comprehension.

Before the 2008 immolation I thought I had a good grasp of how the world worked, as a journalist and writer on politics with an interest in economics. I didn't. And it was my ignorance during that crisis a decade ago that first prompted me to start writing books about financial history. There was worse to come, once I set out trying to understand by asking questions and telling the story. I soon had a horrifying realisation. Many of those in charge of the system did not understand it either.

I did, though, have enough of an understanding of politics – as a political journalist by trade – to grasp, along with many others, that this confusing crisis was going to have a long tail, that is to say a profound and enduring impact beyond finance. And what an impact it has had. This was an epic crisis of such violence that a decade later it continues to shape our politics and arguments about ethics and public policy. Among the wealthy and comfortable, those who benefited disproportionately from the asset price bubbles inflated as a consequence of the measures, such as quantitative easing (QE), introduced to prevent the crisis turning into a depression, it can be tempting to think that, with the banks rescued, 2008 was a blip, a bump on the road in the successful story of financial globalisation. But that is a delusion, I'm afraid, at odds with the evidence of what continues to flow.

Populism on the Left and the Right has ballooned in recent years. The migration crisis may be the greater driver of discontent in countries such as Sweden, or in Germany, the EU's powerhouse state. But the elites blamed for not taking concerns about migration and culture sufficiently seriously are, in the popular imagination, the same elites who defend or enable the global financial system. Dig down, and you find that money and finance unfairly distributed is always in there somewhere as a source of resentment among angry voters.

In the UK, it has been much more direct. The financial crisis and the

rescue drove increases in public debt. Then the policies implemented by the Conservatives – to slow and check that rate of growth in debt – triggered arguments about austerity and inequality. It revived the far Left. A decade on, the decision to bail out the bankers and to not put any of their leaders in jail is still cited by British voters and politicians, such as former prime minister Gordon Brown, who was in charge of policy in the UK until 2010, as an explanation for deep discontent.

The ideas of Karl Marx, tested to destruction it had been thought, are back in vogue, and the leader of the opposition Labour party is surrounded by genuine Marxists. Several of Jeremy Corbyn's advisers were until recently active communists. This is not overblown rhetoric, merely an acknowledgement of the facts and worth stating because it is so shocking considering the previous assumption that the fall of communism at the end of the Cold War was supposed to have finished that creed off forever. Yet the old far Left is back in Britain, with new support from younger campaigners, members and a slice of the electorate.

In America, the experience has been different, although the term socialism is being used approvingly by a new generation of activists there too. The post-crisis backlash took the US rightwards, not to the left. Barack Obama was elected in the midst of the crisis, but the slowness of the recovery on Obama's watch was one of the factors that explains the appeal of Donald Trump in the 2016 US general election in states that the Democrats had assumed were Hillary Clinton's by right. Trump spoke to those voters angry with elites, including financial elites that intersected with mainstream party elites. This was classic American populism.

What of the EU and the eurozone? During the initial stages of the crisis, with Wall Street and the City of London in meltdown, there was some smugness in northern European chancelleries that this was an Anglo-Saxon crisis arising from greed and gambling to which sensible, mainland continental Europe was immune. This turned out to be nonsense. German banks had filled their balance sheets full of rubbish too. The eurozone crisis that followed showed that the eurozone debt machine was a flawed construction.

Resentment with the elites who designed the euro – another troubled, globalised, financial project – has contributed to the current situation in Italy. At the time of writing, a weird left-right populist coalition governs in Italy – if that is the right word considering the eccentric antics of its main players. In Spain, a left-wing populist government spent the late summer

of 2018 attempting to arrange for the body of General Franco to be exhumed. It is difficult to think of a proposed act more likely to galvanise conservative opinion in that country, by reopening the wounds of the civil war period.

There has been another change since 2008–09. Almost everywhere in the West, the difficult argument over globalisation – is it beneficial? is it fair? what are its proper limits? – was largely restricted, pre-crisis, to activists, anarchists and mask-wearing demonstrators on the agitprop far Left who marched at international summits. No longer. In the last ten years, concern about globalisation has gone mainstream, in the form of anger about the scale of migration flows, with the question of economic migration and refugee status becoming entangled. The rules of the international system were designed before an era of mass air travel and instant, digital communication, and they are going to have to be redrawn to fit new realities.

The financial crisis might not on its own explain these shifts in politics, but in the West it made the weather. As a historical period, the climactic end of the West's long boom and controversial aftermath may even end up ranking alongside the impact of the defining year, 1973, with the oil crisis and the end of the Bretton Woods financial system, and other related emergencies. That ushered in a new approach to economics on the centre-right that became popular, although hardly universally so. The broad consensus among policymakers about open markets lasted from the mid-1970s until 2008.

As an advocate of markets, what worries me most about the current situation is that a decade has passed and before long there will be another correction or downturn, as part of the normal and natural process that occurs in developed economies. American monetary policy is finally normalising after the shock therapy of the post-crisis period. The US economy is strong and, at the time of writing, growing fast boosted by tax cuts and deregulation. But when the next recession does eventually occur, politics in the West is dangerously primed. The populists are well-positioned. Markets and capitalism, along with migrants, will get the blame.

Some of the populist parties already in place are theoretically pro-market, but that will not matter in the scapegoating process if it comes. If you do not like these principles we have others, as the old saying goes. European populist parties can and do adapt at speed in an economic

emergency – as they demonstrated in the Italy of the 1920s and Germany in the early years of the 1930s. In the UK, it is obvious already. The newly resurgent far Left under Corbyn talks in terms of wanting to put people before profit. That sounds beguiling, people before profit. Apart from the obvious point that you cannot do much for people unless you make a profit.

Rather than just sitting waiting, I wonder if it might be possible to construct a new political economy, and a defence of the market economy in an era of resurgent protectionism and populism. There is, however, a major complication – and that is the reality that market complexity thanks to technology has increased in the last decade and is only going to keep on increasing. Finance is transferring to the cloud away from the mainframe computer; transactions are becoming more difficult to see inside; speed and volume get ever greater. In that respect, one of the main difficulties for those who believe that profit is the essential product of a healthy, functioning commercial society, is that what was once easy to explain has become increasingly hard to understand or conceive.

The merchant or free trader of the late 18th and 19th centuries in Britain, or France, or Germany, had no difficulty understanding markets, and the elementary aspects of a market society and the principles underpinning it. Of course, there were financial instruments that only a banker in Hamburg or a market-maker in Paris or London understood. But the basics of the system – use of resources, deployment of capital, debt, insurance, invention and innovation – were relatively easy to follow for the engaged and literate citizen. In London, the traders may not themselves have read Adam Smith's *The Wealth of Nations*, but those who ran the ministries or published newspapers had. Later, the Marxists (having studied Smith) had an alternative, simple – if wrong – explanation for what was going on. But classical liberals had their own accessible language for explaining why free trade and markets worked. It was a relatively fair fight. Today, financial capitalism has grown so complex, with systems so intertwined and autonomous, and technology growing ever more powerful and fast, that it is extremely difficult even for its advocates to understand.

What do I mean by market complexity? We hear a lot about artificial intelligence, and the dilemmas this will pose as it pushes new boundaries. The vision presented is frequently dystopian, of humans monitored and scanned, powerless against a giant, autonomous, whirring machine.

Adam Smith.

The writer on technology Andrew Keen has spoken about the need for consumers to take back control. He's right. And he is hardly alone. But the area outside warfare where technology has had the biggest transformational impact in the last half century is in financial markets, the debt machine, the wiring of the global economy, without which sophisticated trade is impossible.

Computerised trading only began in the US in the period between 1975 and 1977, with a series of regulatory reforms and the establishment of computerised transactions. In the UK it was slower, and the switch to computers in the Stock Exchange only took place in 1986 with the Big Bang regulatory revolution launched by Margaret Thatcher's pro-market government. This helped make London once again the main European financial centre. Incidentally, that event – the Big Bang – is often presented as an example of deregulation. Wrong. It was the introduction of regulation, the application of law, in a field – stock markets – which had previously been managed informally by the market participants themselves according to the rules of a club with codes of behaviour governing proceedings. That revolution in the 1980s in London was initially about equities, but of much greater importance is the global debt market. Global long-term bond issuance in 2016 was $21.4 trillion. Of the $300 trillion global market, only about a quarter is comprised of the stock market. Selling, insuring, and swapping that debt is the main business of the markets. Globalisation meant a mammoth scaling up for financial firms, through consolidation and the race to expand, creating in the process banks that are so large that it would be beyond the ability of even the brightest CEO to understand all, or even half, of what their institutions do. We saw this play out in the financial crisis, with CEOs introduced too late to the complex instruments their staff had been selling. But if markets are only to become more complex, and the systems more autonomous still in the era of "fintech", how on earth can we manage and cope with this process? So that the advantages are retained – profit, the juice that funds investment and incentivises innovation.

The Chinese answer to these complex problems is mass control and the single party. Fused with a revolution in the payments system, it may become the dominant ideology. For free societies, interested in human dignity and free expression, that is unappealing. Is there a democratically sustainable alternative? If there is, the answer in the West lies not, I suspect, in the contents of Smith's *Wealth of Nations* and a crude interpretation

of that work, or in just banging the drum for profit. Smith's other great work comes into play instead – *The Theory of Moral Sentiments* reveals Smith as a much more complete and rounded thinker. Enlightened self-interest is at the core of it, but obligation to others and the public realm matter just as much. Going in that direction does not mean so much radically reforming capitalism, as reinfusing it with that spirit of obligation.

Tech reformers and radicals speak of this purely in terms of the need for regulation. But there is an entirely false choice there. The idea that there are only two alternatives – laissez-faire or the regulatory state – is wrong. Of course there must be regulation. Markets outside the Wild West have always been regulated, even if only by law and civic code. Only the most devoted libertarian thinks there is no role at all for regulation. Smith was clear that the public realm and markets are not in conflict. It is not one or the other. They need each other. One pays for the other. But markets only function truly effectively within a sound legal framework. This was understood by Teddy Roosevelt in the US at the start of the 20th century, when as a trust-buster and reformer he tackled vested interests in the pursuit of the public interest.

Soon, we will need some of that animating Rooseveltian spirit if we are to create a new political economy in the West, a new language of politics and markets when complex finance and rampant tech are merging. The largest tech companies own the cloud, on which the banks are building their platforms and into which the banks are pouring their and our data. Add technologies such as blockchain – which creates an unbreakable, impenetrable and secure record of transactions – and potential successors to blockchain and you have financial behemoths which will become increasingly difficult to see inside.

I finished my book (published in 2013) on the collapse of RBS by asking speculatively of banks and technology companies whether we work for these new giants, these money machines – or do they work for us? Technological change continues year on year to make the question more pressing. It is a new democratic emergency revolving around an old question – who is in charge?

We had better be sure it is us, as voters and consumers, through our legislatures. But it will be impossible – outside of an authoritarian regime such as China – to micro-manage these corporate machines or to have oversight of every single aspect of an institution's activities as the

technology outruns regulators. We can make directors of these new generation companies even more directly accountable under the law, with much tougher sentences and sanctions to encourage them to be alert, behave responsibly and minimise any damage. But our defence will have to rest first and foremost on an appeal to ethics, obligation, and duty.

Michael Young, author of *The Rise of the Meritocracy*.

MERITOCRACY AND THE RISE OF POPULISM

Adrian Wooldridge

WHY did Donald Trump win the 2016 presidential election? Why did Britain vote for Brexit? And why does Erdoğan win loud applause whenever he mocks liberal "blah blah blah"? Why, in short, is liberal democracy in turmoil and populism on the march? Commentators are competing fiercely to produce the best answer to these questions. But as far as this author is concerned the prize goes to a book that was published in 1958 – when Donald Trump was just 13 and Vladimir Putin was seven. The book is Michael Young's *The Rise of the Meritocracy.*

Young argued that the most significant fact about modern society is not the rise of democracy, or indeed capitalism, but the rise of the meritocracy, a term he invented. In a knowledge-based society the most important influence on your life-chances is not your relationship to the means of production but your relationship to the machinery of educational and occupational selection. This is because this machinery determines not just how much you earn but also your sense of self-worth. For Young, the greatest milestones in recent British history were not the Great Reform Act of 1832 or the granting of votes to women in 1928. They were the Northcote-Trevelyan report of 1854, which opened civil service jobs to competitive examinations, and the Butler Education Act of 1944, which decreed that children should be educated according to their "age, ability and aptitude".

Young was a towering figure in British life – the author of the Labour Party's 1945 manifesto, the founder of the Open University, and a pioneering sociologist. But for all his distinction many readers misread the book as a celebration of meritocracy. The likes of former prime ministers Harold Wilson and Tony Blair shamelessly marketed themselves as meritocrats – enemies of the fusty old order and embodiments of modernity and justice rolled into one. In fact, it was meant to act as a warning. Young believed that the rise of the meritocracy was dividing society into two

polarised groups: the exam-passers and the exam-flunkers. This would inevitably end in tears. The exam-passers would become the hereditary elite: selected on the basis of their brain power they would nevertheless do everything possible to make sure their less than brilliant children were given every educational advantage. The exam-flunkers would become increasingly embittered, first turning in on themselves, in misery and despair, and then turning against the society as a whole, in pig-wrestling rage. The result would be a revolution: the "failures" would finally rise up against their meritocratic overlords (abetted by members of the ruling class who could no longer tolerate the system) and wreak their revenge for all the snubs and sneers.

Look around the world and almost everything that Young worried about can be seen in action. His only mistake was one of timing. Young thought that the populist revolution would be delayed until 2033. In fact it is already occurring. The biggest division in modern society is not between the owners of the means of production and the workers, as Karl Marx posited. It is not between the patriarchy and women or the white races and non-white races, as the post-modernists posit. It is between the meritocracy and the people, the cognitive elite and the masses, the exam-passers and the exam-flunkers. The winners are becoming intolerably smug. The losers are turning in on themselves, with an epidemic of suicides and drug addiction reducing the life-expectancy of working-class Americans for the first time in a century. And the tumbrils are beginning to operate.

The global establishment is, above all, a meritocratic establishment: it consists of people who have done well at school and university and who have gravitated to jobs that require both intellectual skills and evidence of those intellectual skills in the form of credentials. There are various sub-divisions within this elite: people who work for universities and NGOs like to snipe at people who work for business and banks, but in fact all members of the global elite have more in common than they like to think.

They routinely marry other members of the meritocratic elite: the marriage announcements in the *New York Times* read rather like marriage announcements between blue-blooded families in the high Victorian age, with the lists of university degrees (Harvard and Yale marries Brown and Columbia!) replacing lists of family pedigrees. Only two out of every thousand marriages are between a partner with a university degree and a

partner with primary qualifications only. They usually share a common outlook. They pride themselves on their cosmopolitan values partly because they live in a borderless world – they are forever hopping over borders, in their business trips and foreign holidays – and partly because liberal immigration policies provide them with all the accoutrements of a cash-rich and time-starved lifestyle, cleaners, baby-sitters and exotic restaurants. They like to demonstrate their sympathy with racial and sexual minorities: businesses are now busily importing affirmative action schemes and gay-friendly policies from universities. But they don't give much of a damn for the old-fashioned working class: whether they will admit it or not, many exam-passers think that those left behind deserve their dismal fate not just because they are less intelligent than the exam-passers but because they are less enlightened as well.

The populist movement that is sweeping the world is, more than anything else, a revolt against meritocracy. The groups that are driving the rise of populism have disparate material interests: they consist of traditional working-class people, Main Street business people such as real-estate agents and old-line manufacturers, and older voters who came of age before the great university expansion of the 1960s. But they are united by their common opposition to the meritocratic elite with their cosmopolitan values and habit of valuing intellectual achievement over physical skills.

The biggest predictor of populist attitudes is failure in the exam race. In Britain's EU-referendum, 72 per cent of people with no educational qualifications voted to leave, compared with only 35 per cent of those with a university degree. In America, whites without a degree voted 67 to 28 for Trump while whites with degrees voted 71 to 23 for Hillary Clinton. The first female presidential candidate for a major party lost white women without a degree by a margin of 27 points. For some strange reason the average waitress doesn't care about getting more women onto the boards of Fortune 500 companies.

The western electoral map is increasingly a map of education institutions. In America the Democrats win places where colleges are thick on the ground – the coasts, the cities and the university towns. The Republicans win places where Wal-Marts and Dennys are more common. In Britain the Remainers won by huge margins in knowledge-intensive cities such as London and in college towns such as Oxford and Cambridge. The Leavers won in the provinces and in smaller towns.

One reason why the Leave vote proved such a surprise for pollsters in Britain was that it was driven by a surge in turn-out among people who had almost given up the habit of voting. Areas with large numbers of people with no educational qualifications witnessed a larger increase in turnout (8.4 points) than areas with large numbers of middle-class graduates (6.6 points). The estimated participation gap between highly educated professionals (who largely voted Remain) and people with lower levels of education (who usually voted Leave) was reduced from 39 per cent in the 2015 general election to only 20 per cent. Those who advocate a re-run of the referendum should think carefully about overturning a vote that galvanised large numbers of people who had given up the habit of voting precisely because they had come to the conclusion that their votes didn't make a difference.

In the 1990s, American politics was profoundly reshaped by culture wars that focused on "gays, guns and God". Today, it is not just American but global politics that is being reshaped by a new iteration of culture wars which focus on questions of education, identity and self-worth. Donald Trump proudly boasts that he "loves the poorly educated". Trump's enemies respond by questioning the ability of the "poorly educated" to pursue their own interests. The most effective way to rile the meritocrats is to attack their faith in expertise: Lord Turnbull, a former Cabinet Secretary, has said that the Brexiteers' willingness to question Treasury forecasts of the impact of Brexit was reminiscent of prewar Nazi Germany. The easiest way to rile the populists is to imply that their attachment to symbols of national identity, such as blue passports or the Union Jack, is a sign of low intelligence.

Why is the revolt against the meritocracy so powerful? Why is it trumping economic factors despite stagnant living standards for the masses? And why does it persist despite concerted attempts to close it down from the establishment? Three things lie behind the fury.

The first is marginalisation. The meritocrats have progressively seized control of almost every institution of any significance and, almost without realising it, muscled aside anybody who doesn't share their values and interests. Few people would begrudge the meritocrats their success in wresting control of the civil service from dim-witted aristocrats in the mid-19th century or wresting control of academia from "men of letters" in the mid-20th century: you need a combination of brains and discipline to administer the modern state or to explore the universe. But recently the

meritocratic revolution has advanced into more questionable areas. Businesses used to provide a ladder for people to climb from the shop floor to the corner office through practical success rather than academic qualifications. Now they are increasingly taken over by people with MBAs and a few years working for McKinsey. National newspapers used to recruit people from local newspapers who cut their teeth on the crime beat. One of the best columnists in Britain, the late Frank Johnson, left school at 16 and started his career as a messenger boy on the *Sunday Express*. Now journalism is becoming an all-graduate profession and you can pass effortlessly from studying gender studies at university to decrying sexism in a major newspaper without ever so much as meeting a member of the general public. Most damaging of all is the marriage between politics and meritocracy.

The essence of democratic politics is that it's open to anyone regardless of background or education. The great democratic reforms of the late 19th and early 20th centuries removed successive barriers erected by property, biology or education. The great left-wing parties earned their spurs by helping working-class people into parliament. Before the Second World War, for example, most Labour MPs were manual workers who had been sponsored by trade unions. But across the West new informal barriers to participation are being erected by the march of meritocracy. Mark Bovens and Anchrit Wille, two academics, talk about the rise of "diploma democracy" or "political meritocracy".

Parliaments are increasingly dominated by graduates. In many European countries more than 80 per cent of MPs have university degrees – and the figure goes up to almost 100 per cent when you look at the latest intake. In Angela Merkel's third cabinet, installed in 2013, 14 out of 15 ministers had the equivalent of a master's degree, nine had a PhD, seven had held some sort of job in a university, and two had held full professorships, before entering politics. (Having a PhD is such a boon in German politics that some politicians have awarded themselves degrees without going through the tedium of actually bothering to study.) More than 80 per cent of MEPs have university degrees and more than 25 per cent have PhDs. It is conventional to agonise about the slowness of the rise in the number of women or ethnic minorities in parliament. The simultaneous decline in the number of working-class MPs arouses almost no comment whatsoever.

Parliaments are the tip of an iceberg of educational privilege. The political parties are ceasing to be mass membership organisations and instead

becoming professional bodies dominated by graduates. Most NGOs are now run by professionals rather than volunteers. Graduates are more likely to engage in political activities such as signing petitions or calling for boycotts than non-graduates. Even the bastions of the working-class, the trade unions, are being colonised by knowledge workers: in Britain the average trade unionist is a woman in her sixties with a higher qualification.

This has important consequences for the political agenda: the 70 per cent who didn't go to university have different priorities from the 30 per cent who did. They are much more preoccupied by questions such as crime (which deserves stiff punishment), immigration (which needs to be curbed) and welfare scrounging (which must be stopped), and much less concerned about the environment and the travails of refugees. One of the most dramatic changes in the United States in recent years has been the reduction in the life-chances of a significant section of white America. In the 1990s the risk of a non-college-educated white person dying in his early fifties was 30 per cent lower than for a comparable black person. By 2015 it was 30 per cent higher. Non-Hispanic white males make up 31 per cent of the population but accounted for 70 per cent of suicides in the US in 2014. Yet politicians and journalists have paid little attention to these problems on the grounds that white men are, ipso facto, embodiments of various sorts of privilege. Between November 8, 2015 and November 8, 2016 the word "transgender" appeared in the *New York Times* on 1,169 occasions. The word "opioid" appeared only 284 times.

The second problem is condescension. The most common complaint made by populists is that the elites look down on them in every imaginable way. They despise the symbols that they hold dear. They chuckle at their favourite sports such as NASCAR racing. They make jokes about their favourite clothes (skimpy T-shirts are "wife beaters"). In many ways this is an age of hypersensitivity: commentators make jokes about racial minorities at their peril. But the working-class remains fair game. This attitude is revealed in a mass of off-the-cuff remarks – some of which, such as Hillary Clinton's description of Mr Trump's supporters as a "basket of deplorables", have captured the public attention but most of which pass for normal. Anti-Brexit warriors such as AC Grayling routinely describe Brexit voters as stupid. The *Sunday Times* quoted an Italian lawyer describing his country's populists as belonging to "another species". Emily Thornberry, while Britain's shadow Attorney General, chortled by

Pro-Remain protesters outside
the Houses of Parliament.

tweet over a image of "white van man" and his stereotypically crude predilection for the Cross of St George.

One reason why populists are so furious about political correctness – the majority of people who voted for Brexit and Trump put opposition to political correctness high on their list of reasons for so doing – is that they regard it as an exercise in condescension. Political correctness serves two covert functions for the elite. It allows them to demonstrate how virtuous they are by taking offence at "insensitive" remarks. It also allows them to demonise blue-collar workers by stigmatising their traditional habits. In many ways it's a postmodern version of conspicuous consumption: it allows its devotees to demonstrate their superiority over their fellow citizens by building mansions of virtue in the same way that 19th-century robber barons built physical mansions. "How does it feel to be a problem?" wrote WEB Du Bois at the beginning of the century in reference to black people. Political correctness is today's way of defining your fellow citizens as a problem.

The third problem is over-reach. The meritocrats – particularly the super-meritocrats who run global institutions – have repeatedly promised more than they can deliver. The architects of the Washington consensus presented two big arguments for globalisation, particularly financial globalisation. The first was that globalisation would make us all richer. A few bankers might get obscenely rich. But that was a small price to pay for the fact that overall living standards would rise. The second was that they knew how to control the gods of finance. Financial liberalisation might unleash a certain amount of turbulence. But wise men such as central bankers possessed the techniques that they needed to bring that turbulence under control. Gordon Brown, the UK's former long-standing chancellor and short-lived prime minister, even boasted that he had ended the cycles of boom and bust in the British economy.

The financial crisis of 2008 blew these arguments to smithereens. The wizards failed to bring the crisis under control until it had destroyed billions of dollars' worth of wealth. And the bankers continued to enrich themselves even as the global economy collapsed: AIG executives insisted on receiving their annual bonuses despite the fact that the taxpayer had been forced to rescue the company from bankruptcy. The hangover from that financial crisis is with us still. Britain's Institute for Fiscal Studies predicts that average living standards won't reach the level that they were at before the financial crisis until the mid-2000s.

The same pattern of over-reach can be seen in the European Union. The EU unwisely introduced a common currency before it had the other prerequisites of a currency union such as a common tax system. The EU keeps insisting that the "four freedoms" are indivisible, as if they were written on tablets of stone and handed down by God, and despite the fact that North America enjoys the benefits of free trade in goods and services without free movement of people. Indeed, freedom of movement is whipping up opposition to the other freedoms that might eventually result in the destruction of the entire edifice. The Brussels elite seems to think that repeating a phrase constitutes an argument and that sticking to your guns regardless of the evidence is proof of courage rather than stupidity.

The final problem is self-interest: the meritocrats have a remarkable ability to fix the rules to suit their own purposes, either by disguising self-interest as the common good or by rewriting the rules to save their own bacon. Many of the greatest 19th-century novelists such as Charles Dickens and Gustave Flaubert railed against the sheer hypocrisy of the Victorian middle class. But the Victorians were mere pikers compared with today's meritocratic elite.

Take the question of immigration. Meritocrats benefit hugely from immigration because it provides them with cheap servants to raise their children (a necessity when two parents are pursuing their careers) as well as cheaper goods and services. For non-meritocrats the calculation is much more complicated: immigration frequently represents a direct challenge to their jobs or, at a minimum, a downward pressure on their wages. But meritocrats have done a brilliant job of presenting support for immigration as a moral imperative rather than as an economic calculation – and in implying that people who are opposed to immigration are moral imbeciles.

Or take the notion that the new division in global politics is between "open" and "closed". This is becoming axiomatic in meritocratic circles. But it is saturated with self-interest and self-adulation. The terms used to describe the division are highly emotive: proponents of the division contrast good things such as openness and cosmopolitan values with bad things such as nativism and being closed-minded. The old division between left and right at least had the virtue of being value-neutral. They are also highly misleading. The supporters of "openness" are much less open than they like to pretend. They carefully protect their interests with

all sorts of barriers to competition such as licenses, closed shops (try becoming a British barrister) and informal protections.

The meritocrats are adept at marking their own homework: most financial regulators have a background in the financial services industry for example. Senior corporate managers sit on each other's boards and determine each other's salaries. For some reason those salaries keep going upwards.

The meritocrats are also adept at changing the rules when they turn against them. The most infuriating example of this is the banking crisis. For decades financiers preached the virtues of competition red in tooth and claw. Remove barriers to competition! Pay people what they are worth! Let people eat what they can kill and only what they kill! But as soon as the market collapsed these adamantine capitalists suddenly became bleeding-heart socialists.

The danger is that meritocratic elitism and populist rage will become self-reinforcing. The meritocrats will double-down on their elitism in response to populist criticism. The populists will get ever angrier and more extreme.

This is already happening. America's universities have become ever more preoccupied with identity politics, and more willing to shout down conservative speakers, in response to Trump's policies. The world's global institutions are also doing more to insulate themselves from the unwashed masses and their reactionary views. Liberal globalists have even taken to advancing a radical new notion of where sovereignty lies: not with the people, as the Americans have always argued, or with the state, as the French maintain, or with parliament as the British insist, but with a universal collection of rights, existing in a Platonic world beyond the reach of politics, that empanelled experts can discover and implement. The populists are replying in kind.

The populists are becoming more belligerent. In Britain, the *Daily Mail* denounces "Remoaners" – those who voted to remain in the EU and who complain about the referendum result – as "traitors" and called High Court judges "enemies of the people". In America right-wing blogs proclaim that their aim is to make "liberal heads explode" ("It's really funny to me to see the 'splodey heads keep 'sploding," says Sarah Palin). Under George W Bush, the conservative movement boasted a counter-establishment of conservative think tanks, high-brow journalists and policy intellectuals. Today they have been sidelined by a conservative-

entertainment complex of shock jocks, cable news presenters and professional bigots who make their living by mocking the educated elite. Irving Kristol and William F Buckley have given way to Ann Coulter and Milo Yiannopoulos. The American Enterprise Institute has passed the torch to Fox and Friends.

It is time for responsible meritocrats to step in and restore some semblance of sanity. They bear a disproportionate share of the responsibility for the mess we're in at the moment. They let their arrogance and self-regard get the better of them. They promised universal prosperity and produced turbulence and stagnation. They owe it to the world to repair the mess that they have created.

CONTRIBUTORS

ERICA BENNER is a Fellow of Ethics and Political Philosophy at Yale University and taught for many years at Oxford University and the London School of Economics. Her publications include *Really Existing Nationalisms, Machiavelli's Ethics,* and *Machiavelli's Prince: a new reading.* Her book *Be Like the Fox: Machiavelli's lifelong quest for freedom* was short-listed for the 2018 Elizabeth Longford Prize for Historical Biography.

GILL BENNETT is a former Chief Historian of the British Government's Foreign & Commonwealth Office and senior editor of the UK's official history of British foreign policy, *Documents on British Policy Overseas.* She has been involved in a number of research and writing projects in White-hall, including working on the official history of the Secret Intelligence Service. She is an Associate Fellow of the Royal United Services Institute, and a Fellow of the Royal Historical Society. Her books include *Churchill's Man of Mystery: Desmond Morton and the world of intelligence,* and *Six Moments of Crisis: inside British foreign policy.* Her latest book is *The Zinoviev Letter: the conspiracy that never dies.*

MARIA BORELIUS is a science journalist, author and entrepreneur living in London. She holds a Master's degree in Science Journalism from New York University, a bachelor in Biology, Physics and Mathematics from Lund University and has also studied Recombinant Gene Technology and Bioethics at Oxford University. She works as an adviser to global pharmaceuticals, tech companies and larger science institutions and as a columnist for the Nordic daily pink paper, *Dagens Industri.*

PETER BURKE is a Life Fellow and Emeritus Professor of Cultural History at Emmanuel College, Cambridge. His many publications include *The Italian Renaissance*; *Popular Culture in Early Modern Europe*; *The Art of Conversation*; *A Social History of Knowledge from Gutenberg to Diderot*;

Eyewitnessing; *A Social History of Knowledge II: from the Encyclopédie to Wikipedia* and *Exiles and Expatriates in the History of Knowledge, 1500–2000*. He is currently at work on a history of polymaths.

NICHOLAS CARR is a writer on technology and culture who received the Neil Postman Award for Career Achievement in Public Intellectual Activity from the Media Ecology Association in 2015. His work, *The Shallows: What the Internet Is Doing to Our Brains*, was a Pulitzer Prize finalist and a *New York Times* bestseller. A former member of the Encyclopedia Britannica's editorial board of advisers and one-time executive editor of the *Harvard Business Review*, his other books include *The Big Switch: Rewiring the World, from Edison to Google*; *The Glass Cage: Automation and Us* and, most recently, *Utopia Is Creepy*.

CHRISTOPHER COKER is Professor of International Relations at the London School of Economics and Director of IDEAS, its foreign policy think tank. He is a former twice-serving member of the Council of the Royal United Services Institute, a former Nato Fellow and is a regular lecturer at defence colleges around the world. His publications include *Men At War: What Fiction Tells us About Conflict, From The Iliad to Catch-22* och *The Improbable War: China, the United States and the Logic of Great Power Conflict*. His most recent books are *Future War* and *Rebooting Clausewitz*.

PETER FRANKOPAN is Professor of Global History at Oxford University, where he is founding Director of the Oxford Centre for Byzantine Research and Senior Research Fellow at Worcester College. He is Scaliger Visiting Professor at Leiden University and Presidential Scholar at the Getty Centre in Los Angeles. He works with the United Nations Industrial Development Organisation (UNIDO) on the future of sustainable cities and on the Belt and Road Initiative. His publications include *The First Crusade: the Call from the East* and *The Silk Roads: A New History of the World*. His most recent book is *The New Silk Roads: The Present and Future of the World*.

JESSICA FRAZIER is a University Research Lecturer at the University of Oxford and a Fellow of the Oxford Centre for Hindu Studies. She is the founder and managing editor of the *Journal of Hindu Studies*. Her publications include *Hindu Worldviews: Theories of Self, Ritual and Reality*; *Categorisation in Indian Philosophy* och *Reality, Religion, and Passion*.

DAVID GOODHART is a journalist and author and is head of the demography unit at the Policy Exchange think tank. He is the founder and former editor of *Prospect* magazine and the former director of the centre-left think tank Demos. His book *The British Dream: Successes and Failures of Post-War Immigration* was runner-up for the Orwell Prize. His other publications include *The Road to Somewhere: The New Tribes Shaping British Politics.*

MICHAEL GOODMAN is Professor of Intelligence and International Affairs in the Department of War Studies, King's College London, and Visiting Professor at the Norwegian Defence Intelligence School. He has published widely in the field of intelligence history, including most recently the first volume of *The Official History of the Joint Intelligence Committee*, which was chosen as one of *The Spectator*'s books of the year. He has recently finished a secondment to the Cabinet Office, where he has been the Joint Intelligence Committee's official historian. Volume II of the committee's history will be published this year.

JOHN HEMMING was director of the Royal Geographical Society in London for 21 years. Made a Companion of the Order of St Michael and St George in 1995, he also holds both of Peru's highest honours – Gran Cruz of the Orden al Mérito Publico and Gran Oficial of El Sol del Perú – as well as the Order of the Southern Cross, awarded to him by the Brazilian government for his work in the region. He has visited over 40 indigenous peoples (four of them at first contact) and led the largest rainforest research project to be organised by a European country. His three-volume history of the indigenous peoples of Amazonia consists of *Red Gold: The Conquest of the Brazilian Indians, Amazon Frontier* and *Die If You Must*. His many other books include *The Conquest of the Incas* och *Tree of Rivers: The Story of the Amazon*.

SUZANA HERCULANO-HOUZEL is Associate Professor in the Departments of Psychology and Biological Sciences at Vanderbilt University in Nashville, Tennessee. She was previously a faculty member at the Federal University of Rio de Janeiro. She won the José Reis Prize for Science Communication in 2003 and was the first Brazilian speaker on TED Global, in 2013. Her publications include *The Human Advantage: A New Understanding of How Our Brain Became Remarkable.*

MARTIN INGVAR is Professor of Integrative Medicine at the Department of Clinical Neuroscience and Director of the MR Centre at Karolinska Institutet, Stockholm. He has written four popular science books about the brain and has authored or co-authored some 250 academic papers as well as supervising 12 doctoral students. He has served in numerous leadership roles at Karolinska Institutet including as Dean of Research and Deputy Vice-Chancellor for Future Healthcare.

ANDREW KEEN is executive director of the Silicon Valley innovation salon FutureCast and is host of the TechCrunch chat show "Keen On". His publications include: *Cult of the Amateur, Digital Vertigo, The Internet is Not the Answer* och *How to Fix the Future: Staying Human in the Digital Age.*

ELISABETH KENDALL is Senior Research Fellow in Arabic and Islamic Studies at Pembroke College, Oxford. She previously served as Director of the Centre for the Advanced Study of the Arab World. In addition to lecturing at numerous universities and think tanks around the world, she features regularly in the international media. For the last five years she has acted as international adviser to a cross-tribal grouping in eastern Yemen that promotes grassroots activities to counter al-Qaeda and Islamic State expansion. She is the author or editor of several books, including *Reclaiming Islamic Tradition* (with Ahmad Khan), *Twenty-First Century Jihad* (with Ewan Stein), and *Literature, Journalism and the Avant-Garde: Intersection in Egypt.*

CLAIRE LEHMANN is a writer and editor-in-chief of the online magazine *Quillette*, which she founded in 2015. Prior to launching the magazine, she worked in government and the not-for-profit sector in the areas of health policy and immunisation research and communication. Her writing has appeared in *Tablet, Commentary, The Sydney Morning Herald* and *Scientific American.*

IAIN MARTIN is a commentator on politics and finance, and an author. A former editor of *The Scotsman* and deputy editor of the *Wall Street Journal Europe*, he is a columnist for *The Times* and the founder and editor of Reaction, a pro-market news website. His book *Making it Happen: Fred Goodwin, RBS and the Men Who Blew Up the British Economy* was shortlisted

for the 2013 Financial Times and Goldman Sachs Business Book of the Year Award. He is also the author of *Crash Bang Wallop: The Inside Story of a Financial Revolution that Changed the World*.

JANNE HAALAND MATLÁRY is Professor of International Affairs at the Department of Political Science, University of Oslo and adjunct Professor at the Norwegian Command and Staff College. She was deputy foreign minister of Norway (1997–2000) and has been a policy adviser to governments and international organisations. She is a member of the Papal Academy of Science at the Vatican and has a weekly column on foreign policy in *Dagens Naeringsliv*, Oslo. Her recent books include: *Hard Power in Hard Times: Can Europe Act Strategically?* and (with Rob Johnson) *The UK's Defence in the Age of Brexit: Britain's Alliances, Coalitions, and Partnerships* (both Palgrave Macmillan, 2018).

LIEUTENANT GENERAL SIR SIMON MAYALL is a retired British Army officer who served most recently as Defence Senior Adviser Middle East for the UK Government and was the Prime Minister's Security Envoy to Iraq after the fall of Mosul. He is Colonel of his regiment, 1st The Queen's Dragoon Guards, Lieutenant of the Tower of London, and is a senior adviser with Greenhill, a global financial advisory firm, and Director of Sandcrest Consulting. He was knighted in 2014 and has also been honoured with the US Legion of Merit for services in Iraq.

RICHARD MILES is Professor of Roman History and Archaeology at the University of Sydney, where he is also the Pro Vice-Chancellor (Education – Enterprise and Engagement). He is the Academic Director of the Ancient North Africa Research Network, which co-ordinates research activities on the ancient Maghreb region. He has directed excavations in Carthage and Rome, and has written and presented a number of documentaries on the ancient world for television. His publications include *Carthage Must Be Destroyed* and *Ancient Worlds: the search for Western civilisation*. He is also the co-author of *Vandals*.

FRASER NELSON is editor of *The Spectator* magazine and a columnist for *The Daily Telegraph*. He is also a director of the Centre for Policy Studies and the Social Mobility Foundation.

BRENDAN O'NEILL is editor of the online magazine, *Spiked*. He is a regular writer for *The Sun* and *The Spectator* and a columnist for *The Australian* and *The Big Issue*. A collection of his essays, *A Duty to Offend*, was published in 2015.

MARK PAGEL is Professor of Evolutionary Biology at the University of Reading, head of the university's Evolutionary Biology Group, and a Fellow of the Royal Society. He is the Editor-in-Chief of the award-winning *Oxford Encyclopedia of Evolution* and co-author of *The Comparative Method in Evolutionary Biology*. Widely published in the journals *Nature* and *Science*, he is also the author of *Wired for Culture: Origins of the Human Social Mind*.

MARK PLOTKIN has led the Amazon Conservation Team and guided its vision since 1996, when he co-founded the organisation. A renowned ethnobotanist, he has spent almost three decades studying traditional plant use with traditional healers of tropical America. Dr Plotkin previously served as Research Associate in Ethnobotanical Conservation at the Botanical Museum of Harvard University, Director of Plant Conservation at the World Wildlife Fund, Vice-President of Conservation International, and Research Associate at the Department of Botany of the Smithsonian Institution. His books include *Tales of a Shaman's Apprentice*; *Medicine Quest: In Search of Nature's Healing Secrets*, and he is co-author of *The Killers Within: The Deadly Rise of Drug-Resistant Bacteria*.

NATHAN SHACHAR is a correspondent of the Swedish daily newspaper *Dagens Nyheter* and is on the editorial board of *Axess magasin*. In 2014 he received Sweden's foremost literary award Övralidspriset. His publications in English include *The Gaza Strip – its history and politics* and *The Lost Worlds of Rhodes*. His latest book, *Sin egen värsta fiende*, on the Spanish Civil War, has been shortlisted, along with ten other books, as one of the century's best non-fiction works in Scandinavia.

MARIANO SIGMAN is director of the Neuroscience Laboratory at Di Tella University (Buenos Aires). A former Fellow of the Human Science Frontier Project and a scholar of the James S. McDonnell Foundation, he is the only Latin American scientist to be a director of the Human Brain Project. His publications include *The Secret Life of the Mind: How Your Brain Thinks, Feels and Decides*.

M. ANTONI J. UCERLER is a Roman Catholic Jesuit priest, Associate Professor of East Asian Studies, and Director of the Ricci Institute for Chinese-Western Cultural History at the University of San Francisco. He has previously taught at Sophia University in Tokyo, Georgetown University in Washington DC, and the University of Oxford, where he is also a member of the Oriental Studies faculty. He has published numerous studies on Christian history in Japan, including *Christianity and Cultures: Japan and China in comparison, 1543–1644*. His forthcoming publication is *The Samurai and the Cross: Life and Death in Christian Japan, 1549–1650*.

ADRIAN WOOLDRIDGE is the Political Editor and Bagehot columnist of *The Economist*. Formerly the magazine's Washington Bureau Chief, he has co-authored a number of books with former fellow *Economist* writer John Micklethwait, including *A Future Perfect: The Challenge and Promise of Globalisation, The Right Nation: Conservative Power in America* and *God is Back: How the Global Revival of Faith is Changing the World*. His most recent book, co-authored with former Chairman of the US Federal Reserve, Alan Greenspan, is *Capitalism in America: A History*.

Image Rights©

KNOWLEDGE AND INFORMATION
The Potential and Peril of Human Intelligence

© The authors and Bokförlaget Stolpe, 2021,
in association with Axel and Margaret Ax:son Johnson Foundation for Public Benefit

The essays are based on the seminar Knowledge and Information held at Engelsberg Ironworks
in Västmanland, Sweden, in 2018

Edited by
Kurt Almqvist, President, Axel and Margaret Ax:son Johnson Foundation
Mattias Hessérus, Project Leader, Axel and Margaret Ax:son Johnson Foundation

Text editors: Alexander Linklater, Andrew Mackenzie
Picture editor: Tove Falk Olsson
Design: Patric Leo
Layout: Petra Ahston Inkapööl, Patric Leo
Cover image: Pieter Bruegel the Elder, (detail of) The Tower of Babel, 1563. Kunsthistorisches Museum,
Vienna/Mondadori Portfolio/Electa/Remo Bardazzi/Bridgeman Images
Pre-press and print coordinator: Italgraf Media, Stockholm
Print: Printon, Estland, via Italgraf Media, 2021

ISBN 978-91-8906-961-9

BOKFÖRLAGET STOLPE

AXEL AND MARGARET AX:SON JOHNSON FOUNDATION
FOR PUBLIC BENEFIT